HOW TO TAKE GREAT PHOTOS WITH

35mm AUTOFOCUS
POINT & SHOOT CAMERAS

HPBooks

HOW TO TAKE GREAT PHOTOS WITH

35mm AUTOFOCUS
POINT & SHOOT CAMERAS

By Amy Stone

HPBooks
a division of
PRICE STERN SLOAN
Los Angeles

Dedicated to my husband, Mark
and
The editors of Petersen's PHOTOgraphic Magazine

With special thanks to:

Dale Labs
Hollywood, FL

Gibbons Color Laboratory
West Hollywood, CA

Sunset Plaza One Hour Photo
West Hollywood, CA

and

The manufacturers mentioned in this book,
for all their cooperation and support

Published by HPBooks
a division of Price Stern Sloan, Inc.
360 North La Cienega Boulevard
Los Angeles, California 90048
© 1990 Amy Stone
Printed in U.S.A.

10 9 8 7 6 5 4 3 2

Library of Congress Cataloging-in-Publication Data

Stone, Amy, 1964-
 How to take great photos with 35mm autofocus point & shoot cameras / by Amy Stone.
 p. cm.
 ISBN 0-89586-827-X
 1. Electric eye cameras—Handbooks, manuals, etc. 2. Photography—Handbooks, manuals, etc. I. Title.
TR260.5.S76 1990
771.3'2—dc20 89-38068
 CIP

NOTICE: The information contained in this book is true and complete to the best of our knowledge. All recommendations are made without any guarantees on the part of Price Stern Sloan, Inc. The author and publisher disclaim all liability in connection with the use of this information.

Recognizing the importance of preserving that which has been written, Price Stern Sloan, Inc. has decided to print this book on acid-free paper, and will continue to print the majority of the books it publishes on acid-free paper.

CONTENTS

INTRODUCTION

A few years ago, when modern point-and-shoot cameras were introduced, photography became as simple as pressing a button once again, just as it was in the days of the Kodak Brownie. But this time there was a difference: simplicity was not based on a camera with virtually no moving parts, but on a sophisticated system that operated lots of dynamic controls automatically.

Neither experience nor technical aptitude is necessary to take a picture with such a camera. With automatic focusing, automatic exposure control and automatic flash, good photography is made available universally.

In addition to a wide range of automatic features, these cameras accommodate 35mm cassettes for full-frame photography, yielding optimum image quality.

Modern point-and-shoot cameras are an apparent contradiction, offering the ultimate in technical sophistication on the one hand and extreme user simplicity on the other.

Although these cameras are designed for foolproof, universal use, they also offer plenty of scope for creative, imaginative photography. So, this book is intended for the most unambitious snapshooter and the discerning photo enthusiast alike.

The most noteworthy technical advancement is autofocus—a major innovation in point-and-shoot photography. The instant you press the shutter button, the camera focuses, completely automatically. This enables you to devote all your energies to other, usually more creative, aspects of photography.

The new breed of autofocus point-and-shoot cameras comes equipped with a multitude of other amenities: automatic film-speed setting with DX-coded film, automatic film advance and rewind, a bright viewfinder for easy and accurate image viewing and framing, battery-level indication, and focus- and flash-status indicators. All of these contribute to

The Canon Sure Shot Joy is one of the simplest autofocus, autoexposure cameras. It has a 35mm lens and features automatic flash and a self-timer. Film transport and rewind are also fully automatic.

making the photographic process both more enjoyable and reliable.

Unlike most single-lens reflex (SLR) cameras, which have a through-the-lens viewing system, manual aperture- and shutter-speed settings, and the capacity to accept interchangeable lenses, the autofocus compact camera has a built-in fixed lens, a viewfinder which simulates the lens's view and no manual aperture- and shutter-speed controls. This makes the compact camera elegantly portable, lightweight, and often relatively inexpensive. If you want to carry a camera at all times, the compact point-and-shoot camera is an ideal choice.

Most of the traditional compact autofocus cameras have a single wide-angle lens for picture taking. However, such cameras can feature a host of added functions, to make shooting in diverse situations both easy and fun. Dual-lens cameras offer two focal

The Ricoh Shotmaster Dual Date provides two focal lengths: 35mm and 70mm. In addition to autofocus, autoexposure and automatic film transport, this camera offers a continuous shooting mode, for taking pictures in rapid succession. There is also a self-timer and an easy-to-read LCD display panel.

The Pentax IQZoom 70 is a fully automatic camera that features a 35—70mm zoom lens. The camera also offers a macro lens setting, for close-up photography, fill-flash capability and a self-timer function.

lengths instead of just one. By pressing a button or flicking a switch, the lens is converted from a wide-angle to a telephoto, enabling you to conveniently frame subjects up close or far away without having to move an inch.

Zoom-lens cameras, featuring a continuous range of focal lengths within a single lens, can zoom quickly and continuously from wide-angle to telephoto and every focal length in between. These cameras provide optimum compositional control, whereby precise framing or cropping can be effortlessly achieved.

The most technologically advanced autofocus cameras are referred to as *bridge* cameras. Intended to span the gap between point-and-shoot photography and SLR technology, these cameras offer a heightened degree of versatility and control while remaining quick and simple to use. Included in their expanded range of features and functions, bridge cameras offer a wider range of shutter speeds, film speeds and focusing zones in order to accommodate a diverse assortment of subjects and situations.

Along with dual- and zoom-lens cameras, bridge cameras occupy the high end of the point-and-shoot

The Olympus Infinity SuperZoom 300 is one of the more complex autofocus cameras, offering some additional controls over exposure, focus, film advance, image framing and flash operation. This camera has a 35—105mm zoom lens.

market. They are slightly larger and more costly than the less-complex autofocus point-and-shoot cameras and their advanced capabilities are primarily aimed at the more serious photo enthusiasts.

Several of the bridge cameras on the market today, although referred to as point-and-shoot cameras, are actually SLRs. In other words, although they function just like compact cameras, they have a single-lens-reflex viewing system that lets you view images through the shooting lens of the camera.

Having earned a reputation for producing quality results through simple operations, autofocus compact cameras have gained respect in the photo industry and popularity in the marketplace.

This book tells you how to make the most of the automatic innovations built into these cameras, including the latest features and accessories available.

Although fully automatic cameras offer significant advantages, they also have some inherent limitations. This book will guide you on how to work effectively with the capabilities of these cameras. When you can make the most of a camera's capabilities and also respect and understand its limitations, you're on your way to producing fine photographs.

1
BASIC CAMERA FEATURES

While cameras come in a variety of types and designs, from fully automatic to completely manual, all cameras have basically the same features. They all have a viewing system, lens, aperture, shutter, and film location and transport system. These components are incorporated in a light-tight "box" in which the photos are made. Understanding how a simple camera functions will help you make optimum use of your camera's more extensive capabilities and will also heighten your creative potential.

All cameras are modeled after the first camera ever made, which consisted of a light-tight box with a pinhole at one end and a plate coated with a light-sensitive emulsion at the other. When light was permitted to pass through the hole in the front of the box, it struck the light-sensitive material, producing a photographic image. Cameras have come a long way since the *pinhole camera,* but the basic essentials are still there: a light-admitting, image-forming opening, which is now a complex, high-quality lens, and an image-receiving surface, which is now roll film, conveniently stored in a compact, light-tight cartridge or cassette. Let's look at the basic components of a camera, one by one.

VIEWING SYSTEM

To enable you to accurately frame a subject, a camera has a built-in viewing system, or *viewfinder,* which provides a view similar to that of the camera's lens. Single-lens-reflex (SLR) cameras have a through-the-lens viewing system in which a mirror, ground-glass screen, pentaprism and eyepiece project to the photographer's eye the image formed by the camera lens at the film plane of the camera. Compact non-SLR cameras provide a separate "window," independent of the camera lens, through which you can view the image.

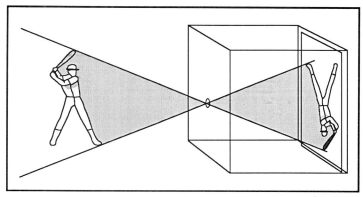

In a simple pinhole camera, light enters through a pinhole and strikes a light-sensitive emulsion at the back of the camera, forming a recognizable, but less than optimum, image.

Whereas an SLR's viewing system contributes to the overall bulkiness and weight of the camera, a compact camera's viewfinder enables the camera to be smaller and lighter than the average SLR.

LENS

The lens provides a sharply focused image of the chosen subject on the film. While the pinhole camera provided an image of less than optimum sharpness, a lens can focus selectively at various distances and provide an image of excellent detail and resolution. A lens can be relatively large, admitting a lot of light, and still produce a sharp image. The pinhole, on the other hand, had to be very small to produce even an acceptable image. The small size of the hole clearly led to the need for very long exposure times.

Comprising several pieces of optical glass, a lens collects the light rays reflected from each point on a subject and projects a sharp image onto the film. The film is located at the camera's *focal plane,* where the light rays converge to form a sharp image.

The viewfinder of most compact point-and-shoot cameras has a window (A) that gives you a direct view of the subject. The view is almost identical to that seen by the lens (B). When the shutter button is pressed, light is permitted to pass through the lens, exposing the film.

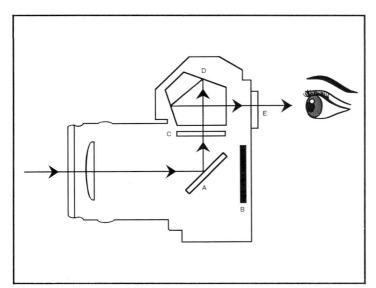

When light enters a single-lens-reflex (SLR) camera lens, it is reflected by a mirror (A) and an image is formed on a focusing screen (C). The pentaprism (D) projects a right-reading image to the viewfinder (E). When the shutter button is pressed, the mirror flips up, out of the way of the film plane, the shutter opens, and light is permitted to expose the film (B).

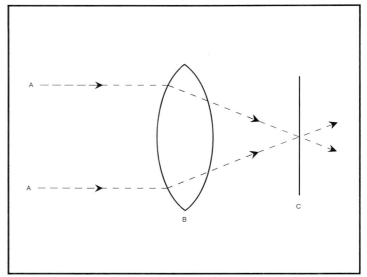

A lens (B) is able to focus light rays (A) passing through it by bending or "refracting" them so that they converge at a common point in a camera's film plane (C). The lens depicted here is a simple, single-element lens. To provide the best possible image, the lens in an autofocus camera consists of several glass elements.

Most cameras can be focused over a wide subject-distance range by means of movable elements within the lens. When these elements are moved closer or farther from the film plane, subjects at different distances move in and out of focus.

LENS APERTURE

A camera lens has a built-in diaphragm, made of overlapping metal leaves, which forms a circular, adjustable opening known as the *aperture*. It regulates the amount of light permitted to reach the film and, together with the shutter speed, controls overall film exposure. It is, in effect, a pinhole that can be extended in size without any loss in image sharpness.

Calibrated in *f*-numbers, the aperture establishes the ratio between the diameter of the lens opening and the focal length of the lens. For example, at *f*-8, the aperture diameter is 1/8 the focal length of the lens. For a 50mm lens, an *f*-8 aperture has a 6.25mm diameter.

Large aperture settings, such as *f*-2 or *f*-4, in which the diaphragm is almost all the way open, allow a great deal of light to enter the lens. Conversely, small apertures, such as *f*-11 or *f*-16, in which the diaphragm is almost closed, let in only a small amount of light. In order to maintain a specific exposure value, whenever the aperture changes in one direction, the shutter speed must compensate in the opposite direction.

Depth of Field—When a lens is focused at a specific subject distance, everything located at that distance will appear sharp in the final image. For objects at other distances to appear sharp as well, a certain amount of *depth of field* is required. This is the distance zone in front of and beyond the actual focused distance in which a subject will appear acceptably sharp in a photograph.

Depth of field is directly affected by the aperture setting. For maximum depth of field, in which the image on film appears sharp from foreground to background, a small aperture, such as *f*-11 or *f*-16, is required; for minimum depth of field, where the subject is sharp while foreground and background are soft and undefinable, a large aperture, such as *f*-2.8 or *f*-4, is appropriate. The latter is usually desirable for portraiture, in which sharp foreground and background detail would tend to detract from the main subject.

Although manual aperture control is not possible with the majority of autofocus, autoexposure cameras, you can take measures to ensure certain types of results. When you move closer to your subject, to get a larger image, the apparent depth of field will decrease. Moving farther away from the subject, to get a smaller image, will yield increased depth of field.

You can also increase depth of field by using a fast film, especially in bright outdoor conditions. Since the camera's exposure program will set a smaller aperture than it would with a slow film, the depth of field will be greater. Using short lens focal lengths, such as 35mm, will also give greater apparent depth of field.

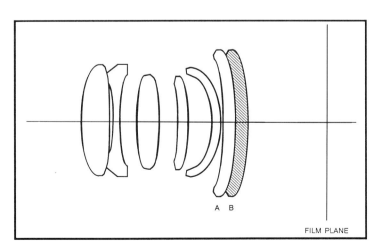

In order for a lens to focus on subjects at different distances, one or more of the elements must be able to move closer to or farther away from the film plane. In the Minolta autofocus system, only the rear element moves, between positions A and B, in order to focus anywhere between infinity and a close subject.

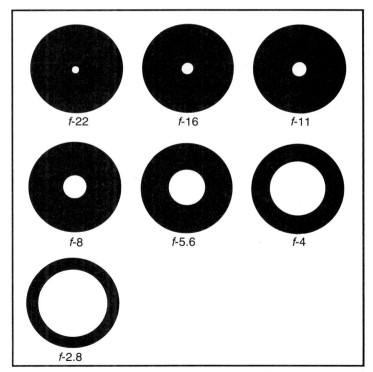

The lens aperture consists of an adjustable diaphragm that regulates the amount of light permitted to reach the film. The smaller the lens opening, the larger the *f*-number. Depth of field is greatest at small apertures, such as *f*-22.

Large apertures produce limited depth of field; small apertures produce a greater depth of field. In the upper photo, taken at a small lens aperture, everything from the near wing tip to the distant scene is in sharp focus. In the lower photo, depth of field is more limited, and the people in the background appear fuzzy. In this case, limited depth of field helps to keep viewer attention on the main subject—the little girl.

SHUTTER

While it's the aperture's job to regulate the *amount* of light that passes through the lens, the shutter controls the *length of time* that the film is exposed to light. In a 35mm SLR camera, a focal-plane shutter is located directly in front of the film plane in the camera body. A compact camera's shutter, however, is of the leaf type, similar to the aperture diaphragm in design, and is located in the lens, between the glass elements. This is why autofocus point-and-shoot cameras are often referred to as *lens-shutter* cameras.

With SLRs, the lens shutter would be impracticable because each interchangeable lens would require its own shutter. However, as compact cameras do not have interchangeable lenses, the lens shutter is a practical design consideration. But it is more than that. An SLR focal-plane shutter permits flash to be used only at a relatively slow *sync speed* or an even slower shutter speed. A lens shutter permits flash to be used at the full range of shutter speeds. This is a very useful feature for *fill flash*—the combination of flash and available light—discussed later in this book.

When the shutter is opened by pressing the shutter button, light enters the camera and exposes the film. The exposure is completed when the shutter closes, thus blocking the light from reaching the film. The longer the film is exposed to light, the more exposure it is given.

Shutter Speed—The term shutter speed refers to how long the shutter remains open. In addition to controlling film exposure, different shutter-speed settings produce other different effects on film. For example, a fast shutter speed, such as 1/500 second, causes the shutter to open and close very rapidly. As a result, most moving subjects will appear to be "frozen" still in the photograph, since the subject can cover only very little ground in such a short time.

Conversely, a slow shutter speed, such as 1/8 second, indicates that the shutter will remain open for a longer period. Shutter speeds of 1/30 second and slower will often enable you to capture the blur of motion, since the subject can move across part of the image frame while the shutter is open. Such subject blur is often desirable in action photos, such as of sporting events and dancing.

You should be cautioned that a slow shutter speed will not only cause a moving subject to be blurred, but may cause total image blur due to camera movement. The camera should, therefore, be firmly supported on a tripod. In general, when lighting conditions are dim, it's advisable to use a tripod or, at least, to hold the camera very steady.

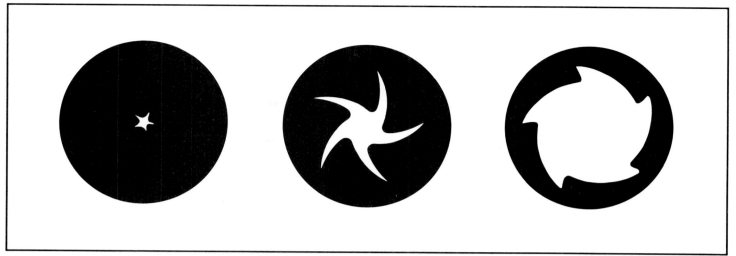

Most compact point-and-shoot cameras are called "lens-shutter" cameras. The camera lens contains a leaf-type shutter between the lens elements. When the shutter button is pressed, the leaves of the shutter open up to permit light to reach the film, and then close to complete the exposure.

While you can't choose specific shutter speeds with automatic point-and-shoot cameras, you can induce the camera to select faster or slower shutter speeds, depending on the effect you want to achieve, by selecting a film of appropriate speed. For more details, see Chapter 4.

FILM LOCATION AND TRANSPORT SYSTEM

A camera requires a means of transporting each frame in a roll of film to the film plane for exposure and then moving it out of the way to make room for the next frame. In the point-and-shoot camera this, as most other operations, is automatic. Basically, all you need to do is place the film in the camera and close the camera back.

When an entire roll of film has been exposed, the film is automatically rewound into the cassette.

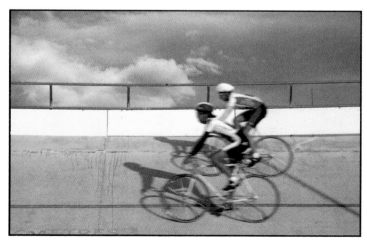

At fast shutter speeds, moving subjects can be "frozen" on film so that they are recorded sharply (upper photo). At slow shutter speeds, you tend to capture the blur of motion (lower photo).

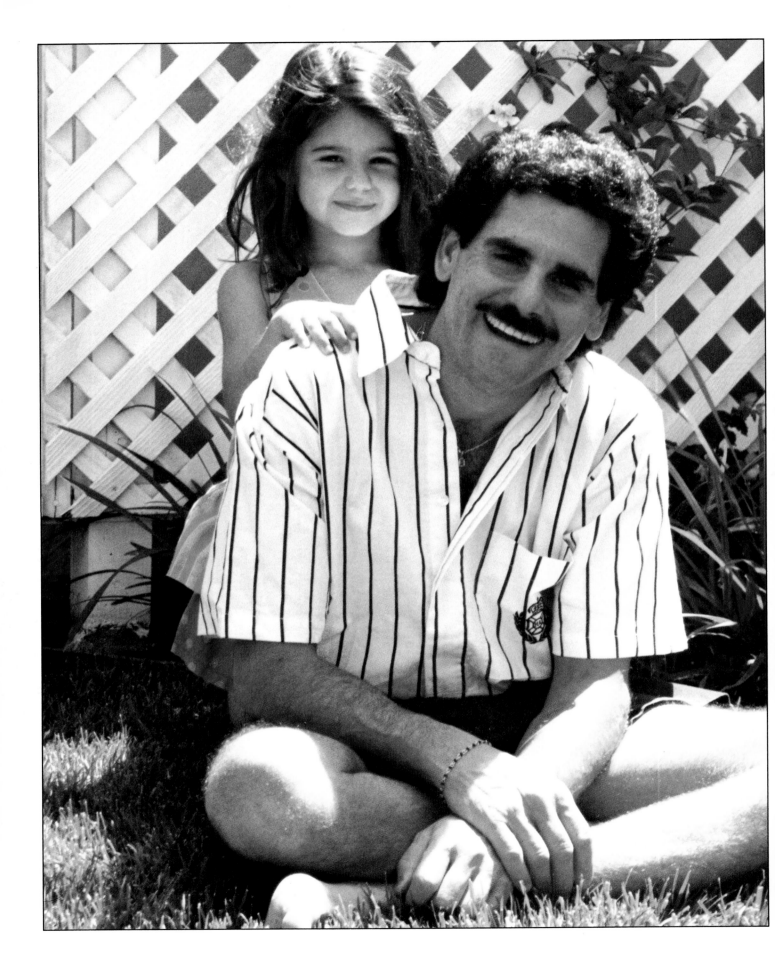

2
THE MODERN POINT-AND-SHOOT CAMERA

In today's hi-tech society, we tend to hear the expressions "user friendly" and "state-of-the-art" so frequently that they tend to lose all meaning. Yet, these are the underlying concepts behind modern point-and-shoot photography. Loaded with precision technology, these little cameras are able to perform a wide range of functions automatically and almost instantaneously while remaining basically "simple" cameras.

The cameras discussed in this book are all made by reputable manufacturers and are of the highest quality. Ultimately, the only thing that makes one camera better than another is how well it suits your own particular needs.

STANDARD FEATURES

Autofocus point-and-shoot cameras can be broken down into six basic elements: camera body, lens, shutter, film plane, viewfinder, and flash. Although the simplest of cameras require little else in order to function, the technologically advanced cameras discussed in this book are endowed with a matrix of electronic circuitry for optimum speed, convenience, and versatility.

CAMERA BODY

Aside from being a light-tight compartment that houses the film at one end and a lens at the other, it's the camera body's job to support all the features and controls intrinsic to the camera's operation. The camera body also carries the basic design that makes the unit comfortable to use and pleasing to look at.

Here are the basic features incorporated in the camera body:

Light Sensor—Located on the front of the camera, the light sensor is a light-sensitive photocell that interprets the luminance level of a given scene. The camera's selected exposure settings are based on the

The three images on these two pages are typical of the "fun" pictures anyone can easily take with an automatic compact 35mm camera.

Fully automatic compact 35mm cameras are very versatile. You can shoot in a wide variety of circumstances, with the assurance that automation will take care of such essentials as accurate focus and exposure. You can shoot everything from distant scenes, to medium-distance shots (left), and close-up detail shots (right).

STANDARD CAMERA FEATURES

sensor's evaluation of the ambient lighting conditions. (See Chapter 5 for details.)

To avoid exposure inaccuracies, be sure to keep the light sensor unobstructed.

Autofocus (AF) Windows—Also located on the front of the camera, the autofocus windows enable the camera to establish focus by means of emitting an infrared beam. (See Chapter 3 for details.)

Be careful not to obstruct these windows, as this would cause inaccurate focusing to occur.

Film-Winding Mechanism—Rather than taking away valuable shooting time for film loading and winding, the camera features an automatic film transport system. You need only insert the film cassette into the film chamber, pull the film leader out to a take-up reference mark, and close the back of the camera.

Instantly, the leading portion of the film is wound onto the take-up spool. Some cameras require an initial push of the shutter button in order for the film to advance to frame number 1; others will advance the film to the first frame immediately. From that point on, the film will advance automatically after each shot, until the last frame has been exposed. Then, the film will either rewind itself automatically or will have to be activated into rewinding via a button or switch.

As an added convenience, many cameras provide a manual mid-roll rewind feature, enabling you to wind film back into the cassette before the final frame has been reached. Should you want to remove the film from the camera at any point prior to the end of the roll, you can do so without having to shoot every frame in order to activate the rewind system. Usually, this feature is oriented in such a way as to prevent accidental activation.

Frame Counter—All cameras provide a frame counter, either on top of the camera or near the viewfinder, to let you see what film-frame number you are shooting at any given time. As a helpful aid, some cameras wind the frame counter backwards as the film rewinds so that you can be sure the film is, indeed, being rewound.

Film-Loaded Window—A feature you're sure to appreciate, the film-loaded window is simply a transparent window located on the back of the camera. It allows you to see the film cassette in the camera without permitting unwanted light to reach the film. Not only can you tell at a glance that the camera is loaded, but you can also see the film's type, speed and length, as printed on the actual cassette.

Film-Speed Setting—Users frequently forget about this important setting, which is responsible for

To load film into a camera, insert the cassette, extend the film leader to the take-up reference mark, align the film perforations with the camera's sprocket teeth and close the back of the camera. In some camera models, the film is loaded into the left chamber and the take-up drum is on the right; in other cameras, it works the other way around.

The "film-loaded" window lets you verify that the camera is loaded. It also lets you see the film type and speed, and the number of frames on the roll.

adjusting the camera's exposure metering system to correspond with the film's ISO speed, or sensitivity to light. If the camera's ISO setting is different from the film's ISO number, the result will be either over- or underexposed photos.

Thanks to DX-coded film, such a mistake can't occur in your point-and-shoot camera. As soon as the film is loaded, the camera reads the film speed directly off the film cassette and selects the appropriate ISO setting. You don't have to touch a thing.

The LCD panel of the Ricoh FF-90 Super displays the film's ISO speed, the maximum number of exposures possible with the film that's loaded, the current frame number, battery check, proper-loading affirmation, on/off status, and exposure-compensation setting.

Some cameras also offer a *manual* film-speed setting so that you can set the film speed yourself. This comes in handy for adjusting exposure to better suit specific needs or preferences, as well as for non-DX-coded films. (See also Chapter 4.)

The manual control can also prove useful when you're using DX-coded film that is either beyond or not included in the camera's DX range, such as the ultra-fast Konica SR-G3200, at ISO 3200.

Should you happen to load a camera with non-DX-coded film, the camera's film speed setting will usually lock at ISO 100, regardless of the film's actual ISO speed. On some camera models, this setting can be adjusted manually, if necessary, in order to accommodate the film.

Film-Speed Indicator—Cameras that have an LCD display panel will show the ISO setting as the film advances to the first frame. On some cameras, it will then disappear from view; on others, this information will remain in view at all times.

Information Display—Many of the new point-and-shoot cameras have lots of "hidden" functions. Consequently, some sort of communication system is required to enlighten the photographer as to what's going on. Whether it's via pointers, LED indicators in the viewfinder, or a readout on an LCD display panel on top of the camera, information including the frame number, focus mode, flash-ready, battery status, and other pertinent items, is conveyed in an instant, eliminating undesirable guesswork.

Batteries—Batteries provide the power necessary to make all of a camera's electronic functions a reality. In the past, alkaline batteries, or the equivalent, were the only way to go. Nowadays, however, the more compact, powerful, and long-lasting lithium batteries

are used, although some camera manufactures still give you an option.

Taking the place of two AA-size or four AAA-size alkaline batteries, one 6-volt lithium battery pack provides a quicker flash recycling time. Also, you can shoot about twice as many rolls of film with a lithium battery as with an alkaline battery.

Many cameras provide a battery-status indicator, so you can be prepared to replace the batteries *before* the camera ceases to function.

LENS

Despite how small and simple the lens of a compact camera may look, such lenses are complex, containing numerous elements of optical glass.

Aperture—Every lens has a maximum aperture, or *f*-stop, which determines how "fast" or "slow" the lens is. The larger the maximum aperture, the faster the lens. For example, a camera with a maximum aperture of *f*-2.8 will be able to provide a faster shutter speed in overcast conditions than will a camera with a maximum aperture of *f*-4 or *f*-5.6 in identical conditions.

Most of the lenses built into autofocus point-and-shoot cameras are relatively fast, with a maximum aperture of either *f*-2.8 or *f*-3.5. Your camera's instruction manual will tell you what the maximum aperture is for your camera's built-in lens. For example, a lens that is described as an *f*-2.8 35mm lens has a maximum aperture of *f*-2.8. In some cases, this information is also on the camera lens or body.

Telephoto lenses and zoom lenses are generally relatively slow. For example, zoom lenses at their longer focal lengths typically will have a maximum aperture of *f*-5.6 or *f*-6.7.

Batteries are the power source of autofocus point-and-shoot cameras. Most of the new cameras operate on 6-volt lithium battery packs, two of which are shown here. The third battery shown is an alkaline battery.

Focal Length—The focal length of a lens is the lens-to-film distance when the lens is focused on a distant scene. The longer the focal length, the narrower the angle of view. Thus, from the same distance, a lens of short focal length will take in a wider view than a lens of long focal length.

Focal length is specified in millimeters, such as 35mm, 50mm, 70mm, etc. Most autofocus point-and-shoot cameras have a relatively wide-angled lens.

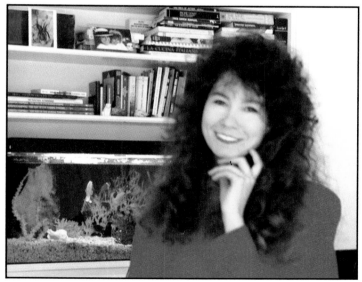

The focus-lock feature, which is activated by partially depressing the shutter button, can be used to lock focus on a centered subject. While holding the shutter button partially depressed, you can reframe your shot with the main subject off center, as shown in the upper photo. Focusing with the subject off center to begin with would make the background sharp but not the subject, as shown in the lower example.

However, dual-lens and zoom-lens cameras offer more than one focal length, for heightened shooting versatility.

Lens Shield—There's nothing worse than taking that shot of a lifetime, only to find the lens cap still on the camera. Evidently this is a common enough mistake, because most cameras are now designed with a fool-proof lens shield. The lens shield essentially acts as an On/Off switch, whereby the camera cannot become operational until the lens shield is opened. Closing the lens shield automatically locks the shutter button and darkens the viewfinder. Thanks to such a safety mechanism, neither battery power nor film can be expended needlessly due to user error.

SHUTTER

The shutter serves to convert a potential shot into an actually recorded image. The shutter regulates the amount of time the film is exposed to light in order to produce a properly exposed image.

When you press the shutter button, located on the top right of the camera, all the way down, the shutter is activated to open and close, to expose a single frame of film to light.

When pressed only halfway down, the shutter button serves to provide other useful functions, as indicated below. In a nutshell, this is what point-and-shoot photography is all about: simply aiming the camera and pressing the button.

Focus-Lock—Often, the shutter button serves as a focus or *prefocus* lock, enabling you to hold a focus setting in the camera's memory while you recompose the shot. In situations where the subject is out of the central focusing frame, you can still achieve accurate focus by first centering the subject in the viewfinder and depressing the shutter button halfway. The established focus setting will remain in the camera's "memory" while you keep the button depressed halfway and reframe the subject to your liking. Press the shutter button down the rest of the way to take the picture.

AutoExposure (AE) Lock—Another useful service the shutter release button provides with many cameras is an AutoExposure (AE) lock feature. This is usually coupled with the focus-lock mechanism, and therefore functions simultaneously with the AutoFocus (AF) lock.

In situations where you want the camera's exposure to be based on a specific portion of the image, like a shadow or highlight area that is not within the central metering area of the frame, you can aim the camera at the desired spot, lock the exposure in the

camera's memory by keeping the shutter button depressed halfway, then reframe the shot and take the picture. Make sure, however, that the metered area is at the same distance from the camera as the subject, or you may not get a sharply focused picture.

FILM PLANE

The film plane in the camera is centered with, and perpendicular to, the lens axis. It is here that the focused lens forms a sharp image and where the film is exposed. For this reason, the film plane is often referred to as the *focal plane*. The film is held in place by a pressure plate, which keeps the frame that is to be exposed flush against the film plane.

VIEWFINDER

The viewfinder reveals to your eye an image similar to the one seen by the camera lens and the film. To give you the most accurate view possible, the viewfinder is positioned as close to the camera lens as practicable. The viewfinder also shows you the angle of view the camera lens sees. Most viewfinders include an autofocus frame that lets you see where in the scene the camera is actually focusing.

The viewfinder's field-of-view frame usually has parallax-correction marks. These are an alternate set of frame lines that must be used when you shoot a subject from the camera's minimum focusing distance. When shooting a subject up close, the viewfinder's viewpoint and the lens's viewpoint cease to correspond sufficiently accurately, and the image area shifts a little in the viewfinder. The parallax-correction marks are visual guides to help you frame close-up shots more accurately.

By means of LEDs or pictorial symbols, sometimes referred to as *icons,* the viewfinder may also display information such as flash status, the focus mode in use, and focus confirmation, which lets you know when accurate focus has been achieved.

FLASH

When you need to shed a little extra light on the subject, the built-in flash is always ready and waiting. Traditionally located a little above and to one side of the lens, the flash functions in direct correlation with the camera's exposure metering system, so that it always knows when it's needed—even if you don't. When you're working in dimly lit conditions, the flash will either be activated automatically when the shutter button is pressed lightly, or the camera will signal, with a blinking LED in or near the viewfinder, that the flash should be activated. As long as the subject is within the camera's flash range, the photo should be exposed evenly and accurately by flash.

A standard viewfinder contains parallax-correction marks, which are an alternate set of frame lines, to ensure correct image framing when you're shooting tight close-ups. A viewfinder may also display, by means of symbols or flashing LEDs, information such as flash status and accurate-focus confirmation.

Many cameras also supply automatic *fill flash,* when it is appropriate. In situations where part or all of the subject is in shadow, as might be the case with bright sunlight from the side or with backlit scenes, an added dose of light will help define subject detail in the shaded regions by effectively reducing the overall contrast of the image.

Flash Activation—Cameras that have a retractable flash, which must first pop up or slide out from the camera in order to be able to fire, need some kind of activating mechanism to do this. The shutter button is the logical choice.

When some camera models sense that flash is required for a specific shot, the flash unit will automatically emerge when the shutter button is depressed lightly. In the case of most cameras, however, pressing the shutter button halfway will simply cause the flash to begin charging or recycling, should flash be necessary to take the shot.

SPECIAL CAMERA FEATURES

Obviously, not all point-and-shoot cameras are totally alike, despite how much they have in common. Some cameras differ only as far as their physical configuration or design is concerned. Others offer features or functions which set them apart from the rest. These are special features that are generally associated with more technologically sophisticated cameras.

LENS CONVERSION SYSTEMS

If you anticipate encountering many situations in which the conventional, standard camera lens is inadequate, a dual-lens or zoom-lens camera is the ideal answer.

Dual-Lens Camera—Every major camera manufacturer now makes dual-lens or twin-lens cameras which, quite simply, comprise two lenses instead of just one. While some cameras have both a wide-angle and a telephoto lens built into the camera body, others incorporate a movable tele-converter unit behind the main lens to increase the effective focal length, for producing larger images of given subjects and scenes.

Whereas the wide-angle lens might be anything from 34mm to 40mm, the so-called telephoto lens can range anywhere from 50mm to 70mm, depending on the camera. The *Canon Sure Shot Tele,* for example, has a 40mm lens and a 70mm lens, while the *Minolta Freedom Dual* has a 35mm lens and a 50mm lens. The lenses can be interchanged by pressing a button or flicking a switch. The camera's viewfinder image will instantly correspond to the focal length in use.

Zoom-Lens Camera—To save you having to alternate between lenses of different focal lengths, a zoom-lens camera moves from wide-angle to telephoto in one continuous action. This provides optimum compositional control and flexibility. Zoom lenses are usually adjusted with a button, dial or lens ring.

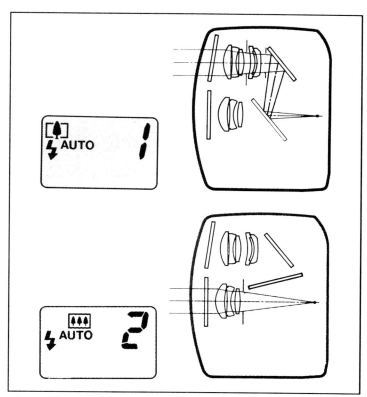

The Olympus Infinity Twin camera has two separate lenses. When the camera is set to its 70mm telephoto focal length (top), the light travels through the telephoto lens to a mirror, which reflects the light down to a second mirror, which reflects it onto the film. When the camera is set to the 35mm wide-angle focal length (bottom), the light travels directly from the lens to the film.

Dual-Lens cameras, such as the Kodak S900 Tele, the Minolta Freedom Tele, and the Ricoh TF-500, offer the user a choice of two lenses—a wide-angle and a telephoto.

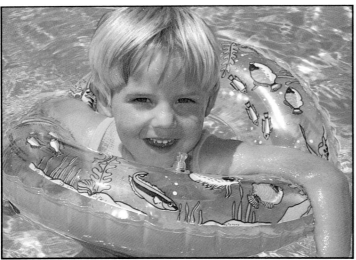

These two photos were made with the Nikon Tele Touch Deluxe. The top photo was made at the 35mm wide-angle focal length; the lower one at the 70mm telephoto focal length. Fill flash was supplied automatically by the camera.

Most zoom lenses offer a *macro* setting, for shooting subjects at close range.

The zoom lens of an autofocus point-and-shoot camera functions in much the same way as a zoom lens on an autofocus SLR camera. By zooming to a telephoto setting, you achieve greater magnification of a subject. At shorter focal lengths, you get a wider field of view. Here's the general rule: The longer the lens focal length, the narrower the view will be and the larger the subject will appear in the frame; the shorter the lens focal length, the wider the angle of view and the smaller the subject will be in the image.

The zoom lenses on cameras like the *Pentax IQZoom 70* and the *Ricoh Mirai,* offering 35-70mm and 35-135mm respectively, can be operated automatically via buttons or a toggle lever. The 35-70mm zoom lens on the *Vivitar TEC 155* and the *Canon Sure Shot Zoom,* on the other hand, must be set manually by rotating the lens. This is an especially gratifying feature if you enjoy the feel of an SLR-type zoom lens or just appreciate the added control you get from adjusting the focal length manually.

As with dual-lens cameras, the image in the viewfinder will always approximate the image the lens and film are actually seeing.

You can create interesting "explosion" effects with a manual zoom lens, which you can't do with electronic zooms. By setting the camera to a slow shutter-speed mode, you can zoom the lens from wide-angle to telephoto, or vice versa, as you take the shot. If your camera doesn't have a slow shutter-speed setting, deactivating the flash in low-light conditions will cause the camera to employ a slow shutter speed.

Zoom-lens cameras, such as the ones depicted here, enable the user to zoom from a wide-angle to a telephoto setting, and everything in between.

Tele-Converter—Many of the more recent camera models are able to accommodate an external tele-converter attachment for increased focal length and close-up photography capability. When attached to the front of the camera, directly over the lens, a tele-converter will increase the focal length of the lens by a given amount, depending on the converter.

The *Chinon Auto 2001, Canon Sure Shot Multi Tele, Ricoh FF-90 Super* and *Ricoh TF-500* models will all accommodate their own brand of lens attachments. Several independent manufacturers also offer tele-converters, for an even longer list of camera brands. (For more details on tele-converters, see Chapter 10.)

HALF-FRAME FORMAT

The half-frame format gives you two smaller images for each standard 35mm frame. There are two advantages to half-frame format photography. First, the effective focal length of the camera lens increases and, second, the number of frames possible on any given roll is doubled.

If you've ever come across a fund of fabulous photo possibilities just as you discover you're on your last roll of film, you'll appreciate the half-frame format offered by the *Yashica Samurai* and the *Canon Sure Shot Multi Tele* as an optional capability.

By sliding the format-selector lever on the inside of the *Canon Sure Shot Multi Tele* to x2, you can shift the camera's format from a full-frame 35mm horizontal to a half-frame vertical. To take a horizontal shot, the camera must now be held vertically, and vice versa. Although this may seem odd at first, you'll get used to it fairly quickly.

35mm

70mm

105mm

The variable focal length of a zoom lens adds versatility to a camera. For this series of shots, made at 35mm, 70mm and 105mm focal-length settings, the camera position remained fixed. Only the focal length of the lens—and therefore the image size—was changed.

Tele-converters, such as the TE-Z100 on this Pentax IQZoom 70, increase the effective focal length of the camera lens.

FILTER ACCOMMODATION

Most compact cameras cannot accept threaded lens filters, simply because their physical configuration will not permit it. In spite of these limitations, virtually every autofocus point-and-shoot camera can be used with a wide variety of color and special-effect filters. This is discussed more fully in Chapter 10.

Some cameras, like the *Nikon One-Touch*, the *Canon Sure Shot Tele*, the *Minolta AF Tele*, and the more advanced bridge cameras, will accept threaded or interlocking UV, diffusion and soft-focus filters, which will not interfere with the camera's automatic exposure system.

The *Nikon Tele-Touch Deluxe* and *Canon Sure Shot Tele* actually have a built-in *soft effect* filter, which can be used for romanticized portraiture. This filter creates a soft effect through diffusion, which can be very flattering, especially for portraits of women and children. On the *Nikon Tele-Touch Deluxe*, this filter can be activated by rotating the front lens ring and holding it in position for the duration of the shot. On the *Canon Sure Shot Tele*, the filter is activated by setting a switch.

By sliding the Half-Frame Format Selector lever inside the Canon Sure Shot Multi Tele (see arrow), you can alter the camera's format from full-frame 35mm to the half-frame format.

In the half-frame format, the full-size horizontal 35mm frame is divided into two vertical frames, so that you can shoot twice as many frames as the film normally provides. The strip of film shown here is reproduced life-size.

AUTOFOCUS MODES

As autofocusing systems get better and better, focusing capabilities become more flexible and diverse, giving a photographer greater control and accuracy in situations that would ordinarily be considered tricky or almost impossible.

Autofocus is discussed more fully in the next chapter. This section introduces you briefly to some of the autofocus modes offered by point-and-shoot cameras.

MULTI-BEAM AF

Having to sacrifice proper focus just because there are too many points of interest in a shot, or too much space in between subjects, can be aggravating. When shooting groups of people, or similar compositions, in which the subjects cannot be confined to the central focusing frame of the camera, the multi-beam autofocus feature is a welcome solution.

Present in the *Chinon Auto 3001,* in which it must be activated by a switch near the viewfinder, the *Olympus Infinity Zoom 200,* and the *Minolta Freedom Tele* and *Minolta Freedom Zoom,* multi-beam autofocus evaluates a wider area of the scene and chooses an appropriate focus setting for the subjects contained in the image frame. Usually, focus is established on the subject closest to the camera. Essentially, this is a focus-lock mechanism that can be utilized without having to reposition the camera, (see also Chapter 3).

CONTINUOUS AF

Also referred to as *Servo AF* on the *Olympus Infinity SuperZoom 300* and the *Konica Z-up 80 Super Zoom,* the continuous focus mode seeks and finds focus continuously, to capture moving subjects in sharp focus. Instead of being restricted to one focus adjustment per shutter release activation, continuous focus allows you to focus continuously on a subject for as long as the shutter button remains partially depressed. This feature also lets you shoot a continuous sequence of photos for as long as the shutter button remains completely depressed.

Not only does this allow you to pan with a moving subject without sacrificing proper focus, but you can capture actions and events from beginning to end without having to miss a shot.

CLOSE-UP FOCUS MODE

Frequently referred to as a *macro mode,* this feature can be found on most zoom-lens and some dual-lens cameras and can be activated by setting a switch or pressing a button. It allows accurate focusing on subjects as close as 1.5 feet—much closer than the average minimum focusing distance of 3 feet. This mode

Minolta's Creative Filter Set includes a star filter, fog filter and soft-focus filter. The set is compatible with the Minolta Freedom Tele and Freedom Zoom 90 cameras, as well as with the Leica AF-C1.

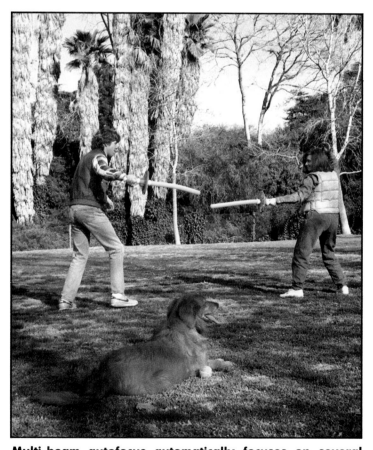

Multi-beam autofocus automatically focuses on several "main" subjects—in this case, the two people and the dog—at different distances from the camera. The camera then provides the appropriate focused distance that will reproduce all of the subjects sharply, if it is possible.

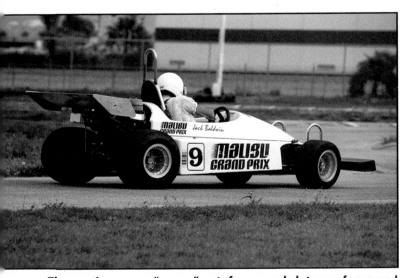

The continuous or "servo" autofocus mode lets you focus and shoot continuously as long as the shutter button remains fully depressed. Here, the servo mode of the Olympus Infinity SuperZoom 300 made it easy to capture sharp images of this swiftly moving subject, whose distance from the camera was changing constantly.

was designed for recording small subjects, such as flowers, which would appear insignificant in the conventional focusing mode.

To compensate for light loss due to the closer camera-to-subject distance, the flash will always fire in the camera's close-up mode.

When working in a camera's macro mode, be sure to frame your subject according to the parallax correction marks in the viewfinder, as discussed earlier in this chapter.

SCENIC MODE

The opposite of the close-up mode, the scenic mode, or *panorama mode,* as it is called on the *Ricoh FF-7* and the *Konica Z-up 80 Super Zoom,* locks the camera's focus at infinity. This is useful not only for landscape photography but, even more importantly, for enabling you to shoot through windows or other transparent surfaces that can interfere with the proper

The Close-Up Mode selector on this Pentax IQZoom 70 camera can be recognized by the flower symbol, adjacent to the camera switch and on the lens. The symbol, utilized by most autofocus compact cameras, is also shown in the viewfinder and the LCD panel.

In the close-up or "macro" focusing mode, you can shoot subjects as close as 1.5 feet from the camera, for exciting, detailed images. ▶

functioning of the autofocus system. It's especially handy if you're traveling and want to take pictures through a car window. The built-in flash will not fire in this mode, since infinity is obviously beyond the effective flash range.

MANUAL FOCUS

Although you wouldn't expect to find manual focus on an autofocus camera, the *Ricoh Mirai* and the all-weather, waterproof *Nikon Action-Touch* provide such a feature. The *Ricoh Mirai* manual-focus option offers heightened control without the need for pre-focusing and reframing. The *Nikon Action-Touch* supplies auxiliary focus control for underwater conditions, which can otherwise mislead a camera's autofocus sensors.

The *Ricoh Mirai* motorized manual focus is operated by pressing the MF (Manual Focus) button, located on the right side of the camera, while using the zoom control dial to focus.

The *Nikon Action-Touch* focus functions by turning a knurled dial on top of the camera. The camera's focusing distance can be set for 2.3, 3.6, 5.3 or 12 feet, with corresponding meter increments on the opposite side of the dial. Regardless of the dial's distance setting, the viewfinder will indicate, via an M symbol at the bottom of the frame, that you are in the manual focusing mode.

AUTO FLASH MODES

While all autofocus point-and-shoot cameras come equipped with a built-in flash, some cameras offer extended automatic flash capabilities, to provide greater shooting versatility in a variety of situations.

FILL FLASH

When you want to use flash in conditions that usually wouldn't call for it, you can set the camera to its fill-flash or *daylight sync* mode. At that setting, the flash will fire regardless of the existing light level. For example, in harsh, overhead lighting, which casts deep shadows in eye sockets and under noses and chins, adding fill-flash will soften the shadows and illuminate the subject more evenly.

Similarly, when the background is brighter than the subject, you might want to illuminate the subject just enough to bring out detail, but not so much as to lose the effect of the natural lighting. Fill-flash will automatically add supplemental light without destroying the scene's inherent shadows altogether.

At the time of writing, the Ricoh Mirai was the only lens-shutter camera to offer a motorized manual focusing capability, described in this chapter. This camera also offers an Aperture-Priority exposure mode that lets you choose the aperture setting and then shows you the shutter speed that the camera has selected automatically.

In addition to its autofocusing system, the Nikon Action-Touch—designed for use above and below water—provides a manual distance setting dial for underwater shooting. Underwater, the autofocus sensor would be misled, causing erroneous focusing.

SLOW SYNC

Especially useful for night photography, the slow-sync mode enables you to flash-expose a foreground subject normally while the camera employs a slow shutter speed to enhance the appearance of existing background lights. Always be sure to use a tripod for slow-sync photography, to avoid blurred results due to camera shake.

FLASH OVERRIDE

Sometimes you appreciate a camera's built-in flash most when you can turn it off. Because many popular

The Olympus Quick Shooter Zoom is equipped with three flash modes—Automatic, Fill and Slow-Synchro—and an Off setting.

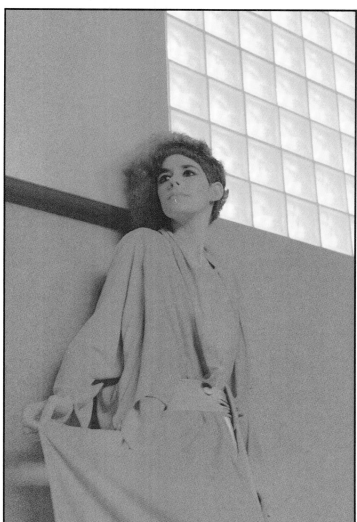

In situations where you are not permitted to use flash or don't want to, it's nice to have the option of switching it off. Here, the flash was deactivated in order to capture the unique quality produced by a colored light source at night. The camera was mounted on a tripod to prevent camera shake and avoid getting a blurred image due to the relatively long exposure time. Photo by Mark Kaproff.

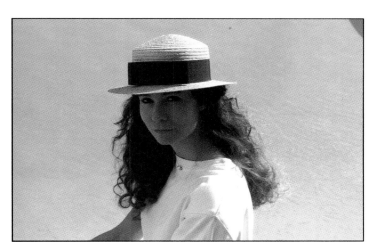

Fill-flash can be used to soften harsh shadows in bright outdoor conditions. It is also useful for adding supplemental light to backlit subjects. The upper photo was taken without fill flash; for the lower photo, fill flash was employed.

attractions and public places ban flash photography, many cameras now offer a *flash off* or *museum* capability, which can be controlled via a switch or button on the side of the camera or near the lens or viewfinder. This is also a particularly useful feature for shooting outdoors at dusk or in evening light, when automatic flash normally would be activated but might not be wanted.

When shooting in dim light, remember to use a tripod or other firm camera support, so you don't get unsharp results due to camera shake at slow shutter speeds.

The Nikon Zoom-Touch 500 offers two autozoom modes, one for subject size and the other for sequential zooming. The symbol in the image frame indicates what size the subject will appear relative to the image frame. The zoom scale, which appears when the Continuous-Shooting mode button is pressed twice, indicates that a series of three shots will be taken—at the 35mm, 53mm, and 80mm focal lengths.

The LCD panel on the Ricoh FF-7 displays the camera's six different shooting-mode symbols. They are, from left to right, the Panorama mode, the Night mode, the TV mode, the Continuous-Shooting mode, the Self-Timer mode and the Multiple-Exposure (M.E.) mode.

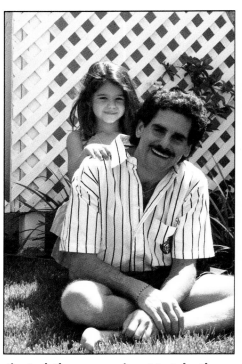

When the Continuous-Sequence Autozoom mode of the Nikon Zoom-Touch 500 is activated, the camera is set to take three consecutive shots—at (from left to right) 35mm, 53mm and 80mm focal lengths.

ADDITIONAL SHOOTING MODES

Modern autofocus point-and-shoot cameras are designed with special emphasis on versatility and fun. You need no longer be restricted to shooting conventional snapshots. Following are several added shooting capabilities.

AUTOZOOM MODE

The autozoom mode is one of the most recent innovations in point-and-shoot technology for zoom-lens cameras. It enables you to maintain the framing of a subject. Normally, you would have to reframe the subject every time you changed the focal length setting or the camera-to-subject distance, which can result in careless cropping.

To prevent you from accidentally lopping off the top of a subject's head, the autozoom feature will automatically adjust subject magnification within the image frame. How this is accomplished varies among different camera models. For example, the *Minolta Freedom 90* automatically establishes a subject reproduction ratio of 1:60 when the Program Zoom button on the back of the camera is pressed.

The *Nikon Zoom-Touch 500* provides two types of autozoom modes: subject magnification and zoom sequence. By pressing the Subject button on top of the camera once, twice or three times, you can select the desired subject size: full length, head-to-waist, or head shot. By pressing the Shooting Mode button twice, you can also program the camera to make three different shots at three different focal lengths. This simultaneously puts the camera into its continuous-shooting mode and sequential zoom mode. When the shutter button is fully depressed, the camera will make three consecutive shots—at the 35mm, 53mm and 80mm focal lengths.

The mode is automatically cancelled when the third shot has been taken or when you remove your finger from the shutter button before the sequence has been completed.

CONTINUOUS SHOOTING MODE

When shooting action, in which it's necessary to fire a series of shots in rapid succession, the continuous shooting mode, offered by a variety of cameras, is the way to go. By setting a switch or pressing a button, the camera will shift from the standard single-shot mode to a continuous shooting mode in which the camera will continue to fire for as long as you keep the shutter button fully depressed.

In this mode, the camera will not continue to focus for each shot but will instead maintain the initial focus throughout the series of shots.

In the Continuous-Shooting mode, you can take shot after shot in rapid succession without taking your finger off the shutter button. This mode comes in handy for photographing active subjects that don't give you time to compose each individual shot, or for capturing an entire sequence of motion, such as this horseback rider dismounting.

Be sure to deactivate the flash—if your camera doesn't do this automatically—when the continuous shooting mode is in use. The built-in flash has a fixed recycle rate and will not be able to recharge quickly enough to be used effectively with the continuous shooting mode.

MULTI-EXPOSURE (M.E.) MODE

Some cameras, such as the *Olympus Quick Shooter Zoom,* the *Ricoh FF-7* and the *Konica Z-up 80 Super Zoom,* will let you take more than one shot on a single frame of film. When the M.E. mechanism is activated by means of pressing a button, the film will not advance to the next frame when the shutter button has been pressed, so that you can then make another exposure on the same frame. However, the cameras do not correct exposure to accommodate for one shot being placed on top of another, and overexposure can result if both images are brightly lit.

The best way to produce properly exposed multiple exposures is to place your subject against a black or very dark background. As long as the subject's images don't actually overlap, the camera's normal programmed exposure will produce accurate results. If these requirements cannot be met for a double exposure, place a one-step (ND 0.30) neutral-density filter over the lens—but *not* over the camera's light sensor—for both exposures. This will balance the overall exposure of the final result. When using a camera that has exposure compensation capabilities, the same effect can be achieved by dialing in -1.0 step.

The general rule for multiple exposures of overlapping subject images is as follows: multiply the ISO speed of the film by the number of exposures you intend to shoot, to decrease exposure accordingly. For example, if you're using ISO 100 film and you want to make two exposures, increase the camera's film speed setting to ISO 200. You can either change the film speed manually, if your camera permits it, or cut the exposure in half with an ND filter over the camera lens. Although a little unpredictable, the ability to make double and multiple exposures is an enjoyable feature to experiment with and one that will most assuredly yield some interesting and unusual results.

SELF-TIMER

The self-timer, which can be activated by a button on top of the camera or a switch on the front of the camera, allows you to delay the shutter release for about 10 seconds after the shutter button has been pressed. This gives you ample time to position yourself in front of the camera to include yourself in a picture.

The Multiple-Exposure capability lets you shoot two or more exposures on a single frame of film to create special effects, such as the photo of this man, in conversation with himself. For clear images, a dark background is essential.

A self-timer is featured on most cameras. It is usually accompanied by a red LED on the front of the camera body, that flashes to indicate the self-timer is in use, and glows solidly to warn you when the camera is about to make the exposure. When using the self-timer, you should place the camera on a tripod or other firm support.

The *Canon Sure Shot Ace, Canon Sure Shot Zoom XL* and *Olympus Infinity Zoom 200* make self-timer photography even easier by providing a remote-control device. The remote control is attached to the camera body and can be easily removed by pressing a release button. When the remote control is removed, a red indicator light on the front of the camera blinks. When the control is aimed directly at the camera, an invisible infrared beam activates the camera's timer mechanism. This device enables you to take shot after shot without ever having to press the shutter button. The *Canon Sure Shot Ace* gives a two-second delay before the shot is taken, the *Olympus Infinity Zoom 200* gives a choice of either a one- or three-second delay time and the *Canon Sure Shot Zoom XL* gives you the choice of immediate shutter release or a two-second delay.

The remote control on the *Canon Sure Shot Zoom XL* also lets you set the focal length of the lens to 85mm, 55mm or 39mm. Each time the transmission button is pressed, the lens changes to the next successive focal length.

The Canon Sure Shot Ace features a built-in, removable remote control shutter release that will activate the self-timer mechanism when aimed directly at the camera. This way, you can make the camera fire whenever you want without having to manually reset the camera for another time-delay shot.

INTERVAL TIMER

Time-lapse photography is not normally associated with point-and-shoot cameras, but the *Ricoh FF-7,* the *Ricoh Shotmaster Zoom* and the *Konica Z-up 80 Super Zoom* do offer this feature. By activating the Interval Timer mode, the camera will take one photograph every 60 seconds until either the last frame of film is reached or you cancel the mode. This is an ideal means for shooting a sunrise or sunset, when every subtle variation of light and color is worth capturing on film.

EXPOSURE MODES

Many autofocus compact cameras provide a variety of exposure modes, to make point-and-shoot cameras more versatile and capable of accommodating special types of situations, and thus to satisfy the growing variety of needs of the photo enthusiast. Each exposure mode directly affects a camera's automatic exposure system.

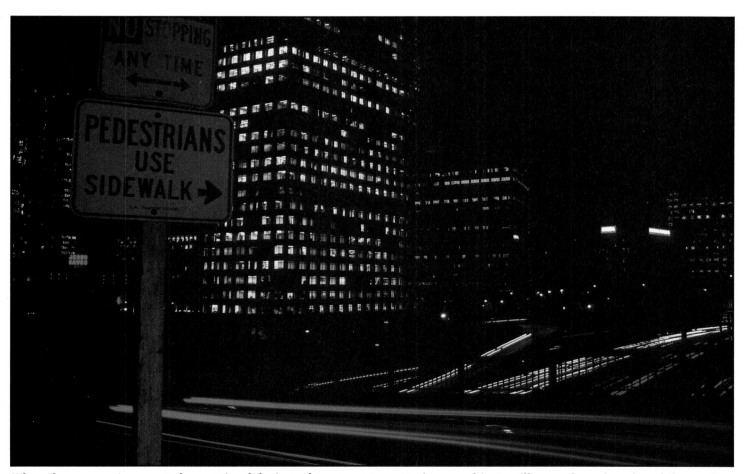

When the camera is mounted on a tripod during a long exposure, stationary objects will reproduce sharply, while moving objects, such as car lights at night, will appear as bright trails.

NIGHT MODE

When shooting night scenes, such as city lights, busy freeways, or nature illuminated by a full moon, automatic flash can be your worst enemy. The night mode, present in the *Ricoh FF-7*, the *Shotmaster Zoom* and the *Konica Z-up 80 Super Zoom*, is one method of avoiding the built-in flash when natural, although dim, light is preferred. By setting the camera to the night mode, not only will the flash not fire, but the camera will assume a fixed slow shutter speed and wide aperture for maximum light efficiency.

When shooting in the night mode, the use of a tripod is strongly recommended, to avoid blurred images due to camera shake.

LONG EXPOSURE MODE

Another mode suitable for night photography is the *bulb* setting, which is intended for long exposures—up to four seconds with the *Canon Sure Shot Multi Tele* or as long as several hours with the *Konica Z-up 80 Super Zoom*. Ideal for fireworks or lightning displays, long exposures will capture dramatic streaks and trails of light.

You can also create colorful abstract images at night by aiming your camera at a dark area that contains a lot of point light sources and then moving the camera during the exposure. This technique is guaranteed to yield unusual and surprising results.

If you want to keep the camera steady during a long exposure, use a tripod.

The TV mode of the Ricoh FF-7 and Ricoh Shotmaster Zoom cameras employs a fixed exposure of ƒ-4 and 1/30 second. This shutter speed captures screen-generated images without the disturbing diagonal bands often seen in photos of TV images.

TV MODE

With the TV mode of the *Ricoh FF-7* and *Shotmaster Zoom* cameras, you can photograph a TV- or computer-generated image directly off the screen or monitor. When the camera is set to this mode, via a button on top of the camera, the exposure setting is fixed at 1/30 second at *ƒ*-4, enabling TV-screen images to be successfully captured without those distracting diagonal bands which often result in this type of photography. Needless to say, the flash will not fire in this mode, since TV and computer screens generate their own light. Flash would only produce unwanted glare on the screen.

EXPOSURE COMPENSATION

A feature that's usually found on an SLR, exposure compensation is also offered by some point-and-shoot cameras. This function enables you to alter the camera's automatic exposure setting to increase or decrease exposure. With the *Olympus Infinity Super-Zoom 300*, the compensation range is plus or minus 1.5 steps. With the *Ricoh Mirai*, it's up to 4 steps in either direction. The compensation is activated by pressing an appropriate button on the camera until the desired amount of compensation appears in the LCD display panel.

Not only is this feature useful for certain types of non-average subjects that are likely to "fool" the camera's meter, but it provides creative exposure applications as well. The camera's meter is programmed to provide accurate exposure for an *average* subject. Some subjects are not average, and sometimes you may want to expose *creatively* rather than *accurately*. By increasing or decreasing exposure in half-step increments, you can customize the exposure to better suit your subject and your sense of aesthetics. (See also Chapter 5.)

BACKLIGHT COMPENSATION

A variation on exposure compensation, the backlight compensation feature, activated by a button or switch on the camera, is programmed to increase the camera's exposure by either 1.5 or 2 steps, to yield an accurately exposed subject in front of an overexposed, washed-out background. Whereas fill-flash utilizes the built-in flash to balance subject and background exposure, the backlight compensation control exposes the subject correctly, but at the cost of losing background detail.

APERTURE CONTROL

To date, the only autofocus point-and-shoot cameras to offer manual aperture control are the *Ricoh Mirai* and *Olympus AZ-4 Zoom.* To control depth of field for

The data back on this Canon Sure Shot Joy Date camera, as on all "Date" cameras, imprints information—such as time, date, month, year and day—onto your photographs.

Backlight compensation is necessary whenever the background is considerably brighter than the subject. Without compensation, the bright background has undue influence on the camera's meter, with the result that the subject reproduces as an underexposed silhouette or near-silhouette (upper photo). For the lower photo, the exposure was compensated by +1.5 steps to record the subject more accurately. When you do this, notice how the background becomes washed out.

desirable results, you can select the aperture of your choice by pressing an up or down button, located near the shutter button. Once the aperture has been set, the camera automatically supplies an appropriate shutter speed. Both settings are shown in the viewfinder display.

SPOT METERING

For added exposure control of backlit subjects or contrasty scenes, the spot meter function of the *Olympus Infinity SuperZoom 300* and the *Olympus Infinity 200* is a highly useful feature. At the touch of a button, the central metering area of the frame shifts to a much smaller diameter, enabling you to meter more precisely a small portion of the scene you intend to photograph. In this way, the camera's exposure can be

based on a specific spot, instead of a general area which might contain too great a contrast range to yield an entirely accurate exposure setting.

MISCELLANEOUS

Sometimes it's not only the big things that count in the long run, but the little things as well. Here are some additional helpful features, available on some camera models.

DATA BACK

For those precious memory shots that occur only once in a lifetime, a data-back camera provides instant and automatic photo documentation. Located on the backs of "Date" cameras, including the *Pentax IQZoom 60 Date,* the *Pentax IQZoom 70 Date,* the *Canon Sure Shot Multi Tele Date,* the *Yashica Samurai,* and most of the *Konica* line, the data back is a clock/calendar that imprints near the border of an image the precise time and date the shot was taken.

Each calendar and clock setting can be adjusted manually by buttons on the back of the camera. Any information that you program into the back will appear as a clearly visible readout in an LCD display panel. Even when the camera is turned off, this information remains visible at all times without affecting the battery level.

PREWIND

One of the most underrated and misunderstood functions is the prewind mechanism, found in the *Fuji DL 300* and the *Fuji DL400* models. Immediately upon loading, the entire roll of film is wound onto the take-up spool in the camera. The film is subsequently exposed backwards, to the first frame. Since the ex-

posed frames are being wound directly into the film cassette, instead of onto the open take-up spool, the exposed images are protected, should the camera be opened accidentally in the middle of a roll.

DIOPTRIC CORRECTION

Another advantageous feature is the +0.5 to +2.5 dioptric correction facility, which is built into the viewfinder of the *Konica Z-up 80 Super Zoom*. It can be easily adjusted to suit your eyesight, by means of a lever to the right of the viewfinder eyepiece. If you normally wear glasses, the dioptric correction facility can enable you to shoot pictures without wearing your glasses. Even if you don't wear glasses, it's comforting to know that you can customize the camera's viewfinder to suit your own eyesight.

TRIPOD SOCKET

Don't sell it short, just because it isn't a control that moves or lights up. The tripod socket is essential in any situation where unwanted camera shake can become a factor unless you use a tripod.

TILT STAND

Offered at the time of writing by the *Canon Sure Shot* cameras only, the tilt stand is a small retractable leg or stand on the bottom of the camera. It can be used instead of a tripod, so long as the camera is resting on a flat, steady surface. This extremely "portable" feature can prove useful in a number of situations, especially in combination with the self-timer.

CABLE-RELEASE SOCKET

A cable release is a handy piece of equipment for eliminating any possibility of camera shake or to enable you to fire a shot from somewhere other than behind the camera. Both the *Ricoh TF-500* and the *Konica Z-up 80 Super Zoom* are equipped with a cable release socket. The *Ricoh FF-90* will accommodate an optional cable release adapter.

WEATHERPROOF AND WATERPROOF CAMERAS

Some autofocus point-and-shoot cameras have been designed specifically to withstand the effects of water and adverse weather conditions. Weatherproof and waterproof cameras are constructed with moisture-resistant seals that prevent not only water and moisture, but also sand and dust, from reaching the inner parts of the camera.

Waterproof cameras, such as the *Minolta Weathermatic Dual 35*, the *Chinon Splash AF* and the *Nikon Action-Touch*, can actually be submerged in water. Weatherproof cameras, such as the *Olympus Infinity*, the *Olympus Infinity Twin* and the *Konica MR 640*, are protected against the effects of rain and snow, but are not intended for underwater use.

In normal shooting situations, these cameras function just like other autofocus point-and-shoot cameras. However, the autofocus systems of waterproof cameras, for underwater photography, are somewhat modified.

At present featured only on the Canon Sure Shot cameras, the Tilt Stand (lower left) is a small retractable leg that will support the camera on a flat surface, aiming it at a slight upward angle. It is ideal for shooting self-portraits.

The Minolta Weathermatic Dual 35, providing 35mm and 50mm focal lengths, can be used above water and below, to a depth of 16 feet. Above water, focusing is achieved with an infrared autofocus system. Underwater, the camera employs fixed focus.

Because water deflects a camera's infrared focusing beam in an unwanted manner, an alternate focusing system must be employed. With the *Nikon Action-Touch,* a manual distance selector enables you to override the autofocus system, so that you can set accurate focus for specific distances. With the *Minolta Weathermatic Dual 35,* a simple positive lens automatically shifts the camera's focus from infinity—which is the setting that results from the infrared beam's failure to find focus automatically—to 5.9 feet. This has been determined an optimum distance for most typical underwater photography.

The Nikon Action Touch camera can be used above water, and underwater to a depth of nearly 10 feet. Above water, infrared autofocusing provides focus; below water, focus must be set manually by use of the focusing dial on top of the camera.

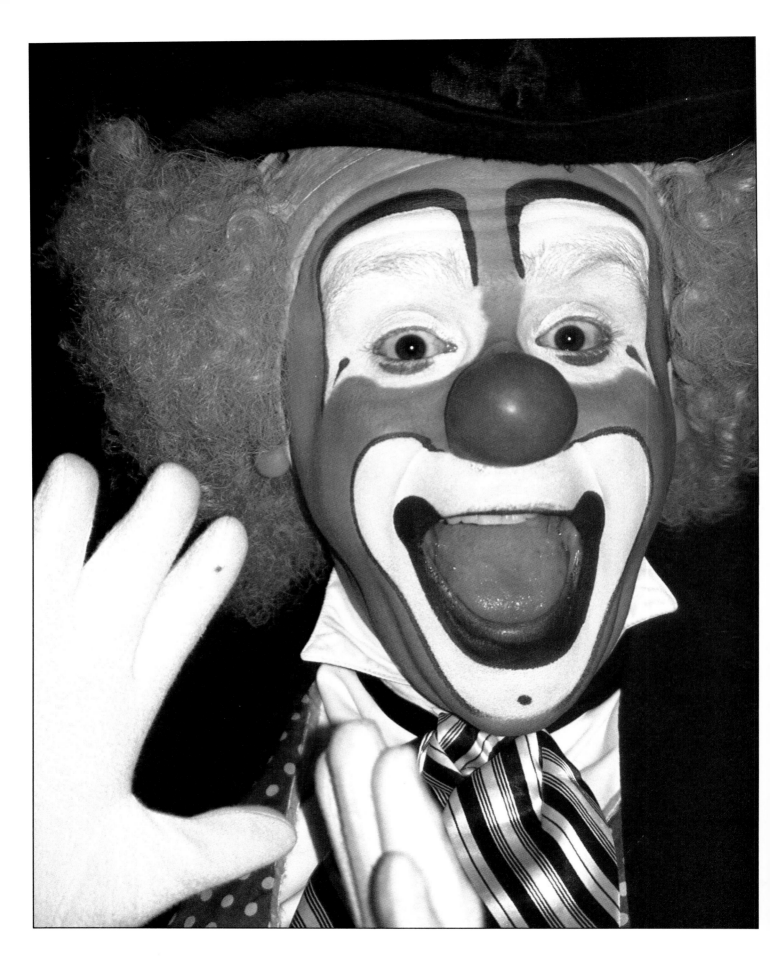

3
ALL ABOUT AUTOFOCUS

When making prints or slides from original negatives, a photo lab can make some corrections for errors in exposure or color balance, but not for an out-of-focus image. Even though the image you thought would be your favorite shot might be perfectly composed and exposed, displaying a good use of color and design, if it's blurred because it's out of focus, you're out of luck. Focus, therefore, is a crucial part of the photographic process.

With an autofocus camera, focusing is as simple as pressing a button. This takes a lot of the pressure and responsibility off your shoulders, enabling you to concentrate on other aspects of your picture taking. However, you must be alert to the fact that an autofocus system cannot evaluate *all* scenes and situations *reliably*. Understanding how autofocus works, and where it falls short, will help you to achieve consistently satisfying results.

HOW AUTOFOCUS WORKS

Autofocus point-and-shoot cameras are capable of focusing over a range of distances as a result of movable elements within the lens. These elements move closer to or farther away from the film plane in focusing *zones* or *steps,* which determine the precise distances at which the camera can be focused. When shooting nearby subjects, at the camera's minimum focusing distance, the optical center of the lens—or, more precisely, its rear *node*—is at its farthest point from the film plane. Conversely, when shooting distant subjects, the movable elements of the lens are closest to the film.

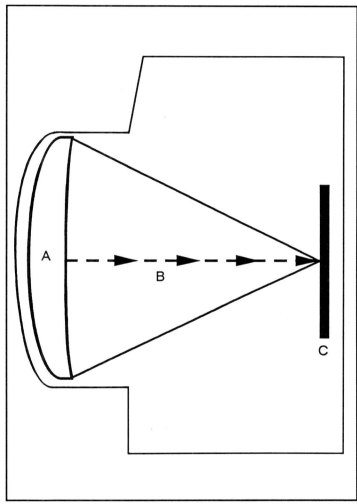

When a lens is focused at a distant scene, at infinity, the distance (B) from the lens (A) to the film plane (C) is equal to the focal length of the lens. As a subject comes closer to the camera, the lens must be moved farther from the film to provide a sharp image.

◄ **An autofocus camera relieves you of one of the technical aspects of picture-taking, allowing you to concentrate your full attention on the event before your camera and how to capture the decisive moment.**

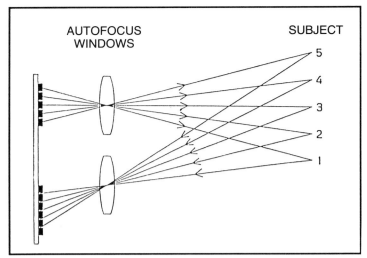

In an infrared autofocus system, the camera sends out a concentrated infrared beam from an autofocus (AF) window to the center of the subject area. When this infrared pulse reaches the subject, it is reflected back to the camera's other AF window. With specially located sensors, the camera can then determine what focusing action is necessary to get a sharp image. Pictured here is the Minolta multi-beam system, which sends out five infrared beams instead of just one.

In a "passive" autofocus system, like the one in the Olympus Infinity SuperZoom 300 pictured here, a prism in the camera reflects back to an electronic AF sensor (rangefinder) two different viewpoints of the same subject. The rangefinder then compares the two viewpoints to determine and set the proper focused distance.

The two common focus-detection methods, the *infrared* method and the *phase-detection* method, are described next.

INFRARED FOCUS DETECTION

Most autofocus point-and-shoot cameras employ an *active* autofocus system in which the camera emits, from one of two AF windows, a concentrated infrared beam to the center of the image area. When this infrared pulse reaches the subject, it is reflected back to the camera's other AF window. The camera then calculates the distance to the subject and focuses the lens accordingly.

For optimum autofocusing, always keep your camera's AF sensors clean and be sure they are unobstructed when the camera is in use.

When the camera's shutter button is partially depressed, the automatic focusing system is activated. The camera emits its infrared signal and, by means of a built-in motor, establishes proper focus. As an added convenience, many cameras feature an indicator, either in or near the viewfinder, which lights up when the subject is in focus and flashes when it isn't. Some cameras actually lock the shutter when the subject is not in focus, in order to prevent you from taking an out-of-focus picture.

One great advantage of the infrared autofocusing system is that it can function effectively in total darkness, since it emits its own focusing beam. This *active* autofocus system is less complex in design, more compact, and less costly than the *passive* system described next.

PHASE-DETECTION AUTOFOCUS

Whereas infrared autofocusing is described as *active*, because the camera actively emits an infrared signal, phase-detection autofocus is considered *passive*, because it works solely with the image *received* by the camera.

Advanced point-and-shoot cameras, such as the *Olympus Infinity SuperZoom 300*, the *Canon Sure Shot Zoom XL*, the *Yashica Samurai* and the *Ricoh Mirai*, all employ a passive autofocus system in which two different viewpoints of the image are directed to two detectors in an electronic rangefinder. When the two images are centered on the two detectors, the camera image is in focus. When they are off center, the image is out of focus in one direction or the other.

As long as the images on the detectors are off center, the autofocus motor will adjust focus until both images are centered in their respective detectors.

FOCUSING ZONES

As mentioned earlier, focusing zones, or steps, determine the exact distances at which the camera is capable of focusing. The distance range of the most simple autofocus point-and-shoot cameras is usually divided into three steps, such as 5 feet, 10 feet and 20 feet. The camera will focus on whichever of these three distances the subject is closest to.

For example, if the subject is 6 feet away, the camera will focus at 5 feet. If the subject is between 7.6 feet and 14.9 feet away, the camera will focus at 10 feet. If the subject is exactly 15 feet away, the camera

will focus at 10 feet rather than 20 feet, because depth of field is inherently greater beyond the point of sharpest focus than in front of it. If the subject is more than 15 feet away, the camera will focus at 20 feet.

From the above, you can see that the camera will not be focused *precisely* on the subject if the subject happens to be located somewhere between the camera's programmed focusing steps. However, the depth of field provided even by the camera's maximum aperture is enough to ensure acceptable sharpness at all distances.

Many autofocus point-and-shoot cameras average anywhere from five to 20 focusing zones, while the more technologically advanced cameras, such as the *Chinon Genesis,* have so many steps that they are considered "stepless." Naturally, the more focusing steps an autofocus camera has, the more precise the autofocusing will be.

FOCUS ON MOST IMPORTANT SUBJECT PART

Because most autofocus point-and-shoot cameras don't permit through-the-lens viewing of a scene, the potential for misfocus does exist. However, as you gain experience with your camera, that danger becomes less likely. The main thing to remember when using autofocus is to always establish focus on the most important part of the subject or scene. For an image to be technically successful, this *primary focal point* must be in sharp focus. Remember, however, that the camera can only focus on that which is centered in the image frame.

Focus Lock—What if the primary focal point of your photograph doesn't happen to be in the center of the image? Prior to the introduction of a focus-lock mechanism, the main subject *had to be* centered in the AF frame. Clearly, this tended to limit a photographer's compositional creativity.

The focus-lock mechanism, standard on all new autofocus cameras, will lock the focus at the desired distance so that you can then recompose the shot. The subject need no longer always be dead-center in your pictures.

To utilize this feature correctly, you must first compose the shot with the subject in the center of the viewfinder's autofocus frame. Once focus has been established by pressing lightly on the shutter button, and confirmed by the camera, if possible, you can reframe the shot with the focus locked in place. Simply keep the shutter button partially depressed. Removing your finger from the shutter button, or making an exposure, will cancel the focus lock and you must refocus the camera before taking the next shot.

SOLUTIONS TO AUTOFOCUS PROBLEMS

No matter how dependable a camera's autofocus system is, it isn't foolproof. The following are problems your autofocus camera might encounter in certain situations. Be aware of them before you go out shooting, so you won't have to learn from your mistakes after the fact.

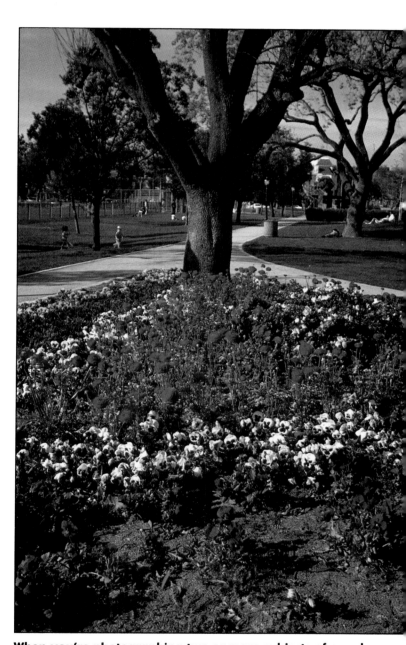

When you're photographing two or more subjects of equal importance at different distances, prefocus somewhere between a third of the way and halfway into the important part of the scene and then reframe the shot to give you the composition you want. If you're shooting in bright outdoor lighting, the depth of field should be sufficient to reproduce the entire scene in sharp focus.

SUBJECTS AT CONFLICTING DISTANCES

When you're taking photos at a zoo, where your subjects are behind distracting fences or cage bars, autofocusing can be an impossible feat. This is just one typical example where conflicting distances will confuse the autofocus system. With some camera models, the camera might refuse to operate altogether.

To ensure proper focus on the subject *behind* the cage and not on the cage itself, you can point the camera at a "substitute" subject that happens to be the same distance from the camera as the desired subject, and activate the focus-lock. When you have proper focus, you can aim the camera at the subject you intend to shoot and make the exposure.

Another means of shooting a subject behind a fence is to position the camera against the fence so that both the lens and the AF windows have a clear view of the subject, through one of the openings in the fence.

In situations where two subjects at different distances are of equal importance to the image, you have a couple of options. If the subject-distance differences aren't very great, you can lock focus on one of the subjects—preferably the nearer one—and hope the depth of field will include the other in sharp focus.

If one subject is quite a bit behind or in front of the other, you can prefocus on a midpoint between them—preferably a little closer to the nearer one—and then reframe the shot. Cameras that offer a *multi-beam* autofocus system will do this automatically.

If you're working in bright outdoor light, the depth of field should usually be sufficient to then reproduce both subjects in acceptably sharp focus.

DIM LIGHT AND LOW CONTRAST

Subjects in dim light, and most low-contrast subjects, are generally not a problem for the *active* infrared autofocusing system. However, the *passive* phase-detection system has difficulty with scenes in dim light and with low-contrast subjects because it depends on a certain subject brightness and contrast level in order to focus accurately. By locking focus on an alternate subject of sufficient brightness and contrast, and at the desired distance, you can then recompose the shot with the original subject and obtain a sharp image.

ACTION PHOTOGRAPHY

Most autofocus point-and-shoot cameras will only focus one time when the shutter button is pressed. Unless you're using a camera that offers a *Servo AF* feature for rapidly repeated autofocusing, moving subjects will prove difficult to focus on with accura-

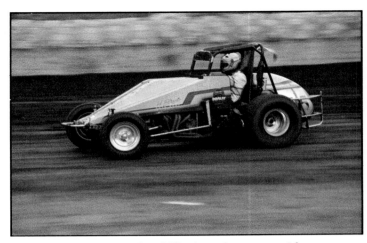

Moving subjects can be difficult to focus on with accuracy. Prefocus on a point where you want to photograph the subject. Employ a camera-panning technique and shoot when the subject arrives at the prefocused point. For this photo, a fast ISO 3200 film was used, to enable the camera to provide a fast shutter speed.

cy. The best method in these situations is to use the focus-lock to achieve focus at the distance the subject will be when you anticipate making the shot. You can then *pan,* or swing, the camera to keep the moving subject in the viewfinder frame, and shoot at the appropriate moment. Action photography is discussed more fully in Chapter 9.

SHOOTING THROUGH WINDOWS

Shooting through a window shouldn't cause a problem for the *passive* phase-detection system, unless the window happens to be reflecting a lot of light toward the camera—in which case you probably wouldn't want to make a photo anyway. However, the *active* infrared system will always focus on the first thing the infrared beam hits, so that the window itself will be the subject of sharpest focus. That's because, to the camera's infrared focusing beam, the window is a solid object that will cause reflection back to the camera.

To take a sharply focused image of a subject located beyond a window, either cover one of the AF windows or position the camera flush against the window. This will cause the camera's autofocus system to revert to infinity focus, enabling you to shoot a distant subject beyond the window. Another alternative, if the space on your side of the window permits it, is to lock focus on a subject that is at an estimated equal distance from the camera as the subject beyond the window, and then take the shot.

Be sure to familiarize yourself with your camera's features, so that you don't cover the camera's exposure metering window by mistake. Also, avoid marks or fingerprints on the AF window because they could lead to out-of-focus images.

Several cameras offer a *panorama* or *scenic* mode that sets camera focus instantly for a distant scene. (See also Chapter 2.)

REFLECTIVE SURFACES

Deliberately photographing a reflection of a subject in a mirror or window can present problems for the *active* infrared autofocusing system. This is because the reflected scene is not at the same camera-to-subject distance as the mirror, but farther away. When the camera aim is perpendicular to the reflective surface, the infrared beam will regard the mirror as the subject and establish focus accordingly. As a result, the surface of the mirror will be sharply focused, while the more distant reflection will be blurred.

There are a couple of methods you can employ to obtain sharp reflected images.

When you want to photograph a distant scene, reflected in a mirror, in water, or in some other reflective surface, a quick and easy method is to position the camera at an angle to the reflective surface. Rather than reflecting back to the camera, the infrared focusing beam will be deflected so that it does not return to the camera's AF window. As a result, the camera will assume that the subject is at a considerable distance and will lock focus at infinity.

Reflected Self-Portrait — When photographing your own mirror image, the easiest way is to allow the camera to focus on the mirror. However, only bright daylight conditions, together with the use a fast film, will ensure maximum depth of field for the subject to be recorded sharply. You cannot use on-camera flash when taking this kind of picture because the light from the flash would bounce right back to the camera, spoiling the image.

Another easy method you can employ, and one which will ensure sharp results under virtually any lighting condition, is to step back until you're twice as far from the mirror as you want to be when you actually take the picture. Lock focus at that position and then return to the position from which you want to shoot. The camera will now be focused on your mirror image.

VERY BRIGHT OR DARK AREA IN CENTER OF FRAME

If you're shooting a subject in which a very bright or very dark area falls in the center of the image frame, neither an active nor passive autofocus system will be able to focus effectively. This is simply because the autofocus system can only interpret subjects within a certain brightness range. A simple way around this is the ever-useful focus-lock procedure. Just prefocus on something else and then reframe the shot with the desired subject.

SUBJECT LACKING VERTICAL LINES

A *passive* autofocus system's focusing sensors are oriented horizontally. In order to focus accurately, it must see contrasting vertical lines. To take a sharp photograph of a subject having only horizontal lines, simply rotate the camera for a vertical format. Focus on the subject while using the vertical format, keep the focus locked while returning the camera to the horizontal format, and take the picture.

CLOSE-UPS

If your camera has a *macro-focusing* capability, you can focus on subjects as close as 1.5 feet with some cameras, enabling you to shoot fairly tight close-ups of relatively small subjects. At such close distances, depth of field is almost nonexistent and, consequently, focusing becomes a critical factor. For this reason, it's important to always establish focus on the most important part of the subject.

For example, if you're making a close-up head shot of a person, locking focus on the subject's eyes will produce a more flattering image than if you focus on the subject's nose. After all, the primary focal point of any portrait is the eyes, since they communicate the most about a person.

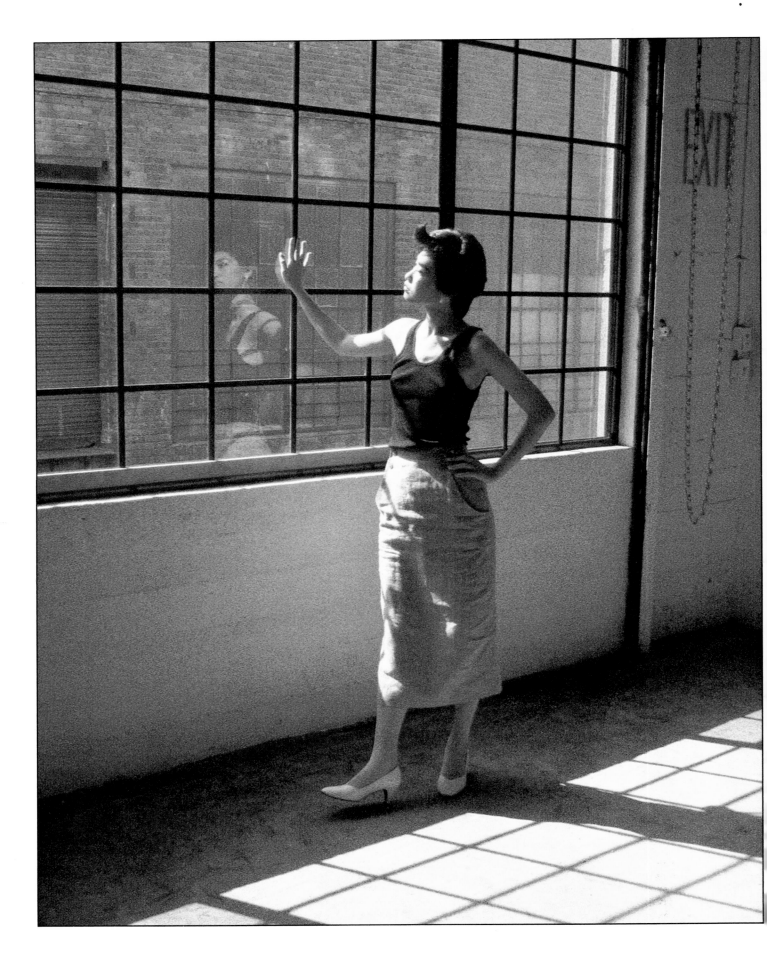

4
FILM

An autofocus point-and-shoot camera is programmed to do many things, but it can't tell you what film to use. That's a decision you have to make on your own. Numerous brands and types of 35mm film are available. With a little knowledge of what different films are capable of, and how the camera's exposure system can affect them to produce specific results, you'll find that choosing a film is not only easy, but can be an enjoyable part of the creative process.

Color print films can generally be identified by the suffix "color" in their names, as in Kodacolor and Fujicolor. The words "Color Print Film" or "Print Film" also generally appear on the film boxes.

FILM TYPES

While there are many *brands* of 35mm film, there are only three basic *types* with which you need be concerned: color print, color slide and black-and-white negative.

COLOR PRINT FILM

Color print films can be identified by the suffix *color* in their names, such as *Kodacolor, Fujicolor* or *Agfacolor,* as well as by the words *color print film* on their boxes. Color print film is often referred to as *negative* film because, when developed, negatives are produced which must then be printed on paper, to produce prints, or on positive recording film, to make slides. Color print films are available in speeds from ISO 25 to ISO 3200.

An advantage of negative film is that considerable correction of both color balance and tonality is possible at the printing stage. The majority of images in this book were photographed on color print film. Slides were made from the negatives by a film-processing lab that specializes in such a service and those slides were used for the reproductions on these pages. There are innumerable color labs that will make prints or slides from your processed film.

Today's color print films are truly amazing. When properly stored, they can be kept in inactive cameras for months at a time without suffering from color or exposure distortion. Ideally, of course, it's good practice to have your exposed film processed as soon as possible.

The great exposure latitude of color print films enables them to be underexposed by at least a full exposure step or overexposed by as much as two or three steps, depending on the film, and still produce negatives that will yield satisfactory color prints. Autofocus point-and-shoot cameras were designed primarily to be used with color print films—by far the most popular film type among amateurs today.

COLOR SLIDE FILM

Color slide films can be identified by the suffix *chrome* in their names, such as *Kodachrome, Fujichrome* or *Agfachrome,* and by the words *color slide film* on their boxes. Referred to as a *positive* film, color slide film produces a transparent positive image, or slide, suitable for viewing by projection. Color slide films are available in speeds from ISO 25 to ISO 1600.

When color print film is developed, a negative is produced (upper photo). The negative can be used to make a positive color print (lower photo) or a color slide.

35mm FILM CASSETTE

CASSETTE
LIGHT SEAL
FILM TONGUE
SPROCKET HOLES
DX-CODING
SPOOL
FILM LEADER

Color slide films can be identified by the suffix "chrome" in their names, as in Kodachrome, Ektachrome or Fujichrome, and by reference to "Color Slides" or "Slide Film" on the film boxes. Color slide films produce transparent positive images known as slides.

Because a finished slide is produced on the actual film on which it is taken, there is no printing step at which color balance or exposure errors can be corrected. This makes slide film much less "forgiving" than color print film and far more demanding for correct exposure.

Exposure Compensation—Inherently, color slide films generally have less exposure latitude than color print films. As a result, the camera's exposure settings must be accurate for the film.

Autofocus point-and-shoot cameras are intended mainly for use with color print film and the exposure system is balanced accordingly. For best results with slide film, *underexposure* by at least half a step is recommended, to ensure detail and good color rendition, even in highlight areas. That's because, basically, a good negative is dependent on *shadow* detail, demanding *full* exposure, while good slides depend on *highlight* detail, demanding relatively more *limited* exposure. (See also Chapter 5).

BLACK-AND-WHITE FILM

Negative black-and-white films are available in a film-speed range of ISO 32 to ISO 400 in DX-coded cassettes, and ISO 25 to ISO 3200 in non-DX-coded cassettes. Black-and-white film has considerably more exposure latitude than color slide film but generally a little less than color print film.

Most creative photographers who work in black-and-white expose their films at other than the manufacturer's ISO ratings in order to obtain the kind of negatives they prefer. For this reason, black-and-white films are not really ideal for point-and-shoot cameras. When black-and-white prints are needed, they can easily be made from color negatives, on special panchromatic black-and-white printing papers. Such prints are likely to possess better image quality than prints made from imperfectly exposed black-and-white negatives.

Infrared Film—A unique type of black-and-white negative film worth experimenting with is infrared film. This film is sensitive to infrared as well as visible radiation and produces results in which blue sky and water generally appear black, while healthy foliage and other subjects that emit or reflect a lot of infrared appear white. The film, having great haze-penetrating qualities, can produce dramatic landscape photos.

To use infrared film effectively, a deep red filter, such as a No.25, must be placed over the lens, but *not* over the light sensor. A No.25 or equivalent red filter blocks most of the visible radiation, transmitting only the longer red wavelengths and the infrared radiation to which the film is sensitive.

Black-and-white infrared film produces interesting and often surprising results. Subjects that reflect infrared radiation, such as many types of foliage, appear almost white. Blue sky, on the other hand, which contains little infrared, appears almost black. To work effectively with this film, a deep-red filter, such as a No. 25, must be placed over the lens—but not over the light sensor. It's wise to use a camera's wide-angle focal length to ensure maximum depth of field. This is important because infrared radiation does not focus at precisely the same distance from the lens as visible light.

With a No.25 filter on the camera lens, Kodak High-Speed Infrared Film 2481 has a recommended ISO rating of about 50 in daylight. The film cassette is not DX-coded, so film speed must be set manually. Most point-and-shoot cameras automatically set a film speed of ISO 100 with non-DX-coded cassettes, and that's close enough for a starting point with the Kodak film. However, it's advisable to experiment with exposures fairly liberally, when possible, to be sure of getting satisfactorily exposed images.

FILM CHARACTERISTICS

Slow films, of ISO 25 or ISO 50, tend to produce richer colors and tones than faster films. Because slow films require more exposure than faster films,

they are best used in bright lighting conditions.

When you use a slow film in dim lighting, the camera's exposure program will set a slow shutter speed and large lens aperture to ensure proper exposure. The slow shutter speed increases the probability of unsharp images due to camera shake or subject motion, and the wide aperture means depth of field is limited. With minimal depth of field, subjects not in the same plane as the main subject may appear unsharp in the photo.

With the simpler cameras that have only two or three autofocus zones and rely on depth of field to cover for not-so-precise autofocusing, the main subject may also appear a little blurry.

Also, the slower the film speed is, the more limited the range of the flash will be.

Medium-speed films, in the range of ISO 100 to ISO 200, are a good choice for general-purpose photography. They produce sharp images of excellent quality. These films are fast enough to be used outdoors or indoors in a wide range of conditions. Kodacolor Gold 100 and 200 print films are good all-around films in many shooting situations.

Fast films generally range from ISO 400 to 3200. They allow the camera to set fast shutter speeds and small lens apertures, for minimal risk of camera shake and maximum depth of field. Fast films are ideal for "freezing" action when shooting subjects in motion and are virtually a necessity when shooting in dim lighting conditions.

To get the best possible image quality, never use a faster film than you really need, for reasons indicated below. Also, before using a super-fast film like Konica SR-G 3200 color print film, be sure your camera will accommodate such a high film speed. Most autofocus point-and-shoot cameras go to only ISO 1000 or 1600. For most general purposes, Kodacolor Gold 400 and Fuji Super HR 400 produce excellent image quality while also providing sufficient film speed for sharp images of moving subjects. Kodak's Ektar 1000 color print film, despite its fast speed, produces images of exceptional quality.

The speed, or ISO number, of a given roll of film not only determines the camera's exposure settings but also dictates the appearance of three basic film characteristics: *grain, sharpness, and contrast.* These qualities vary according to a film's ISO speed.

GRAIN

The tiny particles of silver or dye which form the image in the photographic emulsion are referred to as *grain.* The structure of grain in both slides and prints can be identified through a high-power magnifying

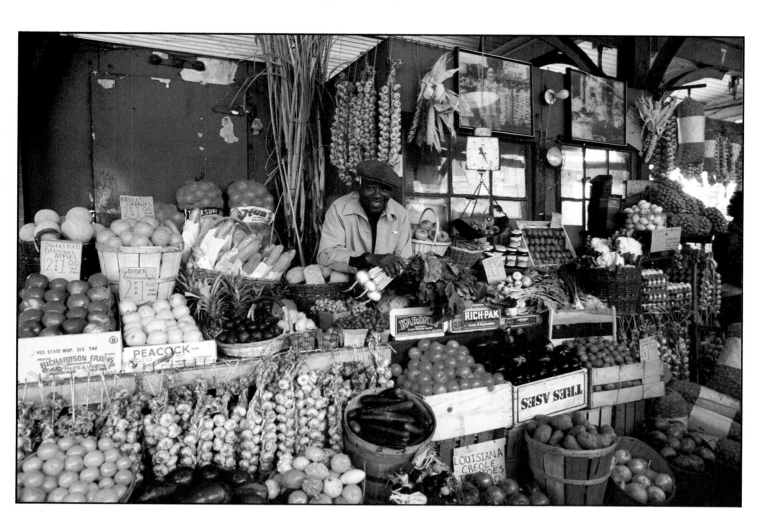

Medium-speed films are a good choice for general-purpose photography, producing sharp images of excellent quality. This shot was taken on Kodak Ektar 125 color negative film. Photo by Eastman Kodak Company.

glass. The faster a film is, the coarser and more readily visible the grain structure will be, especially when an image is enlarged or projected.

Usually, a fine-grain image is preferable. However, coarse grain can be used effectively for producing special artistic effects. Such results can be achieved by using a fast film, and can be exaggerated further by high image enlargement.

SHARPNESS

The inherent sharpness of an image—assuming that camera focus was accurate and there was no image blur due to movement—depends largely on how fine or coarse the grain is. The finer the grain, the sharper the image will be.

CONTRAST

Contrast applies to the relationship of tones within the image. Normal image contrast implies that an image contains basically the full scale of tones, from dark to light, present in the original subject. A photo-

graph that's low in contrast is one that has a limited range of tones, often lacking both deep shadows and bright highlights. A high-contrast photo contains pure white, pure black, and usually a limited intermediate tonal range.

Generally, the more light-sensitive or fast the film is, the lower its inherent contrast will be. The slower the film is, the more inherent contrast it will have.

COLOR CHARACTERISTICS

Before you can choose a film, you must obviously consider whether you want color prints, slides, or black-and-white images. You must also consider the lighting conditions. Decide, prior to shooting, how you want the results to look. For example, if you specifically want grainy images for a special artistic effect, a fast film will suit your needs; if you want to capture the blur of motion, a slower film will be ideal.

When you select a color film, it's also important to choose one that gives the kind of color *quality* you

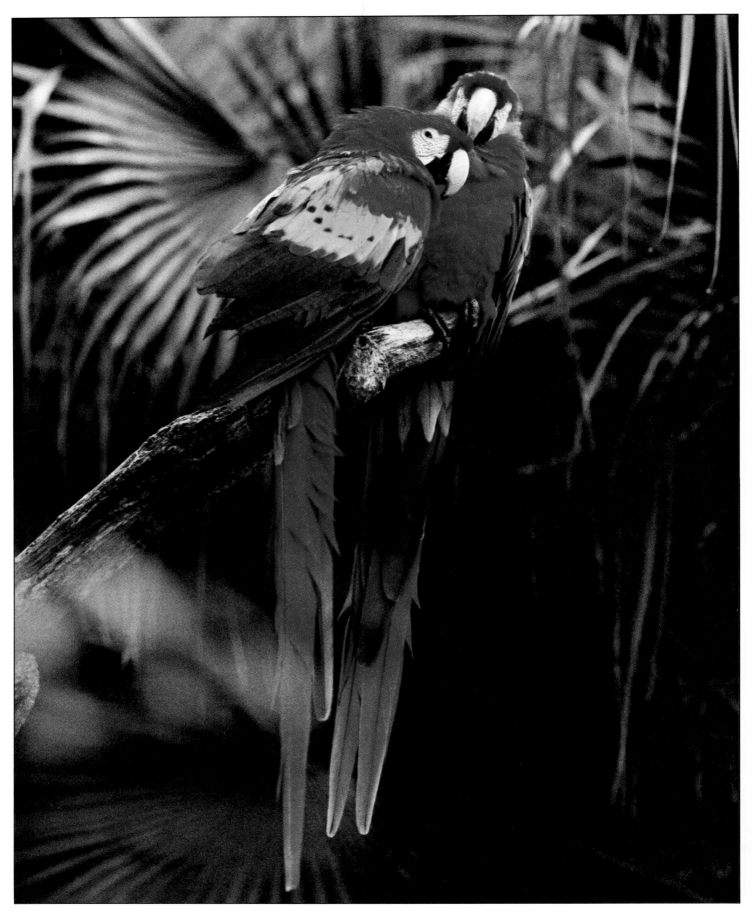

want. This doesn't mean that one film type is *better* than another. But color characteristics of different films are *different*.

Each brand of film has inherent color characteristics that will affect the overall appearance of an image. Personally, I find that Fuji films tend to slightly exaggerate natural colors, making a blue sky appear bluer and green foliage look greener. Fuji films produce vibrant colors and can be ideal for nature and scenic shots that benefit from a pronounced range of dynamic colors. I find that Fuji films are not as well suited for portraiture or people shots because skin tones tend to reproduce less naturally, with faces taking on an excessively ruddy complexion.

Kodak color films produce remarkably realistic colors of most subjects. The colors are rich and satisfying and the films are a good choice for both people and scenic photography.

Agfa color films usually reproduce the tones of nature, such as browns, yellows and greens very realistically, while bright colors appear somewhat muted. Agfacolor film is a good choice for portraiture or landscape photography in which you desire a realistic image without excessively bright colors.

These are just a few examples of how different brands of films produce different kinds of results in various situations. Of course, the evaluation of color quality is a very subjective thing. You should do some testing on your own to determine what color film you like the most.

Try shooting several types of subjects, such as people, nature scenes with blue sky, and brightly colored objects like flowers, in a variety of lighting conditions, using different brands of film. Compare the results you get, making note of which film type you liked most for each subject and lighting condition. Perhaps one type of film will satisfy all your needs, or perhaps you'll need several, to satisfy a variety of conditions.

THE COLOR PROCESSING LAB

The color processing lab you choose will also have an effect on your photographic results. Basically, the better the lab, the better and more consistent the results are likely to be. However, for most general purposes, a regular one-hour lab might be just fine. If you're more particular about your results, you should send or take your film to a lab that specializes in processing the type or brand of film you normally use, and is prepared to do a custom job.

Once you find a lab you like, stay with it, as this will ensure getting consistent results from the film you shoot, so that you can always have a good idea of what to expect from the results.

◄ **This photo was made on fast Kodacolor negative film. The exposure was such as to provide a sharp, unblurred picture, even though it was raining when the image was shot. In spite of the dull lighting conditions, the image is full of vibrant colors. Photo by Eastman Kodak Company.**

5
ALL ABOUT EXPOSURE

For a satisfactory image to record on film, the film has to receive the right amount of light—not too much or too little. The camera controls this *exposure* to light through a combination of shutter-speed and lens-aperture settings, as described in Chapter 1. An ideally exposed photographic image has detail throughout the tonal range, from near-white to near-black, with discernible detail in both the shadow areas and the highlights.

If a photographic print or slide is excessively light, with a faded or washed-out appearance and no highlight detail, the film has been *overexposed*. If a print or slide is too dark, with no detail in the shadows, the film has been *underexposed*.

When a photographic negative, in color or black-and-white, is printed, some compensation can be made in the general brightness or darkness of the image. However, subject detail that is missing in the highlights or shadows due to over- or underexposure cannot be regained by printing adjustments.

Under normal shooting conditions with *average* subjects, discussed a little later, point-and-shoot cameras are programmed to provide appropriate aperture/shutter speed combinations completely automatically to produce accurate exposure. With today's color print films, the exposure systems of most lens-shutter cameras will work just fine for producing properly exposed subjects in a wide variety of situations.

The exposure was based on the overall water surface, which averaged out to almost a mid-gray tonality. No exposure compensation was necessary to produce this impressive image.

Although you never have to worry about setting the correct exposure, because these cameras do it all for you, you can increase your photographic control by understanding those elements which affect exposure, as well as the effects of exposure on your results.

BASIC EXPOSURE PRINCIPLES

Two basic factors determine the exposure necessary for a given subject: the speed of the film being used and the ambient light in the scene.

Film Speed—Film speed is a numerical expression of the film's sensitivity to light and is given as an *ISO number*. On older cameras, the ISO number is expressed as an ASA number. For practical purposes, they are the same.

The higher the film speed, or ISO number, the more sensitive the film is to light and the less exposure is required to produce a satisfactory image. Conversely, the lower the film speed, or ISO number, the more exposure will be required to produce a satisfactory image.

When you insert a roll of DX-coded film into a camera, the camera automatically sets the appropriate film speed by reading the DX-code of the film's ISO number on the side of the cassette. When the film speed has been set in the camera's built-in computer, the camera will set its exposures accordingly. Faster films enable the camera to set smaller apertures, for greater depth of field, and faster shutter speeds, for stopping action. Depth of field was discussed more fully in Chapter 1.

Light Level—The amount of light illuminating a scene affects the required exposure. The camera's built-in light sensor meters the scene's brightness and thereby determines how much exposure is necessary to record the image accurately on film. If the meter senses that the light level is very bright, the camera

A correctly exposed image contains detail in both shadow areas and highlights (center). When a photograph is too light, with a faded or washed-out appearance and "burned out" faces and highlight areas, the film has been overexposed (left). When a photograph appears too dark, with no detail in the shadows and an overall murky appearance, the film has been underexposed (right).

sets a small aperture and fast shutter-speed combination. In dim light, the camera will utilize a larger lens aperture and slower shutter speed, in order to let sufficient light reach the film.

When the ambient light level is so dim that the largest aperture and slowest shutter-speed combination is not sufficient to produce a correct exposure, or when the shutter speed is too slow to allow handholding the camera without getting blurred images, the camera's built-in flash will automatically come into action, supplying the subject with the necessary illumination.

Most camera manuals indicate in their specifications the lowest light level the camera can accommodate without the need for flash illumination, when using ISO 100 film.

In camera terminology, a given light level is expressed as an *Exposure Value* or *EV*. For example, EV 15 indicates an exceptionally bright situation and EV 0 is about as dark as a distant night-time skyline. Room light normally ranges from EV 5 to EV 8. Most autofocus point-and-shoot cameras can expose images properly, without flash, from EV 8 to EV 18, with ISO 100 film.

The exact exposure range depends on the maximum aperture as well as the focal length of the lens in use. The latter affects the exposure range not only because longer focal lengths have smaller maximum apertures, causing the need for *longer* exposure times,

but also because longer focal lengths demand *shorter* exposure times to ensure a sharp image with a handheld camera. Hence, the need for flash generally occurs at a brighter ambient-light level with the longer focal length settings.

To determine a camera's EV range when using a film speed other than ISO 100, simply subtract one EV number from each end of the ISO 100 range for each doubling of the film speed. For example, a camera that has a metering range of EV 9.5 to EV 15.5 with ISO 100 film will have a range of EV 7.5 to EV 13.5 at ISO 400 and a range of EV 10.5 to EV 16.5 at ISO 50.

CAMERA METERING

The majority of compact autofocus cameras have a photocell, or light sensor, that measures the average brightness of a scene, taking into account both the light and dark areas. Most point-and-shoot camera meters are *center-weighted,* which means the exposure setting is based primarily on the luminance in the central portion of the image, where the main subject is most likely to appear.

In the viewfinder, the *autofocus* frame also serves as the *autoexposure* frame, so you can see where the camera's *predominant* metering is taking place. The remainder of the image area is metered also, but to a lesser extent. As a result, the camera knows when a subject is backlit and requires appropriate compensation in order to be exposed accurately.

Average Scene—In order for the meter to evaluate a scene so that the camera can select an appropriate exposure setting, the meter has to have a means for comparison. The light sensor is programmed to recognize an 18-percent mid-tone gray as an *average* light reflectance level. That's because the most commonly photographed subjects or scenes have been found to have an *average* reflectance of about 18 percent of the light that strikes them.

The camera is programmed to *always* assume that the subject averages at 18-percent gray, and to reproduce the image accordingly.

Not all scenes are *average,* however. If the camera's light sensor is aimed at a particularly dark area, the camera will increase the exposure to reproduce the subject as a mid tone, rather than the dark tone it actually is. At the other extreme, when the camera's meter reads a bright subject, the camera will employ less exposure to compensate for the subject's brightness. As a result, a black horse and a white building would both reproduce as gray.

It's important to be aware of this, especially if you intend to photograph such subjects as snow or bright beach scenes. Without proper exposure compensation, as described a little later, the pure white snow you sought to pictorialize will reproduce as a murky, mid-tone gray, much to your disappointment.

PROGRAMMED AUTOEXPOSURE

In its normal program mode, an autofocus point-and-shoot camera will provide automatic exposure appropriate for the camera's film-speed setting, the brightness of an average subject, and the focal length of the lens. In bright outdoor conditions, the camera will employ a fast shutter speed and a small aperture. As the light level drops, the exposure will be increased by both a widening in the aperture and a slowing down of the shutter speed.

An "average" scene usually contains a high proportion of middle tones, in addition to some dark and light areas. Don't confuse the inherent tonality of a subject with its effective tonality in specific lighting conditions. For example, the wall of the building on the left is white. However, because it is in shadow, it appears as a mid-gray to the camera's meter. The camera will meter it as such, and the film will record it as such.

An exposure-program curve is a chart of shutter-speed and aperture combinations a camera will select at specific light levels. This exposure curve of the Olympus Infinity Super-Zoom 300 shows the exposure setting the camera will establish at a given light level, without the use of supplementary flash. In this example, at a telephoto focal length and light level EV 13, the camera sets an exposure of 1/125 second at *f*-8. With a wide-angle focal length, at the same light level, the camera sets an exposure of about 1/180 second at between *f*-5.6 and *f*-8.

A camera's meter will assume that what it is reading represents an average subject of approximate overall mid-gray tonality. The camera will record the scene accordingly. In the photo on the left, the beach was lit by direct sunlight, while the girl's face was shaded from the sun. Using the camera's automatic exposure, the relatively large expanse of beach would have been exposed correctly, but the girl's face would have recorded too dark. By using exposure compensation, the girl's face could have been lightened, but the beach would then have been burned out. To get a uniform exposure over the entire subject, fill flash was the answer. The sunlight exposure on the beach and the flash exposure on the girl were automatically balanced to produce a pleasing image. In the photo on the right, the tonality and illumination of background and girl were almost identical, and the overall tonality was of about mid-gray value. As a result, the camera's meter provided accurate exposure of both subject and background without the need for any exposure compensation.

The camera is not programmed to favor a particular aperture or shutter speed. For example, it will not try to maintain a small aperture of *f*-16 by decreasing the shutter speed until a balance is achieved, nor will it favor a fast shutter speed, like 1/250 second, by widening the aperture all the way. Aperture and shutter-speed combinations are always balanced in a way that assures *both* as much depth of field and as short a shutter speed as possible, within the camera's exposure range.

At the time of writing, the only autofocus point-and-shoot cameras to offer a manual *aperture-priority* mode were the *Ricoh Mirai* and the *Olympus AZ-4*

Zoom. These cameras allow you to choose the aperture you desire by dialing it into the camera. A corresponding shutter speed will automatically be set by the camera. It appears, alongside the aperture setting, in the viewfinder display. An aperture-priority mode enables you to choose an exposure based on how much, or how little, depth of field you want the scene to have. (See also Chapter 1.)

When you use a dual-lens or zoom-lens camera, the meter will always calculate exposure based on the focal length in use. If a *long* focal length is being used, the camera will employ a *faster shutter speed*, to minimize the risk of *camera shake*. If a *wide-angle* focal

length is in use, the camera will employ a *small aperture,* to ensure maximum *depth of field.*

Some cameras offer special exposure modes that enable you to take properly exposed shots in specific situations. For example, the TV mode and the Night mode in the *Ricoh FF-7* and the *Ricoh Shotmaster Zoom* employ a fixed exposure setting to record TV-generated images and night scenes, respectively, with ease and accuracy.

EXPOSURE COMPENSATION

Generally, if you want a very dark subject to appear very dark or a very light subject to appear very light in a photograph, exposure compensation is necessary to prevent the camera from reproducing the subject as gray.

Also, when photographing highly reflective surfaces such as water, in which bright highlights can cause the meter to read the scene as brighter than it actually is, the subject will be underexposed if no compensation is used.

Backlit subjects present a similar problem. When a subject that does not occupy the greater part of the image area is in front of a very bright background, the meter will average the background brightness with the subject brightness, and thus determine that the main subject is brighter than it really is. As a result, the camera will employ less exposure, thereby underexposing the main subject while accurately exposing the background—unless appropriate exposure compensation is used.

In some cases, exposure compensation might be desirable for purely creative purposes. For example, underexposing a landscape by 1/2 an exposure step can make the image look more dramatic and the blue sky appear as a deeper, more visually satisfying shade.

Exposure compensation is also necessary for creating *high-key* images, in which the photo maintains mainly light tonalities, and *low-key* images, where the photo is intended to contain predominantly dark tones. These are situations that would otherwise reproduce as a drab range of middle-value grays.

If you're not sure whether a specific image might be enhanced by either a little extra or a little less exposure, you might try *bracketing* your exposures. To make a bracketed series of exposures, take at least three separate shots of the same subject: one at the camera's programmed exposure setting, one a full step over the normal exposure, and another a full step under the normal exposure.

Color Slide Film—Autofocus point-and-shoot cameras are primarily intended for use with color print film, but can also be used with color slide film. However, to get the best possible results with slide film, some exposure compensation is recommended.

The exposure requirements for good color negatives and good color slides are somewhat different. To get a good color print from a negative, the negative must be exposed for detail in the *shadow* areas. To get a color slide with rich, saturated colors, it is important not to overexpose the *highlight* areas. Thus, a slide film inherently requires less exposure than a print film of the same ISO speed.

To expose color slide film accurately in your point-and-shoot camera, exposure compensation of at least minus 1/2 step (1/2 step underexposure) is recommended. For best results, make test exposures with a roll of your chosen color slide film to determine the exposure compensation needed.

Exposure compensation, or the "fine tuning" of exposure, can be accomplished using any of the following techniques.

Exposure Compensation (+ / −) Contol—The easiest way to alter a camera's exposure is with an exposure compensation dial, present on several autofocus point-and-shoot cameras. It enables the camera to give more or less exposure to a subject than it normally would. Usually, the exposure can be compensated in 1/2-step intervals up to plus or minus 1.5 or 2 steps. This enables you to bracket exposures without having to lock the exposure on an alternate subject to get the exposure you desire.

This feature can be set for one or two specific shots that might need it, or it can be set for the duration of an entire roll, if desired.

Autoexposure (AE) Lock—This feature, which is not available on all camera models, is coupled with the camera's focus-lock mechanism, so that whenever you activate the focus-lock by lightly pressing the shutter button, you also activate the AE lock. (See also Chapter 2). This feature permits you to lock an exposure in the camera's memory while you recompose the shot.

For example, when shooting a subject against a particularly bright background, in which you want the subject to be off-center in the image frame, you can lock the focus—and consequently the exposure—on the subject, and then reframe the shot to your liking. This way, the subject will be properly focused and exposed in the final image.

Another good use of the AE lock is for shooting snow or bright beach scenes, in which you'll want to have one or two steps of *added* exposure, in order for the white snow or bright sand to appear equally bright in the finished photo. To *increase* the camera's expo-

sure sufficiently, lock focus on a darker subject *at the same distance* as the desired subject, and *in the same light,* and then reframe the shot. To *decrease* the camera exposure, in order to reproduce a dark subject as dark, you should lock focus on a lighter subject *at the same distance* and *in the same light* as the actual subject and then recompose the image and make the exposure.

You can also get an acceptable exposure by including in the metering area more than the snow, beach or dark scene. By metering an overall "average" scene, including a full tonal range, everything—including the very light or dark areas—will reproduce in an acceptable manner.

Remember, the autoexposure lock is coupled with the autofocus lock, which means that whatever subject you lock the camera's focused distance on will also be what establishes the exposure. If you activate the AE lock on a nearby subject when you actually intend to photograph a distant subject, the exposure may be correct, but the image will be out of focus.

Spot Meter—When a scene or subject has an exceptionally wide tonal range, from pure white to pure black, it has *high contrast*. This is where a spot-metering capability, available at the time of writing on the *Olympus Infinity SuperZoom 300* and the *Olympus Infinity Zoom 200,* is useful. It enables you to meter a small portion of the scene so you can make sure the camera bases its exposure on the most important part of the subject.

Neutral-Density (ND) Filters—If your camera lacks the other exposure-compensation methods discussed in this section, *neutral-density* filters can be used for effective exposure compensation. These can be purchased in density increments of 1/3 step, ranging from 1/3 step to 4 or more steps. They can be used to reduce the amount of light entering the camera's lens or meter sensor.

To give *more* exposure than the camera normally would, place an ND filter of the appropriate density over the camera's *light sensor* only. This will make the meter think there's less light and thus provide more exposure. To give *less* exposure than the camera normally would, place an ND filter of the desired density over the *camera's lens,* but *not* over the light sensor. This will reduce the amount of light reaching the film and, therefore, reduce exposure.

ND filters reduce the light intensity without affecting color rendition to any noticeable extent. The only real disadvantage of ND filters is that they are somewhat expensive.

Neutral-density filters are commonly graded in density values. Each 0.3 density value doubles the density and light-withholding capacity of the filter. Thus, an ND 0.3 is the same as a 2x or 1-step light reducing filter, while an ND 0.6 is the same as a 4x or 2-step light-reducing filter, and an ND 0.9 is the same as an 8x or 3-step filter, and so on.

Manual ISO Override—Setting your camera to a higher or lower ISO speed by means of a manual film speed selector, if your camera has this feature, will also provide consistent exposure compensation. This is useful for customizing your exposures to better suit specific film types.

As indicated earlier, while the exposure system in point-and-shoot cameras is intended mainly for use with color negative print film, where good shadow detail is most important, color slide film should be exposed for best rendition of the highlight areas. For this reason, if you use color slide film in your point-and-shoot camera, it's generally best to underexpose your shots by at least a 1/2 step. By slightly underexposing slide film, colors will appear richer and burned-out highlights can be avoided.

To provide *less* exposure than the camera would normally supply, the film speed must be set to a *higher* ISO number; to give the film *more* exposure, the film speed must be set to a *lower* ISO number. The ISO speed at which the film is actually used is known as an *Exposure Index* or *EI.* To underexpose an ISO 100 color slide film by about a 1/2 step, set the ISO speed to EI 160; to underexpose by a full exposure step, set the ISO speed to EI 200.

A manual ISO override feature is also needed when you use non-DX cassettes, such as some recording films, infrared film and Kodak's ultra-fast, fine-grain T-Max P3200 black-and-white film. With the majority of autofocus point-and-shoot cameras, a non-DX film cassette will automatically cause the camera to lock its film-speed setting at ISO 100. When a camera has a manual ISO override feature, it permits you to adjust the film-speed setting for the actual speed of the film being used, within the camera's range of ISO settings.

Without exposure compensation, the white snow reproduced as a dull, unrealistic gray (upper photo). An exposure increase of + 1.5 steps helped to reproduce the snow as a crisp, bright white (lower photo). ▶

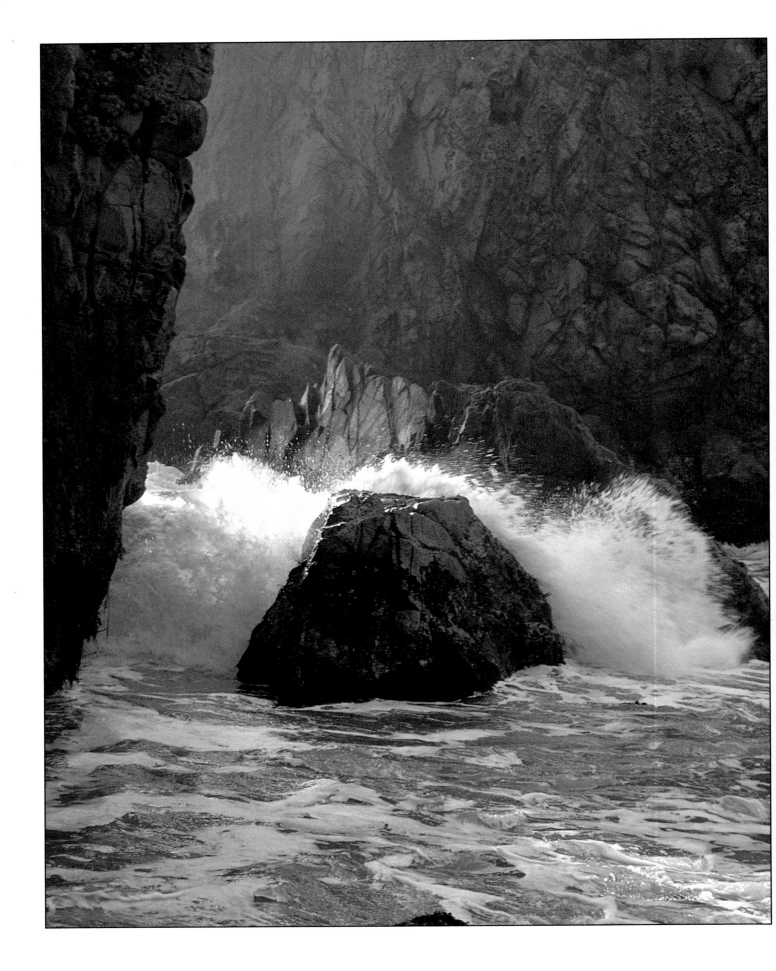

6 SHOOTING IN AVAILABLE LIGHT

The term *available light* refers to any light source that is not brought to the scene by the photographer. Daylight is the most common example, although lighting installations, both in a home and in public places, qualify as available light also. Sometimes the light itself can be the main feature of a photographic subject. A few typical examples are a sunset, sunlight filtering through a screen door or pouring through a window, or beams of sunlight in a hazy mountain landscape.

Although the built-in electronic flash of an autofocus point-and-shoot camera is a convenient and reliable source of illumination when it's necessary, it produces a flat, unnatural-looking image in which people tend to look more like cardboard cutouts than three-dimensional figures. As wonderful as on-camera flash is, and as useful as it can be, it cannot provide the magical "presence" that available light—in the form of daylight or artificial illumination—so often yields. When possible, it's advisable to shoot in available light.

An additional and important advantage of available light is that, unlike a brief burst of flash illumination, it is *continuous* illumination. This means you can view its effect on a subject before, during, and after you take the shot. With flash, you don't see the lighting effect until you get back the processed film.

LIGHT INTENSITY

The intensity of *sunlight* on a subject is dependent on the amount of atmosphere, haze or cloud that the sun has to penetrate.

The intensity of a *small, man-made light source's* illumination on a subject depends on the inherent

Essentially, "available" light is illumination that the photographer does not bring to the scene. In practical terms, it is usually daylight, although it can also consist of artificial indoor illumination, street lighting, and so on. Daylight can be very variable, providing many different effects and moods. This charming photo was taken in direct sunlight, which is appropriate for a beach scene.

brightness of the source as well as its distance from the subject. A 100-watt light bulb is inherently brighter than a 50-watt bulb. However, a 50-watt light bulb right next to a subject will illuminate the subject more brightly than will a 100-watt light bulb 10 feet away.

Generally speaking, the closer a small light source is to the subject, the brighter will be its illumination on the subject. The farther the light source is from the subject, the dimmer will be its illumination on the subject.

The law of physics known as the *Inverse Square Law* describes this phenomenon: As the distance of a small light source, such as a tungsten bulb in a relatively small reflector, increases, its intensity on the

◀ **Daylight, in its many forms, can have an ambience and impact that cannot be duplicated with artificial light sources.**

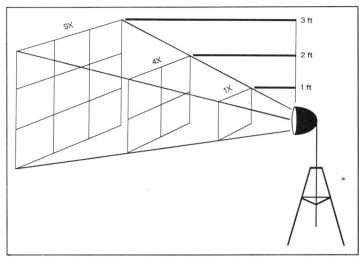

The Inverse Square Law illustrates how the light intensity of a small, man-made light source decreases as the square of its distance from a subject. Here, you can see how the intensity of light decreases as it's spread over a larger area. Notice, as explained in the text, that this law applies only to artificial light sources, but not to sunlight.

The quality of sunlight changes constantly with the position of the sun. Subjects look different as a result. Notice how the appearance of this scene changes, from early morning (top), to midday (center), to dusk (bottom).

subject decreases in inverse proportion to the square of the distance. In other words, if you double the distance between the light source and a subject, the illumination provided by that source on the subject will be reduced to 1/4 of what it was. If you triple the distance, the illumination will be reduced to 1/9 of what it was.

For the above purpose, a *small* light source is one contained in a typical reflector of a diameter no greater than about 12 to 15 inches. The inverse square law does not apply to large sources, such as windows letting in diffused daylight.

Although the inverse square law can be applied to available light that's of an artificial kind, such as tungsten light, it has virtually no application in daylight. Diffused daylight is too large a source to apply. Direct sunlight cannot qualify, either. It's true that the sun is far enough away to appear, to us, as an effectively small source. However, the sun is also at a virtually infinite distance from us. This means that every point on earth is basically at the same distance from the sun. Obviously, this would make nonsense of the inverse square law—at least to those confined to the planet we live on!

LIGHT QUALITY

The size of a light source, relative to its distance from the subject, determines the *quality* of light—whether the light is *hard* or *soft*. When the light source is large relative to the size of the subject, the lighting is soft, with subtle, graduated shadows. When the light source is small relative to the size of the subject, the lighting is hard, with harsh, distinct shadow outlines and small, bright highlights.

Remember, it's the *relative* sizes that are important. For example, although the sun is an enormous light source, much larger than the earth itself, it's so far away that, for photographic purposes, it has the effect of a small, harsh light source. A 4x6-foot studio light

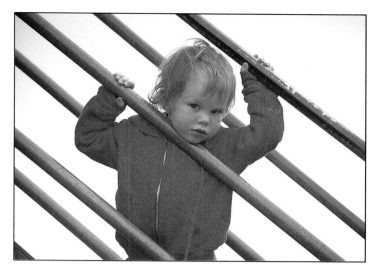

A uniformly overcast sky softens the quality of daylight through diffusion. The sky acts as a large light source, yielding soft images.

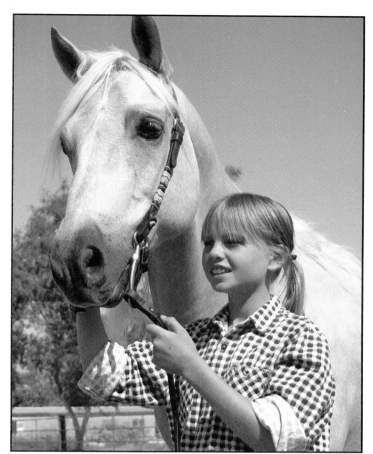

Direct sunlight, because of the distance of the sun from us, acts as an effectively small light source, creating distinct shadows, bright highlights, and good modeling of a subject's shape.

bank, on the other hand, placed three feet from a subject, acts as a relatively large and soft light source.

One way to soften the effect of a given light source is to make it larger by passing the light through a diffusing surface. This can be done by placing diffusion material, like frosted acetate or glass, between the subject and the light source. The source will, effectively, become as large as the translucent diffusion material.

This technique can be used even with sunlight. Direct sunlight, pouring through an open window, will be very hard, with a sharp distinction between light and shadow. However, sunlight filtering through a large pane of frosted glass will be much softer, as will light from an overcast sky. In fact, the most common example of diffused light is the sky on an overcast day. A uniform layer of clouds on an overcast day serves as an enormous diffusion screen, spreading the light over a large area. Dusk provides a similar situation, with the sun below the horizon line and the sky acting as a large, uniform light source.

When shooting at dusk or in overcast conditions, use a fast film, such as ISO 400, to reduce the risk of unsharp images caused by camera shake at slow shutter speeds. When using a slower film, such as ISO 100, use a tripod to ensure clear, sharp results.

LIGHT DIRECTION

Two factors determine the direction of the lighting in a photograph: the position of the light source relative to the subject and the position of the camera relative to the subject. If you don't like how a subject

When the sun is low in the sky, near the horizon—in early morning or late afternoon—its light has to pass through a thicker atmosphere layer. The atmosphere disperses much of the blue light content, so that the sunlight that reaches us at those times of the day is warmer, more reddish. This warm glow can be very pleasing in some people pictures. If "correct" color rendition is desired, it can be achieved by use of a bluish filter in the 80 or 82 series.

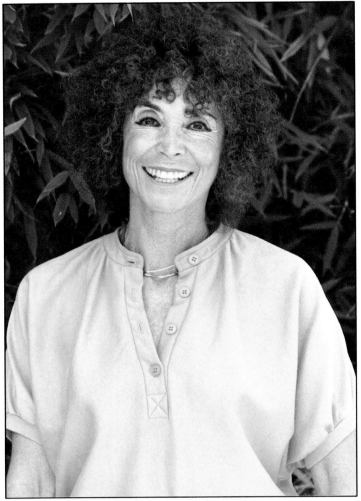

Front light occurs when the light source is in front of the subject and aimed at the subject from not much higher than eye level. It hides surface contours and texture, with only minimal shadow detail visible to the camera.

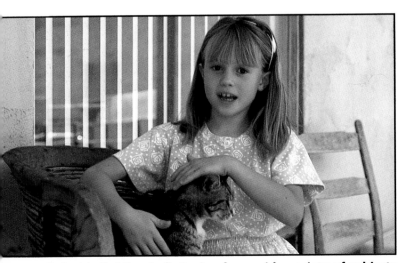

Soft side lighting is flattering for a wide variety of subjects because it creates a pleasing gradation of tonalities from light to dark as it "wraps around" the subject. As a result, it accentuates form, dimension, and texture.

appears in respect to a fixed light source that you can't move, such as the sun, you can move the subject so that the light will strike him or her from the desired side or angle. You can also change the position of the camera.

For example, a subject illuminated by frontal sunlight can be given better facial "modeling" by arranging for the light to come from one side. Similarly, a sidelit subject can be backlit by simply moving the camera as needed and posing the subject accordingly.

Front Light—Front lighting occurs when the main light source is in front of and *facing* the subject. When light hits a subject head-on, surface contours and texture tend to be lost and three-dimensional forms appear two-dimensional. This is because frontal light produces only minimal shadows that are visible to the camera.

The intensity of frontal sunlight causes most people to squint. Therefore, for the sake of the subject's comfort and for the quality of the expression, avoid having a subject face direct sunlight.

Shadowless front light can be flattering for subjects with a poor complexion or with less-than-perfect features. It is even better if that frontal light is relatively soft.

When shooting with front light, be careful that your own shadow doesn't accidentally appear in the shot, or worse, fall on the subject.

Side Light—In the early morning and late afternoon, when the sun is low in the sky, conditions are ideal for side lighting. This is a flattering type of lighting for a wide variety of subjects, including scenics, portraits and still lifes. Generally, side lighting creates a pleasing gradation of tonalities from light to shadow, accentuating form, dimension, and texture. When light hits a subject from the side, it seems to "wrap around" the subject, providing excellent modeling of the features.

When you shoot a side-lit portrait, a white reflector card, placed on the side of the subject opposite the light source, will supply fill light to the shadow areas without actually eliminating the shadow effect. If you don't have a handy reflector of some sort, positioning the subject next to a white or light-gray wall will serve the same purpose. Don't be tempted to use a colored wall, however, as it would tend to impart its color to the subject.

Side light in daylight implies a low sun. It's important to remember that the light from a low sun tends to be somewhat reddish. To avoid an excess of red in your photos, use a bluish filter. Filters are discussed more fully in Chapter 10.

Overhead Light—Most snapshots taken outdoors are made during the middle part of the day, when the sun is more or less *above* the subject. For better or worse, the most popular times of day to be out and about with a camera are the late morning and early afternoon. Depending on the weather conditions, light at those times can produce either very hard, contrasty effects or soft, even illumination without harsh shadows.

When the sunlight is totally diffused by a heavy overcast, the sky essentially becomes a gigantic "soft-box," or source of soft, diffused light. Such shadow-less lighting can be flattering for portraits of people. Such light also tends to be excessively bluish, so that a corrective filter may be needed. See more details on filters in Chapter 10.

On a clear day, when the sun is shining directly down upon the subject, the quality of light is very hard and contrasty. Often, this is a problem because the hard overhead light produces distinct, elongated shadows on a subject. With people, this is especially unflattering, causing eyes to recede into deep eye-socket shadows and noses and chins to cast long distracting shadows on the upper lips and necks. Even with a slight overcast, when distinct shadows are still visible, although they may be softer, the light from an overhead sun can be less than flattering.

You can artificially "lower" the light from a high sun in a couple of ways. First, you can pose the subject with the head raised toward the sun, although the subject should not be actually looking toward the sun. Or, you can have the sun above and *behind* the subject. A white or silvered reflector, placed *in front of* the subject, will illuminate the subject with soft, reflected light from a lower angle.

Backlight—When the main light source is directly *behind* the subject, very little or no light falls on the part of the subject seen by the camera. The subject will therefore appear as a dark form, or silhouette, unless appropriate exposure compensation is used.

Silhouettes can make very effective photographs, emphasizing a subject's outline rather than content

When the background is considerably brighter than the subjects in front of it, a silhouette will result if the exposure metered for the background isn't increased. Here, however, the skylight is the most important part of the subject and, therefore, no exposure compensation was called for. Increasing exposure would have resulted in a loss of the deep, dramatic color and tone in the sky. The palm trees were most effectively recorded in silhouette, anyway.

and detail. Shooting such recognizable forms as a city skyline or a row of telephone poles against a striking sunrise or sunset will often produce attractive, graphically appealing images.

When you shoot silhouettes of people, be sure to pose them appropriately. Remember that the only information the photo will convey will be outline. Therefore, you should find the "recognizable" angles from which to photograph the subject, such as the profile, in which the subject's features are clearly discernible.

If you want frontal detail in a backlit subject, give from 1.5 to 2 steps more exposure than the camera's exposure system dictates. If your camera has a spot-metering capability, you can use it to measure only the light falling on the front of the subject. This way, the camera's exposure will be based on the subject, and not on the bright background. For more on exposure compensation, see Chapter 5.

Backlighting can also be used to create a *rim light,* or

halo effect, on a subject. This type of lighting is often used in studio portraiture and fashion photography— *in addition* to the normal main and fill lights—to add sparkle to a subject's hair or to clearly outline a subject against a darker background.

Rim lighting can also be used to create subtle, yet dramatic effects on other natural subjects, whereby a bright rim around a dark form defines the subject's shape. A horse's mane, or a fringe of fine needles on a cactus, are just a couple of examples of the types of subjects that can be enhanced by rim lighting.

When shooting with back light or rim light, be sure that the light from the sun or other source being used is not permitted to strike the lens directly, as this would cause undesirable flare in your images.

OTHER SOURCES OF AVAILABLE LIGHT

While the sun is the primary source of *natural* light, it is not the sole source of "available" light. Tungsten, fluorescent and other artificial-light installations are

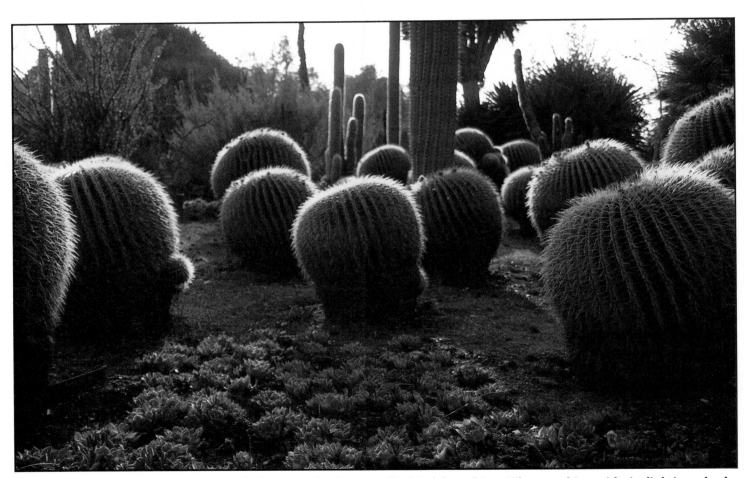

Rim lighting occurs when the dominant light source is above and behind the subject. When working with rim lighting, shade the lens from direct illumination by the source, to prevent glare from spoiling the image. By shielding the lens, you may also cut off the viewfinder's line of sight. However, with a little care, you may be able to shield the lens without such a cutoff. It may be easier to do this if you mount your camera on a tripod. Make sure your fingers, or whatever form of light shield you're using, won't appear in the shot. **Photo by Mark Kaproff.**

also sources of available light. It's important to be aware that different light sources will appear differently on color film, depending on the light's *color characteristics*.

COLOR OF LIGHT

Our eyes can readily adapt to the color characteristics of any light source. For example, while a tungsten bulb produces light which is considerably more red than daylight, a white sheet of paper will look white to our eyes under both kinds of illumination. Color film, however, will not adapt to color differences from one light source to another. Thus, the *white* paper in *tungsten* light will have a *yellowish* appearance when reproduced on *daylight-balanced* color film.

For this reason, color films are made balanced to a specific light source. A daylight film should be used in daylight and a tungsten-balanced film in tungsten light. Color print films are generally balanced for daylight. For best results in tungsten light with these films, a blue filter in the 80-series is recommended.

Color Temperature—The color of a light source is stated as its color temperature in degrees Kelvin (K). At higher color temperatures, light appears more bluish, like skylight, which has a color temperature of about 10,000 K. At lower color temperatures, light appears more reddish, like tungsten light, which has a color temperature ranging from about 2700 K to about 3400 K. The standard color temperature of daylight—a mixture of sunlight and blue light from the sky—is about 5500 K.

Mixed Light Sources—Indoor lighting often consists of a mixture of different light sources. A single room may have a mixture of tungsten, fluorescent and daylight illumination. If you use daylight-balanced film in such a situation, the tungsten and fluorescent

When daylight-balanced color film is shot in tungsten lighting, the results will appear too yellowish or reddish (left). An 80A blue color conversion filter, placed over the lens and light sensor, will correct this imbalance (right).

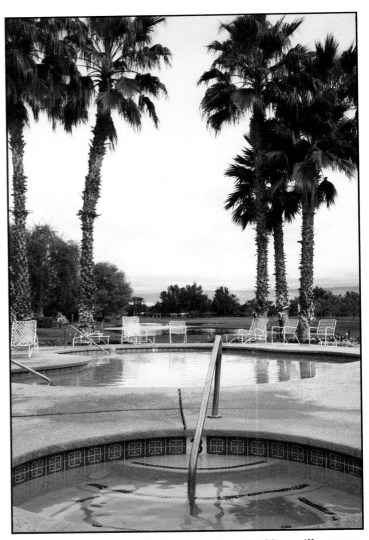

When shooting tungsten film in daylight, the photo will have an overall bluish color cast (left). An amber 85B filter will remove this imbalance (right). Notice the difference in the color of the palm-tree stems and the pool deck in the two photos.

lights will cause a specific color imbalance in the portions of the image that they illuminate.

When you're shooting exclusively in tungsten room light, you can use tungsten-balanced film which will record the tungsten light normally, without color imbalance. If you shoot regularly both indoors and outside, you're better off using daylight-balanced film and employing the necessary corrective filters, or having your color lab correct for color shifts in the printing process.

Blue color conversion filters in the 80 series will balance tungsten light for use with daylight film. Amber filters in the 85 series will correct the color of daylight for tungsten-balanced film.

A special FL-D filter, which has a magenta color, will balance some types of fluorescent lighting for daylight-balanced film. Alternatively, you can opt for Fuji Reala film, which has a special, additional emulsion layer designed to correct the imbalances normally caused by fluorescent light sources.

Generally, it's best to avoid shooting in mixed lighting conditions because it's impossible to correct for every source of light. However, if it's unavoidable that you shoot in such conditions, use a film or filter to balance the most prominent, main-light source illuminating the subject.

For more on filtration, see Chapter 10.

Deliberate Color Imbalance—Sometimes the

To record this tungsten-lit scene, daylight-balanced film was deliberately used without a correction filter. The result is a photo of a warm, cozy looking scene. Photo by Mark Kaproff.

"wrong" color of light source can actually enhance a subject, in which case you wouldn't want to correct for it. Tungsten light, for example, can make a room appear warm and cozy, when shot on daylight-balanced film. Always visualize in your mind how you want a specific image to look prior to taking the shot, so that you can better achieve the kinds of results you desire.

WORKING EFFECTIVELY WITH AVAILABLE LIGHT

To work most effectively with available light, it's important to be able to visualize light the way film records light. Although you might not be able to discern subtle color shifts, you can train your eyes to see the subtle tonalities that light creates as it interacts with subjects and scenes.

Subject Contrast—One effective way to view highlight and shadow areas in a scene as film sees them is to squint your eyes. This enables you to observe whether the quality of light is contrasty or soft. When you squint your eyes, the image contrast that you see will most closely approximate that which will appear on film.

Avoid Spotty Shadows—Be careful when shooting in the shade of a tree. While trees basically block out light, the open areas between branches and leaves permit light to come through. This can make an image appear spotty and untidy. Unless you specifically want a spotty effect, try to position your subjects in the shade of a solid structure or surface, so that unwanted light doesn't enter the scene and produce unbecoming effects as a result.

The Light Should Flatter The Subject—The direction and quality of the light will determine how the subject will appear in the photograph. If you aren't completely satisfied with the lighting, try moving the subject, if possible, or altering your camera position.

Positioning a subject near a white reflective surface will cause light to be bounced back onto the subject, softening shadows and eliminating the need for on-camera flash. There was a white wall to the right side of the camera, reflecting light into the deep shadows on the left side of the subject's face.

Exposure compensation and filters can help to make an existing situation more suitable to a specific subject as well. (See Chapter 5 for Exposure Compensation and Chapter 10 for Filtration.)

To produce a truly successful photograph, the lighting should enhance the scene and flatter the subject.

Color Imbalance Through Reflection—Reflected light tends to be of the same color as the surface from which it is reflected. When using color film, be sure your subject isn't positioned too close to a colored reflective surface. For example, a subject close to a green wall or green foliage is likely to appear in the photograph with a distinct green color cast. You can create some interesting special effects with deliberate color reflections, but a face with a greenish complexion is never an appealing sight.

Consider *all* the light in a scene, including reflected light, before you take a picture. For example, areas that are lit only by blue skylight will tend to photograph bluish. To "warm up" the image and reduce the amount of blue in such a scene, you can use an amber filter in the 85 or 81 series.

Some types of colored reflections can produce unique and eye-catching results. To purposely achieve such an effect, position your subject as close as possible to a shiny, reflective colored surface, so that the camera will clearly pick up the color reflected onto the subject. In the shot on the left, the color rendition is uniform on both sides of the subject's face. For the photo on the right, the subject was placed close to a bright-red reflecting surface. Notice the red glow that has been introduced to the one side of the face.

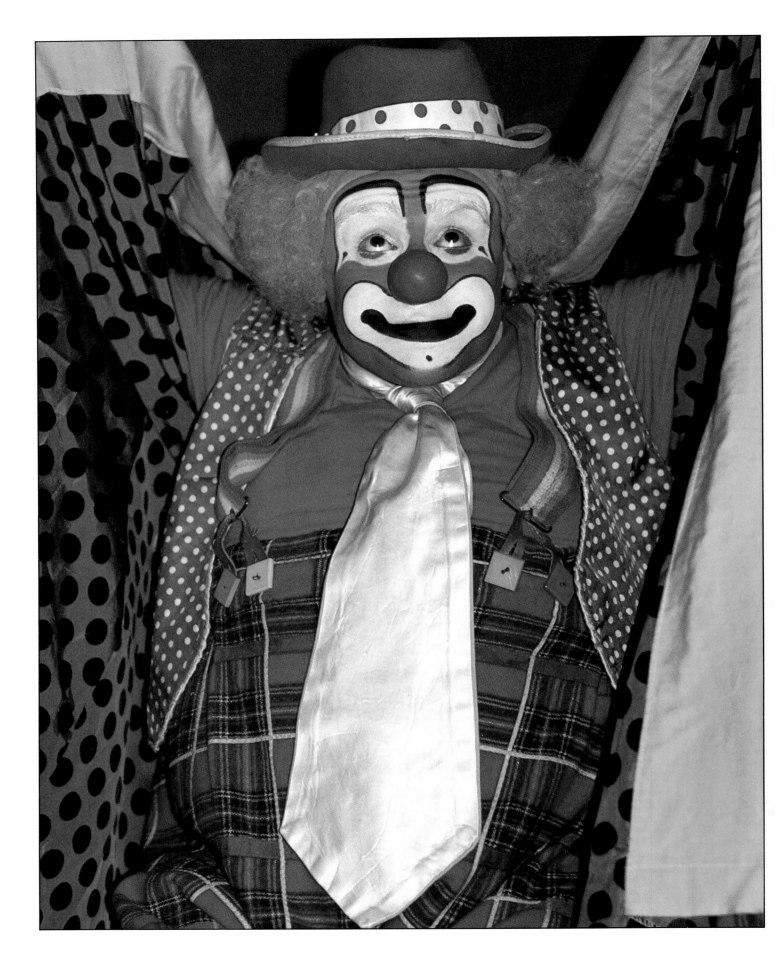

ELECTRONIC FLASH

Virtually every autofocus camera on the market today comes equipped with a built-in electronic flash unit. This is a convenient source of light that you can never forget to bring along, and which is as simple to use as the camera itself.

In its automatic mode, the flash is programmed to charge and fire whenever it's needed, while the camera supplies accurate exposure. When used properly, these flash units can be used for creative as well as practical purposes. However, they do have their limitations. This chapter will tell you how to use your built-in electronic flash correctly and effectively to produce quality results every time.

FLASH BASICS

Electronic flash produces a brief but bright burst of light by the application of a high-voltage electric current to xenon gas contained in the flash tube. The flash lasts 1/500 second or less. Unlike the old-fashioned flashbulb, which was good for only one shot, an electronic flash unit can be fired thousands of times, making it efficient, economical, highly portable, as well as easy to use.

To achieve desirable results with your camera's built-in flash, it's useful to understand the basic principles by which it works.

POWER OUTPUT

The power output of a flash is usually expressed in

The majority of compact cameras have a fixed flash unit that is always ready and waiting.

◄ **On-camera flash is ideal for taking many types of candid, spontaneous photographs. Although the "modeling" in a subject is not brought out to best advantage with flat, frontal light, the ease and portability of such a setup for fast shooting often outweighs all other considerations. The photo reproduced here represents a truly ideal subject for on-camera flash because the success and effectiveness of the image is almost entirely dependent on the lively colors, and barely at all on subject form and contours.**

terms of a range of shooting distances. A typical range, with ISO 100 film, is 3 to 13 feet. The more powerful the flash unit, the farther its reach and the farther from a subject it can be used.

Guide Numbers—Some camera instruction manuals express the power of the built-in flash unit in terms of a *guide number*. This is the product of the

Some cameras, such as this Ricoh FF-7, have a pop-up flash unit that must be popped up before it can be fired.

distance and the *f*-number that will produce a proper exposure when the flash is used as the primary source of lighting. By dividing the flash-to-subject distance into the flash unit's guide number, you can determine the aperture necessary for an accurate exposure. For example, a guide number of 40 (feet) indicates that the flash unit will properly expose a subject 10 feet away when the lens is set at *f*-4.

As you can't actually set the aperture of a compact camera, guide numbers are not frequently used in reference to the built in flash. However, guide numbers can be useful for comparative purposes. A higher guide number means a greater usable flash distance range, assuming the cameras being compared have lenses of identical maximum aperture.

When you compare guide numbers, be sure they are given in the same units, since a guide number in feet will be 3.3 times greater than a guide number given in meters. Also, make sure all guide numbers being compared are for the same film speed. A guide number for ISO 400 film will be twice as large as a guide number for ISO 100 film for the same flash unit.

RECYCLE TIME

Another number you must be aware of is the flash unit's recycle time. This is the time it takes the flash unit to recharge after it's been fired. Recycle times for flash units built into autofocus compact cameras generally range from two to six seconds. The quicker the flash recycles, the better, because you can take flash photos in more rapid succession.

Generally, cameras that use lithium batteries, which are more efficient than the conventional alkaline-manganese type, can provide the shortest flash recycling times.

FLASH RANGE

Whenever you use your camera's built-in flash, it's important to know the maximum distance the flash illumination can reach. This way, you won't waste your time flash-exposing subjects that are beyond the flash unit's range.

Lens Aperture—One factor that affects the flash range is the maximum aperture of the camera lens. The larger the maximum aperture, the greater the flash range will be, since more light is able to reach the film. With dual-lens or zoom-lens cameras, the flash range is usually greater at the shorter focal lengths because such focal lengths employ wider maximum apertures.

Film Speed—The speed of the film being used also affects the flash range. The faster the film, the greater the flash range will be, since fast films require less light for proper exposure than slower films. For example, by switching from ISO 100 film to ISO 400 film, you can double the effective reach of the flash output.

However, no matter how fast your film is, no compact camera's built-in flash is powerful enough to reach a subject that's more than 25 or 30 feet away. Therefore, if you're shooting a night baseball or football game from the third deck of the grandstands, don't expect your camera's built-in flash to illuminate anything more than the heads of the spectators in front of you. In such a situation, you're better off deactivating the flash, if your camera permits that.

FLASH DURATION

Although not usually listed for the built-in flash units of autofocus point-and-shoot cameras, *flash duration* is a pertinent factor, too. This refers to the amount of time the flash lasts, which is usually 1/500

to 1/1000 second. This short duration makes electronic flash ideal for "freezing" images of fast-moving subjects on film—provided they are within the flash unit's shooting range.

Electronic flash is also ideal for close-up photography, as its brief duration minimizes the effects of camera and subject movement. Furthermore, the brightness of the flash enables smaller apertures to be selected, which in turn provides greater depth of field.

Rather than varying the flash duration according to the flash-to-subject distance for correct exposure, many built-in flash units employ what's known as a *flashmatic* system, in which the aperture is coupled to the autofocus system. The flash always emits a full-duration, full-power flash, while the lens aperture automatically changes to provide correct exposure at any given flash-to-subject distance within the flash unit's range.

ANGLE OF COVERAGE

The angle of coverage refers to how wide a field of view the flash actually covers. Usually, a built-in flash unit's angle of coverage is sufficient to accommodate the angle of view of the camera's built-in lens.

Dual-lens and zoom-lens cameras often have flash units with adjustable reflectors that automatically shift with the lens focal length to provide adequate flash coverage. However, with some cameras there will be some light fall-off with wide-angle focal lengths, producing noticeably dark edges or corners in flash photos.

AUTOMATIC FLASH

In its normal automatic mode, the camera's built-in flash will fire when needed—in dim light and in backlighting. How does the camera know when flash is needed? Its built-in exposure computer is programmed to fire the flash when the light drops below a specific level. Although this level varies slightly with different camera models, it's generally a level that requires a shutter speed of 1/30 second or slower—the slowest shutter speed recommended for shooting with the camera handheld.

With some cameras, if the built-in exposure computer determines that the central subject is more than one exposure step dimmer than the background, the camera will fire the flash, too.

When shooting in the autoflash mode, all you really have to pay attention to are the flash indicators, which are located either in or near the camera's viewfinder. These let you know, by means of symbols or

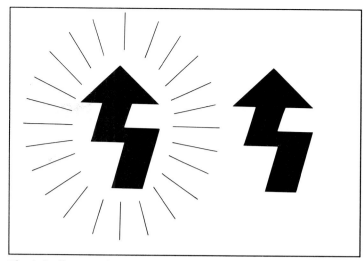

Flash indicators in or near the viewfinder will let you know when the flash is recharging and when it is ready to be fired. When the symbol blinks intermittently (left), the flash is in the process of recharging for the next shot and cannot yet be fired. When the symbol glows steadily (right), the flash is ready to be fired.

LEDs, when the flash has recycled and if the subject is within the proper flash range. These indicators vary slightly from camera to camera, so it's always a good idea to refer to the camera manual and become familiar with your own camera's indicators prior to shooting. Usually, a symbol glows to let you know that flash is needed to take the shot, and blinks while the flash is recycling. A green LED will usually blink when your subject is too close for proper flash exposure.

Other than keeping an eye on these little indicators, you can just point the camera and shoot, and the flash will function automatically to produce properly exposed results.

FILL FLASH

Many cameras offer a *fill-flash* or *daylight-sync* mode that enables the flash to fire regardless of the light level. This is useful when the lighting on the subject is harsh, producing deep shadows that are less than flattering. Ideally, the flash will lighten the shadows for a more pleasant-looking image without overpowering the shadows altogether.

The simplest way to achieve natural-looking effects with built-in flash is to combine the fill-flash mode with available light from a specific angle. You can use sunlight as the main light source, with the flash supplying minimal supplemental light. This way, you can produce properly exposed images that lack the flat, on-camera flash look.

In harsh, overhead lighting, shadows are created that can often be less than flattering (left). Fill flash can soften such shadows, to produce a more attractive image (right).

Fill flash also comes in handy for backlit subjects, which would otherwise appear too dark in the photograph. Since the exposure-metering system in cameras is affected by the *overall* illumination of a scene, the camera would give an exposure appropriate to the brightness of the *surroundings,* resulting in an *underexposed subject.* Utilizing fill-flash ensures a properly exposed subject against a background that's also properly exposed.

If the camera has a "B" setting, or long exposure capability, along with a fill-flash mode, you can create some exciting motion shots by combining a long existing-light exposure with a brief flash exposure. When photographing a moving subject in moderate to dim ambient light, the flash will freeze a sharp image of the subject while the long existing-light exposure will record a blurred motion image.

To ensure sharp results when employing a slow shutter speed, the use of a tripod is essential. Cameras that offer shutter speeds slower than 1/30 second almost always feature a tripod socket.

If, according to your personal taste, the flash on your camera overpowers the main light, yielding shadows that are too weak or virtually invisible, you may need to use a neutral-density (ND) filter over the flash unit. It's advisable to make some test shots with your camera and flash, to see how your camera handles such a situation. Start with a 1-step ND filter and examine the results. If necessary, change to a filter of a different strength.

SLOW-SYNCHRO FLASH

Some cameras offer a slow-synchro flash mode, which automatically provides the same effect as combining fill flash with a slow shutter speed. When photographing a subject outdoors at night, in front of

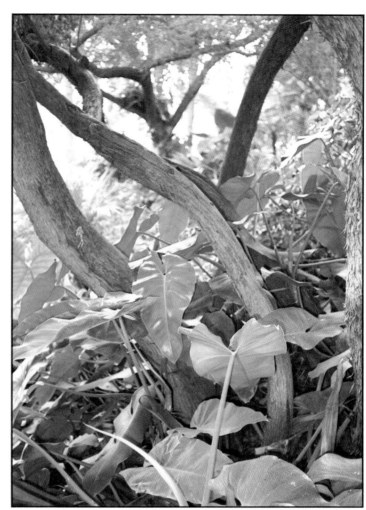

Fill flash can be used creatively to enhance an existing-light situation. The left photo was made without flash. For the photo on the right, flash was used to augment the foreground lighting, thus calling more attention to the tree trunks and leaves, without burning out the bright background with an excessively long exposure time.

colorful city lights, for example, the flash will properly expose subjects that are nearby, such as people. The long exposure will record the existing light in the background. This technique works equally well indoors in dimly lit conditions.

Again, always use a tripod when working with slow-synchro flash, to avoid unsharp images due to camera shake.

FLASH-OFF MODE

Many autofocus compact cameras offer a flash-off mode, enabling you to turn the flash off so it won't fire, regardless of the light level. This is useful when you're shooting at stage shows or in museums, where flash isn't permitted. It's also handy when you want to shoot night and low-light scenes by existing light only, for more natural-looking results.

If a particular scene calls for flash, but you choose to ignore the camera's indication and turn off the automatic flash capability, it's a good idea to use a tripod, as the camera's shutter-speed setting will probably be too slow to produce sharp results with the camera handheld.

OFF-CAMERA FLASH

The camera's built-in flash is essential in many situations, from complete darkness to harsh noon sunlight, in that it enables you to capture images that otherwise would appear underexposed or too contrasty. Flash can also eliminate color shifts caused by different colors of light.

Unlike natural lighting, which usually comes from above or to the side of a subject in the form of sunlight, skylight, or man-made light fixtures, a built-in flash

Slow-Synchro flash combines flash with a slow shutter speed, so that you can expose a foreground subject normally with flash while a long exposure time records the existing illumination in the background. Here, the flash illuminated the green leaves, which otherwise would have been in silhouette. In this kind of situation, always use a tripod, to prevent blurred results due to camera shake.

unit provides but one type of lighting—frontal and flat. Such lighting minimizes subject texture and form, whereas side lighting provides modeling on a subject, accentuating form and texture. For better or worse, subjects lit with built-in electronic flash will usually have a flat, two-dimensional appearance.

The solution to this problem is the use of off-camera flash, as described next.

SEPARATE SLAVED FLASH

For the off-camera flash technique, you need a second flash unit, more powerful than the camera's built-in unit, and a slave trigger. The slave trigger is a device that fires the separate flash automatically when it "sees" the burst of light from the camera's built-in flash.

You can position the slaved unit wherever you wish, as long as its slave sensor can "see" the flash from the camera. You can mount the slaved unit on a light stand or have a friend hold it for you. You can even hold it yourself, at arm's length from the camera.

The Morris Mini Slave Flash is a compact, inexpensive, slave-triggered flash that fires automatically when it "sees" the burst of light from your camera's built-in flash. With a guide number of 33 (feet) with ISO 100 film, the Mini Slave is more powerful than the camera's built-in unit, and can therefore cover a greater distance. It can also be used for creative applications. Two AAA-size alkaline or nicad batteries are required.

The automatic exposure system of your camera ensures proper exposure with the on-camera flash. If you take a portrait at a distance of 6 feet, and your camera's built-in flash has a guide number of 34 (feet), the *flashmatic* system will set the lens aperture on your camera automatically to *f*-5.6. (Guide numbers were discussed earlier in this chapter.)

Separate, slaved flash units are generally more powerful than a camera's built-in flash. If you shoot the portrait mentioned above with a slaved unit, the camera's *flashmatic* system will still set an aperture of *f*-5.6. If the slaved unit is four times as powerful as the built-in flash, and positioned at the same distance from the subject, the subject will be overexposed by 2 steps.

Balancing Slaved and On-Camera Flash—You can correct this error by placing a 2-step ND filter on the camera lens. Not only will this correct the main-light exposure from the slaved flash, but it will also reduce the effect of the built-in flash, making it, in effect, a fill flash.

If you don't want to invest in a neutral-density filter, you could simply place the slaved flash farther from the subject. Being four times as powerful as the built-in flash, the slaved unit will give correct exposure at twice the distance from the subject, which is 12 feet.

The problem with the above arrangement is that the slave flash and the built-in flash will now give the same exposure, eliminating tne benefit of the fill-flash effect. To retain the fill-flash effect, place the slaved unit about 8 feet from the camera. This will give you approximately a 2:1 light ratio between the main light and the on-camera fill. Of course, the film will now be overexposed by about 1 step. With color print film, this should present no problem. With slide

Built-in flash can only provide frontal lighting. Photos lit in this way will reveal little modeling and surface detail (left). A separate flash unit, with a built-in slave trigger, is designed to fire automatically whenever the camera's built-in flash is fired, providing side lighting, for better modeling of form and texture (right).

film, however, you would certainly be well advised to use the neutral density filter method instead and get accurate exposure.

The guide number for each slaved flash unit is indicated in the unit's instruction manual. Point-and-shoot camera manuals rarely publish guide numbers. However, you can easily calculate it. Multiply the maximum aperture of the lens by the usable flash distance. For example, a camera with an *f*-3.5 lens and a maximum flash range of 10 feet, with ISO 100 film, has a flash guide number of 35 (feet), with ISO 100 film.

You may not care to do all this calculating. After all, the reason you bought a point-and-shoot camera was to get good pictures without a lot of hassle. In that case, I would advise you to enjoy your photography and not make hard work of it. Simply place your slaved flash at different distances, make notes, and compare results when you get your photos back from the processing lab. You'll then be able to repeat the results you like best at any time in the future.

The Nikon Tele-Touch 300 offers a novel red-eye-reduction mode. The built-in flash fires twice. The first flash, about one-third as bright as the actual picture-taking flash, occurs before the exposure is made. Its function is to close down the pupils of the subjects' eyes. When this has been achieved, the second flash fires to make the exposure.

HOW TO AVOID
THE RED-EYE EFFECT

One distinct disadvantage of on-camera flash is *red-eye*—those distracting red spots that appear in the pupils of a subject's eyes. Red-eye is caused by the flash being very close to the camera lens. The red is caused by the reflection of the retina in the back of the eye.

Besides moving the flash farther from the lens—which is normally impossible with built-in flash—one way to minimize this unpleasant effect is to increase the overall illumination level, causing the subject's pupils to close down, thus eliminating most of the red reflection from the retinas. Obviously, it also helps to have the subject look somewhere other than in the direction of the camera.

In a few camera models, interesting measures have been taken to reduce this annoying side-effect of on-camera flash. The *Nikon Tele-Touch 300*, for example, emits a brief flash at reduced power before the exposure begins. This causes the pupils of the subject's eyes to close somewhat before the exposure. The *Olympus Infinity Zoom 200* emits 15 low-powered flashes prior to exposure. The *Minolta Freedom Zoom 90*, on the other hand, raises its flash head at the telephoto focal lengths, generally used for close head shots, so that the flash will not be as close to the lens as it otherwise would be.

One disadvantage of on-camera flash can be a phenomenon called "red-eye." The close proximity of the flash to the camera lens causes bright reflections from the red retinas inside the eyes to be directed straight back to the camera lens—and onto the film. The best way to eliminate red-eye is to move the flash farther from the lens. Of course, this is not possible with a fixed, built-in flash unit. An effective way of minimizing red-eye in such circumstances is to increase the ambient-light level so the pupils of your subjects' eyes are as "closed down" as possible. The photo above was made with window light behind the subjects but relatively little ambient light in front. The red-eye effect in the dilated eyes is very evident. For the photo to the left, the subjects were positioned to face a window. Because the irises of the eyes were now "stopped down" to a small diameter, red-eye has been virtually eliminated. Another obvious way to eliminate red-eye—when it fits in with the kind of photo you want to take—is to have your subjects not look in the direction of the camera.

8
HOW TO TAKE GOOD PICTURES

Although operating an autofocus point-and-shoot camera is as effortless as pressing a button, taking *good* pictures results from thoughtfulness, skill and practice. By employing proper technique and a creative approach, you can achieve impressive, satisfying results.

Before you begin using your camera, read the camera's instruction manual. Become familiar with the lens, built-in flash, AF windows and light sensor. These components must remain unobstructed at all times. Also, since you do not view the subject through the camera lens, you should be sure that such things as camera straps, fingers and hair never obstruct the view of the camera lens.

Good photography begins with proper handling and operation of the camera. Autofocus point-and-shoot cameras are compact and lightweight enough to be handled casually. This can lead to careless shooting techniques. To avoid these risks, get in the habit of holding and operating the camera correctly.

HOLD THE CAMERA STEADY

In addition to holding the camera *correctly,* it's essential to hold the camera *steady* when you're shooting. The steadier the camera, the sharper and more accurately framed the picture will be. As you have no way of knowing what shutter speed the camera is using, you should always make a point of keeping the camera as stable as possible to prevent camera shake from causing unsharp images with slow shutter speeds.

Use Both Hands—No matter how lightweight your camera is, never rely on one hand to hold the camera steady. After all, the lighter the camera is, the easier it is for you to unknowingly jar it as you press the shutter button. Always use both hands, with a firm grip, to support the camera.

Maintain Balance—Let the camera rest against your face and assume a comfortable and stable stance. For best results, keep your knees slightly bent, your legs slightly apart, and your elbows close to your body.

Additional Support—Whenever possible, try to use additional means of supporting the camera, especially when shooting dim-light interior or evening shots, when the camera is most likely to employ its slower shutter speeds.

When shooting indoors, a wall, table or mantelpiece can provide the camera support you need. Outdoors, objects such as a tree trunk, fence railing or ledge can come in handy. If you do a lot of low-light photography, a sturdy tripod is definitely a worthwhile investment.

Pressing the Shutter Button—Pressing the shutter button abruptly or too hard is a common cause of camera shake. To avoid producing fuzzy or crooked photographs due to jarring the camera at the moment of exposure, practice "squeezing" the shutter button gently, easing down on it gradually so that the camera remains motionless during the exposure.

CHOOSING A FORMAT

Only that which is contained within the viewfinder's frame lines will appear on film. Before making an exposure, you should first consider what *format*—horizontal or vertical—will best suit the subject you

◀ **Emphasizing the texture of a subject gives an image a more "tactile" quality. Texture can be brought out in several ways. One is the use of contrasty side lighting. Another, as shown here, is the contrasting of one texture against another. The smooth, silky coat of the young bull is enhanced by the coarse texture of the hay.**

Always use both hands to hold the camera steady. Maintain balance by assuming a comfortable and stable stance, with your elbows close to your body. Make sure you don't obstruct the lens with your finger in the manner shown in the photo on the right. Also avoid obstruction of the flash, the autofocus windows and the light sensor.

intend to shoot. The camera's normal horizontal orientation makes it easy to get into a horizontal-format rut. Therefore, you should make a deliberate effort to view subjects with a possible vertical format in mind, too. Often, a change in format can give a whole new quality and meaning to a photograph.

Horizontal Format—The horizontal format conveys a feeling of expansiveness, in which a scene's breadth is emphasized over its height. Subjects most suited to the horizontal format include panoramas, scenics and groups of people. A horizontal format is also well-suited for action photography in which subjects are moving across the frame.

Vertical Format—The vertical format conveys a feeling of height. It is frequently the appropriate choice for portraiture, architecture, and such sporting events as diving or pole vaulting, in which the subjects are moving in a vertical direction. Any time you want to accentuate a slender subject or a narrow scene, employ a vertical format.

Vertical Format and Flash—When holding the camera vertically to take flash pictures of people, be sure to hold the camera so that the flash head is *above* the lens. If the flash were *below* the lens, the illumination might look unnatural and produce unflattering results.

LENS FOCAL LENGTH

If you have a dual-lens or zoom-lens camera, you can choose a focal-length setting that will best suit the subject or scene you intend to photograph.

Wide-Angle—The standard lens on autofocus compact cameras is a wide-angle lens. It can be anything from a 32mm to a 40mm lens, although most cameras have a 35mm lens. The wide angle of view of the short lens records more of a scene at any given camera-to-subject distance than would a standard 50mm lens of an SLR and is, therefore, appropriate whenever you want a photograph to convey depth or expansiveness.

If you want to shoot a close-up portrait using a wide-angle lens, don't be tempted to come too close to the subject. To avoid unflattering facial distortion, it's best to shoot from no closer than about five feet. Although the resulting image may contain more of the subject than you desire, you can have your photo lab crop the image to your specifications, so that the printed enlargement will show only the subject's head and shoulders.

Keep in mind that a slow, fine-grained film will yield the best image quality in enlargements. If you use a fast film, image sharpness may be less than optimum because of the inherent coarse grain of the film.

Standard Focal Length—A 50mm focal length will, in most situations, give a photo with the most *normal* subject perspective. If your camera features this *standard* focal length, you're equipped to shoot a wide variety of subjects, from scenics to portraits, with minimal perspective distortion.

Telephoto—A telephoto focal length of 60mm and longer does just the opposite of a wide-angle setting: it

The horizontal format is effective for conveying spaciousness in scenic views. It is also a good choice for action shots of subjects moving in a horizontal direction.

Changing the camera's format from vertical to horizontal will alter the appearance, and therefore the effect, of an image, even though the subject remains the same.

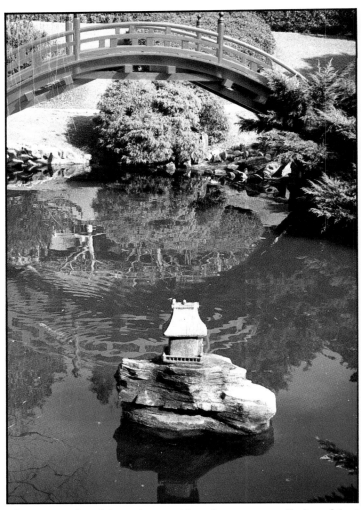

A camera's wide-angle focal length, usually in the region of 32mm to 40mm, is the best choice for conveying the depth or expansiveness of a scene.

The 50mm focal length provides the most realistic subject perspective. The scene's depth seems neither elongated nor compressed. The 50mm focal length is well suited to a wide variety of subjects.

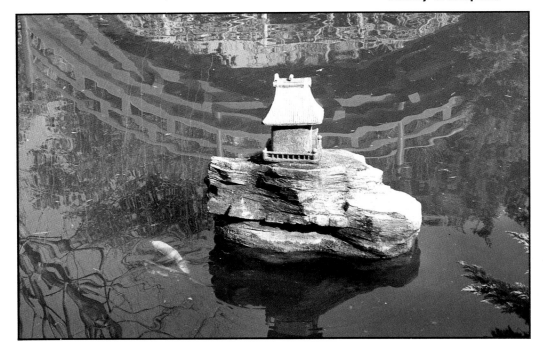

Telephoto focal lengths, ranging from 60mm upwards, crop in on distant subjects, making them appear closer than they actually are, and larger in the image frame. This focal length is useful when you can't get as close to your subject as you would like.

makes objects at different distances from the camera appear closer together than they actually are.

The telephoto setting is particularly flattering in portraiture. You can shoot from a distance that's comfortable for the subject and that does not cause undesirable distortion of facial features. In addition, the reduced depth of field, due to the longer focal length, enables you to record an otherwise distracting background as a less distinguishable blur.

A telephoto setting is also useful for getting a larger image of a subject you can't get very close to, and for creating graphic, two-dimensional-looking images.

CHOOSING THE VIEWPOINT

The angle from which you photograph a subject determines the perspective and the relationship of subject and background to the photographer. A subject can be made to look large or small, intimate or aloof, isolated or not, simply by the use of an appropriate camera viewpoint.

Perspective refers to the appearance of three-dimensional scenes as reproduced on a two-dimensional surface, such as film or paper. In photography, perspective is established by the camera angle and the camera-to-subject distance. The focal length of the lens alone is not a factor, since changing focal length merely changes the size of the *entire* image, but not the relative size or relationship of its *parts*.

Frontal View—Most "snapshooters" tend to shoot subjects head-on from a standing position. It seems the obvious, easy and convenient way. When you record a subject head-on, the general visual effect is one of objectivity. Architectural photography often requires a direct, frontal approach to prevent vertical lines—and sometimes horizontal lines—from converging. Sometimes, people shots can be quite successful when made this way, too. However, to make your photography more exciting and creative, you should always think of the possibility of a different viewpoint.

Low Angle—Dramatic results can often be achieved by photographing a subject from a low point of view. Such a view will enhance a subject's height or stature, and will usually convey a sense of respect, dignity and strength about the subject.

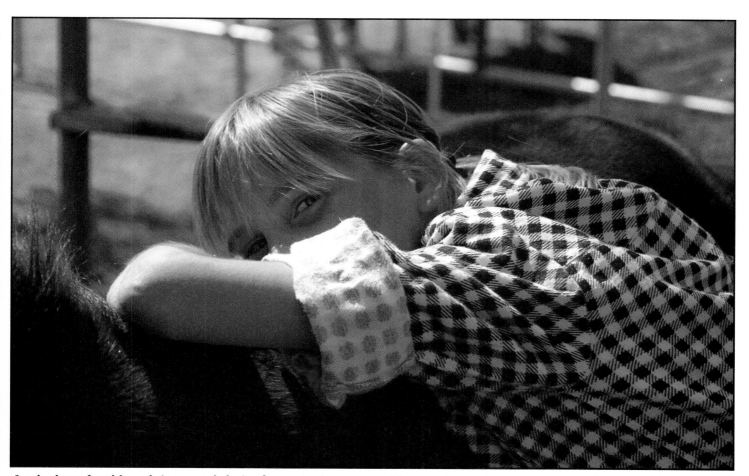

A telephoto focal length is a good choice for portraiture. It enables you to get far enough away from a subject to avoid unflattering distortion of features and limbs. It also gives limited depth of field, providing a soft, unobtrusive background.

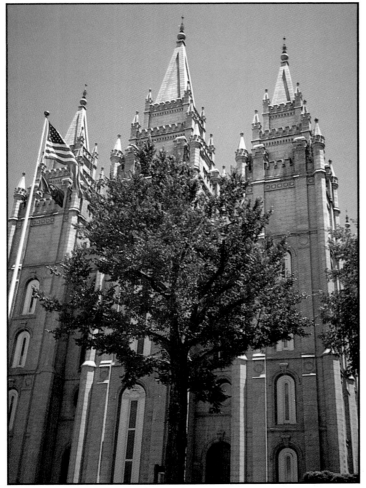

When the camera lens is tilted upward, vertical lines will converge toward the top. Such a low-angle perspective is ideal for emphasizing a structure's height. For this photo, a normal standing position, with the camera tilted slightly upward, was all that was necessary to create converging lines and a feeling of height.

With large subjects, such as buildings or statues, you can easily establish a low angle by moving close to the subject and pointing the camera upward. With small subjects, you might have to kneel, or even lie down, in order to achieve the necessary upward view.

When you shoot upward from a low angle, vertical lines will appear to converge toward the top of the image.

High Angle—Photographing a subject from a high angle, looking down, creates just the opposite effect of a low-angle perspective in that vertical lines will appear to converge toward the bottom of the image. Depending on the nature of the subject, the precise viewpoint, and the background, the subject's height may appear emphasized or diminished. Subjects shot from directly overhead will often yield a two-dimensional, graphic image, consisting primarily of shape and pattern.

COMPOSITION

Although the term "point-and-shoot" suggests quick and easy picture taking, successful photographs are made when you give some thought to image *composition*. This is the proper *arrangement* of elements contained in the image frame, including the subject itself, the background, the foreground, props, and all other visual details. How these elements interact with one another determines the overall effect of an image—whether it be static or dynamic, serene or dramatic.

The primary purpose of composition is to maintain a *balanced* image. This is the distribution of *visual weight* in an image and is usually established through balancing contrasting elements, such as light tones and dark tones, large objects and small objects, straight lines and curved lines.

BASIC ELEMENTS OF COMPOSITION

The basic building blocks of imagery are lines, shapes, colors, tones, patterns and textures. These elements of composition are inherent in all people, places and things. By themselves, these compositional tools can make for graphically appealing and visually stimulating images. As subordinate elements, they can add interest, convey a specific mood, enhance a scene or setting, and complement a subject's appearance or character.

Lines—Lines are frequently used to lead the viewer's attention in a particular direction—usually toward the subject or primary focal point. For example, a horizon line will lead the eye to a subject that interrupts its continuous path across the image plane. Often, a line that is broken up by other elements will have more tension and visual impact than a continuous line that is reassuringly, and often boringly, predictable.

Lines produce different effects in a composition, depending on their appearance and direction. For example, a curved line, like the S-curve of a winding road, is more soothing to the eye, and more sensual, than a jagged line. Often, the use of straight lines in a composition will complement the presence of a curved line to create visual tension and balance.

The weight or thickness of a line is also an important consideration. Thin lines have a more fragile and delicate quality; thick lines have a bolder and heavier presence in an image.

Depending on the angles of the lines within a composition, the overall effect will be either *static* or *dynamic*. For example, lines which are parallel to the image frame, whether they be horizontal or vertical, tend to have a static and tranquil effect while diagonal

Textures, tones, shapes and colors—all evident in this shot—are some of the major visual tools that can be combined to create images with impact.

Curved lines in a composition have a more soothing effect than do jagged or irregular lines. The winding red curb (left) is thick and dominates the scene while the hairline cracks in shattered glass (right) have a more delicate quality. The central convergence of the crack lines helps to keep the viewer's attention within the picture.

 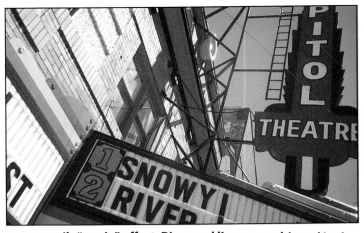

Vertical lines, as repeated in the fence and trash cans (left), have a tranquil, "static" effect. Diagonal lines, as achieved in the low-angle view of an old theater marquis (right), create a more dramatic, dynamic effect.

 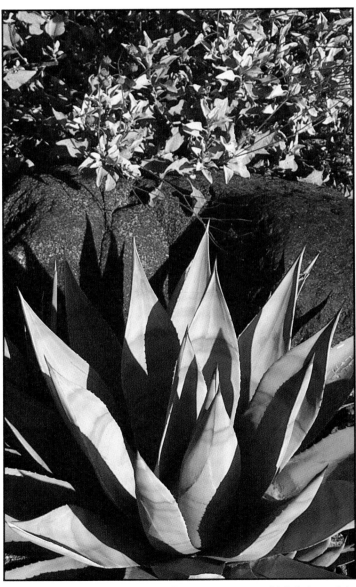

Lines that curve downward (left) often suggest a soothing, sometimes pensive, quality. Lines that point upward (right) tend to have a more positive, bold character.

or converging lines are dynamic and create a sense of motion and excitement. When static and dynamic lines are juxtaposed in a composition, the results are often more satisfying and visually stimulating.

Lines that curve or sweep downward, such as the branches of a weeping willow tree, can connote a feeling of sadness or pensiveness. Lines that lead the eye upward, on the other hand, convey a lighter, more positive feeling.

When lines occur randomly in a composition, they can produce a frenetic and energetic effect that can sometimes be disturbing and displeasing.

Remember that slightly shifting or altering your camera angle can dramatically change the direction or appearance of the lines contained in a composition.

Shapes—Shapes that are simple, bold and pleasing to the eye have instant impact in an image. For example, a silhouette of a human profile or of a city skyline at dusk attracts immediate attention. Shapes, such as circles, triangles, squares and ovals, can be very effective in generating balance, tension and direction in a composition.

Following are some brief discussions on the most common shapes and the part they play in pictorial composition.

- *Circles* and rounded shapes are always satisfying and comfortable to the eye. Devoid of corners or points to distract the eye, they are independent entities, commanding attention for their own merits. They can also be supportive elements, to enhance or contrast with other shapes. A typical example would be a round inner tube, contrasted against a couple of rectangular rafts. Often curved shapes have a stronger presence in a photograph when offset or balanced by angular shapes.

- *Rectangles* can serve to establish symmetry and balance. Placing a straight horizon line a third of the way up or down in a composition automatically divides the background into two unequal rectangles. This can provide a static, balanced setting for a dynamic subject.

- *Squares,* with their four equal sides, can create an even stronger sense of symmetry and balance than rectangles, especially when placed in the center of a photograph. They can be highly effective in a different way when positioned off-center and juxtaposed with other shapes, such as circles or triangles.

- *Triangles* are perhaps the most dynamic shapes. Their diagonal lines and acute angles tend to create excitement and tension in an image. Compositionally, triangles are often best complemented by curved or symmetrical shapes.

Circles, and circles within circles, as shown here, are usually satisfying compositional elements. They are also helpful in keeping a viewer's attention within the picture.

Rectangles and squares sometimes provide a sense of geometric rigidity in a composition. The curved architectural detail and shadow, as well as the shadow of a palm tree, offset this rigidity, providing a soothingly asymmetrical image.

Triangles can have a dynamic effect in a composition. In this photo, consisting primarily of rectangles, one bold triangle adds an element of interest to what otherwise would be a static and boring photograph.

Color—Color can be used effectively to evoke a specific response. Not only does it characterize a subject's appearance, but it is effective in emphasizing mood or ambience and in providing interest to an otherwise drab composition.

Often, contrasting color combinations—which occur when light colors and dark colors, saturated colors and pastel colors, or "warm" colors and "cool" colors, are juxtaposed—create the greatest impact. However, a monochromatic color scheme, which contains basically only one color and light and dark variations thereof, can produce striking results as well.

Different colors tend to evoke different responses. For example, red, the most dynamic and attention-grabbing of colors, can connote sensuality and excitement, but also tension and danger. Red is an "intimate" color, often appropriate in small, enclosed spaces. Pink, a muted version of red, is softer and more gentle and passive. Yellow is bright and cheer-

When used effectively, colors of all kinds and combinations can be an instant eye-catcher. Chuby the Clown (upper photo) provides an array of bright colors. The shot of the bull (lower photo), featuring mainly earth tones, is no less interesting. Notice how the purple bin in the background provides relief and adds emphasis to the monochromatic brown theme of the picture.

ful, and orange, which is a mixture of yellow and red, is warm and mellow.

Blue is a "cool" color. Being associated with a blue sky, it signifies distance and open space. Green, the "color of nature," is pleasing and soothing to the eye. Violet, a combination of blue and red, is mysterious and often considered exotic or regal.

Generally, bright colors are boldly appealing, whereas subdued colors have a softer and more subtle presence in a photograph.

Whenever contrasting colors such as red and green, orange and blue, or yellow and violet are juxtaposed, the extreme contrast gives each color added impact. Depending on the subject, the result can be either exciting or disturbing. This is very much a subjective evaluation and must, therefore, be left up to the personal taste of each photographer.

As indicated earlier, "cool" bluish colors appear to recede into the distance, while "warm" reddish colors seem to advance toward the viewer and stand out from the image surface. Also, bright colors tend to stand out against more muted colors.

Ideally, the subject of a photograph should be prominent against the background and the two should not clash or compete unduly with each other.

Tone—The proper combination of light and dark tonalities is important to the overall balance and impact of an image, whether you're using black-and-white or color film. Usually, a successful composition contains black, white, and a range of tones in between. The image should have both detailed shadow areas and highlights with some detail.

Often, dramatic effects can be achieved by placing a light subject against a dark background, or vice versa. In such situations, special exposure compensation may be necessary, as described in Chapter 5. Generally, light areas pop out against dark areas, which have a "heavier" presence in a composition.

Sometimes you may want to omit tonal contrast to achieve a specific result. For example, high-key photographs, which consist mainly of light tonalities, convey a more ethereal or cheerful atmosphere, whereas low-key photographs, which contain almost entirely dark tones, convey a more somber or pensive mood in an image.

Pattern—A pattern is a design that usually contains a repetition of shapes, lines, colors or forms. Patterns are often effective in creating strong, graphically appealing, images. By itself, a pattern can create a feeling of harmony, uniformity and symmetry. However, as the sole subject of a photograph, a pattern's comfortable predictability can be static and boring. For maximum visual impact, a pattern is best employed to offset or complement a contrasting subject, or to show off a significant irregularity within the pattern.

Texture—When the "tactile" quality, or texture, of a subject is emphasized, the result is a realistic, three-dimensional looking image. Texture can be used effectively to accentuate the character or mood of a scene. For example, rough surfaces such as burlap and hemp will convey a coarse, unrefined and "natural" quality in an image; smooth surfaces, like glass or plastic, have a more slick, smooth and "modern" presence.

Often, striking and satisfying results occur when contrasting textures are juxtaposed in an image. For example, the soft, fine hair of a newborn colt will appear even silkier when juxtaposed against a background of coarse hay.

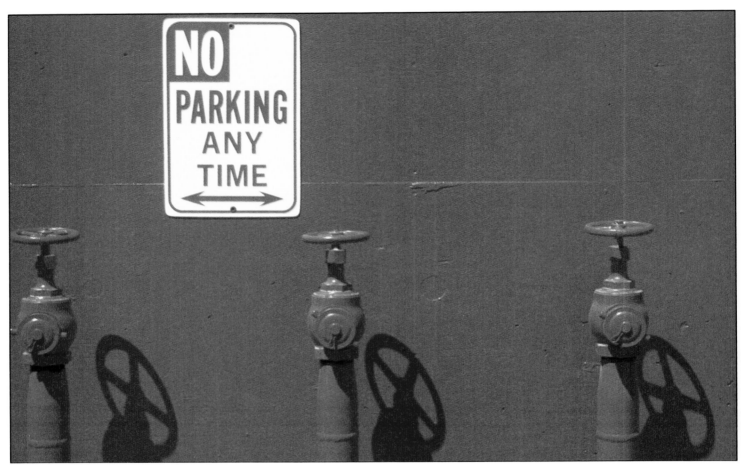

Red always has a dynamic and powerful effect (above). Blue is a more subdued, soothing color (left).

Notice how the white surf helps the composition of this image. It directs your attention directly to the boat. The boat was static at the time the photo was taken. When a subject is moving, it should generally move into the picture rather than out of it. In other words, if this boat had been clearly moving from left to right, this composition would be fine. If it were moving in the other direction, the boat would have been better placed on the right side of the picture.

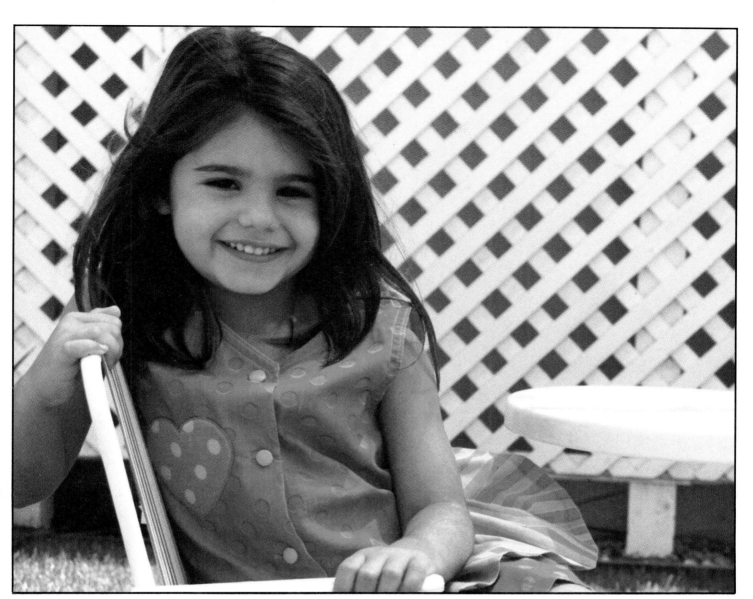

The "Rule of Thirds" can be used to make a composition more dynamic. Rather than centering a subject in the image area, which frequently leads to a symmetrical and static result, think of the image in terms of thirds. Placing your main subject approximately at such junctures within the image frame will usually produce appealing results. The photo reproduced here was composed in accordance with the Rule of Thirds. The main focal point—the girl's face—is about one-third of the way into the picture from the left, and one-third of the way down from the top.

To enhance the visual characteristics of surface texture, the light source should be contrasty and the light should strike the subject at an oblique angle.

SUBJECT PLACEMENT

Because a subject has to be centered in the viewfinder's autofocus frame in order for autofocusing to take place, the natural tendency is to take the shot with the subject dead-center in the composition. This usually produces static and rather uninteresting results in which the eye will go straight to the center of the image and stay there.

To create a more dynamic image, in which the eye will be drawn to different areas within the image, try placing the subject off-center in the frame, using the camera's focus-lock mechanism. (See also Chapter 2.) This is an effective compositional technique for emphasizing a subject and its surroundings, and producing a pleasing compositional balance.

The well-known compositional "Rule of Thirds" suggests placing the main subject in an image about a third of the way into the picture from left or right, and about a third of the way from the top or bottom border.

Using a wide-angle focal length, you can include much background detail that will help relate something about a subject, to create a personal, meaningful portrait (upper photo). Portraits shot with a telephoto focal length can yield a large enough image to convey intimate detail about the subject's features and characteristics (lower photo). Photo of race-car driver Tommy Astone by Mike Stensvold.

Do not place the major focal point of an image too far away from center, as too much "weight" placed to one side will make the image seem off balance and the subject will appear to be falling out of the photo.

When you photograph two or more people together, avoid having all heads at the same level. A group photo is much more pleasing when one person sits on the floor, one kneels, one sits on a couch, and a fourth sits on the arm of the couch, than if all four simply stand next to each other.

BACKGROUND

The background is a critical factor in a photograph. It should complement the subject without overpowering it or detracting from it. Generally, the best types of backgrounds are simple and uncluttered. Sometimes, however, a background which contains elements that relate to the subject, or one which directs the eye toward the subject, can be very effective.

The Horizon Line—An integral component of many compositions, the horizon line divides a background into two separate areas. When the horizon is placed in the center of the frame, the composition is divided horizontally into two equal parts. This creates a symmetry in which the two halves compete for attention. Usually, your results will be more pleasing if you place the horizon line a third of the way up or down in the frame, depending on which half of the scene is most important.

A subject shot from a low angle, with a resulting low horizon line (right), will appear more prominent than a subject against a relatively high horizon line (left). Photos by Mark Kaproff.

If you want to emphasize the sky, tilt your camera upward to lower the horizon line in the picture. If you want to emphasize the terrain, tilt your camera downward, to raise the horizon line in the photo.

When photographing a person, be aware of the placement of the horizon line relative to the subject. If the horizon is low in the frame, the subject will appear more prominent than if the horizon line is above the subject. Try to avoid placing the horizon line at major body junctures such as neck, waist or knees, as this can be distracting.

FOREGROUND

A common flaw in otherwise potentially pleasing images can be the inclusion of more foreground than is necessary. You can tell there's too much foreground when it's distinctly intrusive and when you can eliminate most of it without disturbing the balance of the composition.

If the foreground is more noticeable than the subject, either crop the image in the camera, or let your photo lab do it at the printing stage.

For a foreground to be an effective part of an image, it should either lead your eye directly to the subject or contribute to the overall balance of the scene in an unobtrusive way.

If you wish to emphasize an interesting foreground, use a wide-angle focal length and, generally, a fairly low viewpoint. To obtain the depth of field needed to sustain sharpness from up close to far away, it's best to establish focus on a point somewhere between a third of the way to halfway into the scene that you want to record sharply, and to work in bright daylight conditions where a small aperture is likely to be employed.

Beware of including foreground objects or props when using flash. These foregrounds would probably burn out in the picture and distract attention from the main subject.

BASIC PICTURE-TAKING TIPS

Practice and experimentation are the best means to improving your photographic skills. However, here are some basic pointers that are universally applicable:

Keep the Image Simple—Simplicity is one of the keys to a successful photograph. A dictum that is applicable to most art forms states that "Less is More." To avoid a subject getting lost amidst a cluttered foreground or background, either move your subject to a less distracting area or alter your camera angle, or focal length, to avoid or crop out the confusing elements.

When you're shooting portraits, a distracting background can generally be easily avoided by either moving your subject or altering the camera viewpoint. Here, moving the camera from the subject's eye level (upper photo) to a higher angle (lower photo) did the trick.

Move Close to the Subject—One of the most common causes of disappointing photographs is a tiny subject amidst a vast image frame. Unless an expansive background is important to the picture, move in close to your subject so that it fills most of the image frame. This way, the subject will have maximum impact in the photograph.

Most point-and-shoot cameras have a wide-angle lens that makes it difficult to get a good, frame-filling image of a person's head. If your camera has a telephoto feature, or you have an attachable teleconverter for increasing the focal length of the camera

If you don't carefully examine the framing of a composition, unwanted detail, such as the arm on the right side, might appear in the resulting image (left). Select camera viewpoint, background, and lens focal length carefully, to avoid distracting elements in the picture (right).

lens, use it. Otherwise, have the negative enlarged to get a frame-filling image. But remember to use a moderately slow film, if you can, so that image sharpness will not deteriorate significantly through enlargement.

Watch the Framing of the Image—When you compose an image in the viewfinder, it's a natural tendency to concentrate all of your attention on the main subject and ignore distracting details in the corners or outer edges of the image. Before you shoot, examine *all* the contents of the image frame. Arrange the image in the viewfinder in such a way that the image is both *composed* and *framed* in a pleasing manner.

◀ Always move in as close as possible to your subject so that it has maximum impact in the photograph. The purpose of these images was to show the interaction between the woman and the animal—no more and no less. For this purpose, the lower picture is more informative, detailed—and effective.

9
HOW TO PHOTOGRAPH YOUR FAVORITE SUBJECTS

When you are familiar and comfortable with the concepts discussed in the preceding chapters, you can begin applying them to specific shooting situations in order to achieve better photographic results. The following guidelines will help you cultivate a more "professional" approach to shooting your favorite subjects with an autofocus point-and-shoot camera.

PEOPLE

Basically, there are two types of people pictures: posed photographs and candid shots. Regardless of which method you use, the major objective is to make your subjects look their best.

POSED PORTRAITS

The advantage of posing your subjects is that you have full control. You can choose the background, lighting, camera angle and composition that best suit the subject. This makes the result fairly predictable.

Generally, people look best when they don't *appear* posed, even if they are. A stiff, formal pose, accompanied by a forced smile, tends to create an awkward, uncomfortable looking result. To generate natural-looking results in posed situations, let a subject have some time to relax and get comfortable in the chosen setting, until he or she is relatively unaware of the camera's presence.

You might want to involve the subject in an activity, or provide something interesting for the subject to look at, so that you can record a natural, spontaneous expression. This technique is especially effective

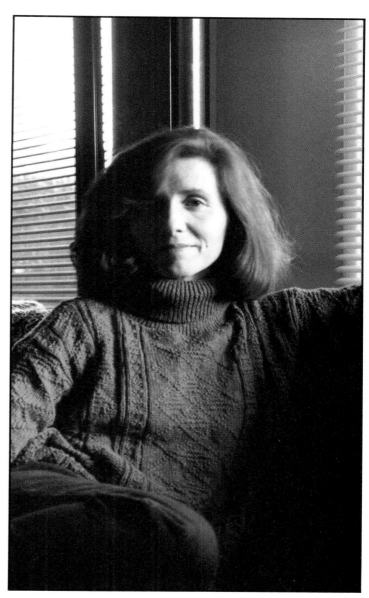

One advantage of posing a subject is that it gives you total control of the lighting. This subject was deliberately placed in a high-contrast situation, with side lighting, to produce a dramatic, provocative image.

◀ A telephoto focal length comes in handy for candid photography. It lets you get an intimate, detailed image without having to get too close.

when you're photographing children, who don't like to sit or stand still for long periods or to be told to "smile for the camera."

When you pose a subject, consider the spatial limitations of the environment, as well as surrounding details that may either enhance or detract from the composition. Position the subject so that he or she feels, and looks, comfortable. Usually a person looks more relaxed seated than standing. If you want the subject to be standing, provide a prop or support, such as a chair or mantelpiece, on which the subject can lean. Not only will your subject be more comfortable as a result, but the composition will be more interesting, too. After all, a subject standing in an open, empty space tends to produce a static, uninteresting photo.

When photographing two or more people, consider the heights of your subjects in relationship to the composition. Generally, tall people should be seated, with the shorter subjects standing beside or behind them. For a pleasing composition, try to have the eye levels of all subjects at different heights.

Try to keep your subjects relatively close together. Not only will this make the camera's job of focusing easier, but the overall visual effect will be more pleasing as well.

Choose a Suitable Background—The setting should be as simple as possible so as not to detract from the subject. It's a good idea to use a setting that contains elements that relate directly to the subject. For this reason, a subject's home, office, or workshop often make an excellent setting and background.

When shooting outdoors, sky, water or building facades can provide pleasing backgrounds.

If a subject is standing in front of an open expanse of space, make sure that distant trees or telephone poles

When shooting outdoors, make sure that trees or telephone poles are not apparently growing out of a subject's head. The problem evident in the photo at left is easily remedied by a simple change in camera viewpoint or subject position.

do not appear to be growing out of the subject's head. Although such a phenomenon can make for humorous photos, it is not appropriate in "good" portraiture.

When you're shooting indoors, a plain wall is always a safe background. If you're using flash, be sure to move your subject far enough away from the wall to avoid an unpleasant, harsh shadow on the wall.

When a subject has dark hair, a light-toned background is preferable, so that the subject clearly stands out from it. Conversely, light-haired people look best before a relatively dark background. Ideally, a subject's hair and clothing should not blend in with the color and tone of the background.

A window can often provide a fine setting for a portrait. If you're using your camera's built-in flash to compensate for backlighting or dim interior lighting, shoot at an angle to the window to avoid a flash reflection from the window.

CANDID SHOTS

Candid photography is, in many ways, more challenging than formal portraiture because you don't have total control of the situation and must rely on your good sense of timing.

You must also have the ability to photograph people without calling undue attention to yourself. This can usually be accomplished in one of two ways: you can involve yourself in what the subject is doing, so that your presence becomes part of the event rather than an observer's intrusion, or you can shoot the subject from an inconspicuous location, so that you are barely noticed or perhaps not even noticed at all. A telephoto focal length, allowing you to get a relatively large image from a distance, is invaluable for this purpose.

The less distractions you have in the composition, the better the results will be. Once you have a subject framed to your liking, maintain focus by keeping the shutter button partially depressed and wait for an appropriate moment to make the exposure.

People look best when they're relaxed and enjoying themselves. The best time to take shots is during moments of obvious enthusiasm, effort and joy. So as not to miss anything significant, you might want to take a series of shots, using your camera's continuous-shooting mode.

Unless your subjects are children, avoid photographing people while they are eating. Such shots are rarely flattering.

Children—Children are ideal subjects for candid photography. The best time to photograph them is when they're engaged in an activity of their own or are

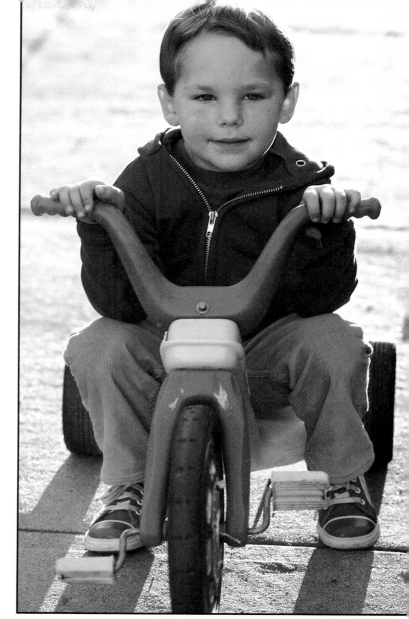

Children are easiest to photograph when they are engaged in an activity they enjoy.

captivated by some other event. With a child, even an "unflattering" shot can often have charm, personality and humor. However, always remember that there's a big difference between *humor* and *humiliation*. Treat children with respect.

When photographing children, it's a good idea to use fast film. Children tend to move rapidly, so you'll need the fastest possible shutter speeds for freezing action, as well as the smallest possible lens aperture for the greatest possible depth of field.

Don't forget to consider camera angle and perspective. When you photograph a child from a standing position, or a normal grown-up's perspective, the subject will seem small, vulnerable and childlike. If you position your camera lower, at the child's eye

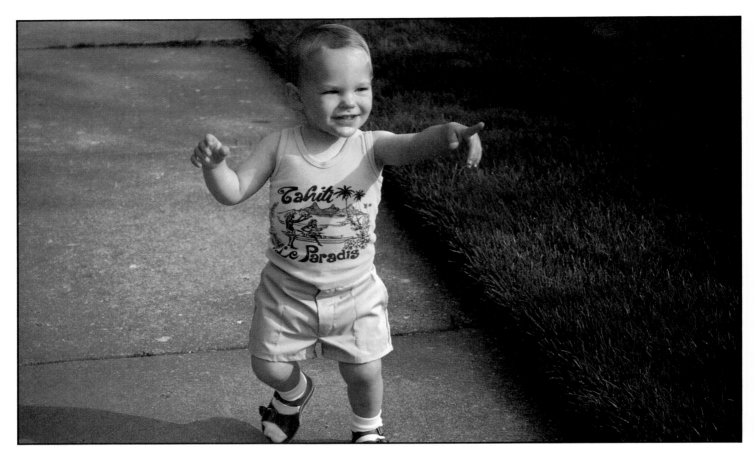

The most flattering pictures of small children are shot at or near their own eye level, not from above.

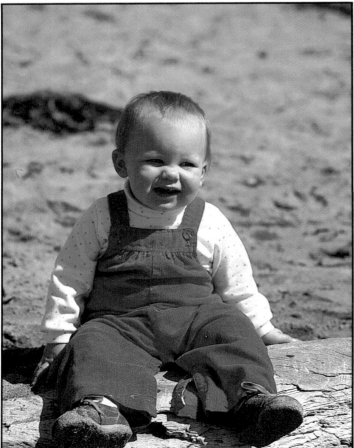

The smallness of a child can be emphasized compositionally by leaving some space in the picture above the child's head.

level, not only will the child feel less intimidated by your presence, but you can also achieve more intimate-looking results.

There's an easy trick that enables you to make a child look small, even from a low angle. Simply leave plenty of space above the child's head in the image frame. This suggests *smallness* very effectively. However, make an effort to have a composition that's pleasing to the eye, too.

ANIMALS

In many respects, photographing animals is not unlike photographing children. Both are usually on the move and neither take directions well. Since the movements of animals are unpredictable, you often won't have enough time to compose your shots. If the animals are timid, you might have to wait some time before they feel comfortable enough to approach you. Consequently, photographing animals can be a challenging endeavor.

Whether you want to capture an animal's humorous, "human" qualities or its natural characteristics and charm as it interacts with other animals or its environment, you need to have three things—patience, good timing, and a lot of film.

PETS

To successfully capture the "personality" that you see in your pet, give it a favorite toy with which it can become involved, or have a friend engage it in an activity. This way, you can take a variety of shots, from different angles, without the pet getting distracted. If the pet is well trained and capable of sitting still, you might try using a small noise-making device to prompt interesting reactions and expressions.

Remember that, for best results, you should usually keep the composition simple and get close enough to the subject so that it fills most of the image frame, if possible. You'll find that, at a telephoto setting of about 80mm, a dog, cat, or even a rabbit, will fill much of the 35mm image frame.

When you're photographing small pets, such as hamsters or birds, use the longest telephoto setting and get as close to the subject as the camera will permit. To get a frame-filling image of the subject, have your photo lab make a cropped enlargement.

For best pictorial results, photograph the pet from its own eye level. To easily obtain the desired low camera angle, place the pet on a raised surface.

To avoid disappointing results, you should be warned that most point-and-shoot cameras are not ideal for photographing fish. When you place a camera against an aquarium wall, the autofocus will

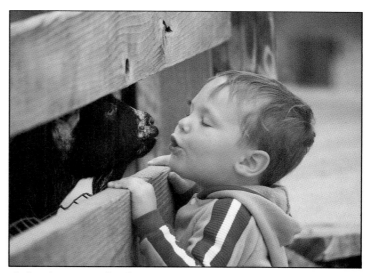

Animals can make for humorous as well as sensitive portraits. The "smiling" elephant (top), the pensive foal (center), and the small child with friend (bottom), all provided good material for eye-catching images.

Give your pet something to do and watch patiently and alertly—and you'll get some worthwhile photos. Move as close to your subject as your camera will permit, in addition to using a long focal length, to get large, detailed images. Indoors, flash is ideal for capturing a fleeting moment sharply on film.

automatically set focus to infinity, and your fish will be out of focus.

Shooting directly into the aquarium glass, you can't use flash, because the flash would bounce right back to the camera lens. With the absence of flash, the camera will set a slow shutter speed, causing blurred pictures.

ZOO ANIMALS

If you can't photograph wild animals in their natural habitat, the next best thing is a zoo. Here, animals are contained. They are also accustomed to the presence of people, thus making them relatively easy to photograph. Although a telephoto focal length is useful for getting the largest possible image, you can also use your camera's 35mm wide-angle setting and have your photo lab crop the print enlargements to your liking. The use of a relatively slow, fine-grained film will ensure the sharpest possible enlargements.

Usually, a zoo enables you to have easy photographic access to the animals. However, many animals, such as lions and tigers, are kept behind fences or bars. This represents the major disadvantage of zoo photography.

If an animal happens to be close to a fence or bars, your camera will automatically focus on the fence and the animal should be in sharp focus also. However, if the animal is somewhere other than directly behind the cage confines, you will have to employ the camera's focus-lock mechanism, as described in Chapter 3. Lock focus on a "substitute" subject at about the desired camera-to-subject distance, to establish the proper focusing distance, and then take the shot. Or, position the camera against the fence so that both the lens and the AF windows have a clear view to the subject.

When you're shooting through glass, either turn off your camera's built-in flash or position your camera

Sometimes a noise or other distraction can help you get the look you want—but you've got to be quick with that trigger finger, or you'll miss the best shots! Here, the cat's alert expression is very typical. A 70mm focal length and the camera's macro mode enabled the subject to fill most of the image frame.

at an angle to the cage so that the light won't reflect back to the camera and produce glare.

Here's a technique you may want to try when shooting through a fence or between bars: Move as close to the fence or bars as possible, so that these will be rendered out of focus, then focus on a "substitute" subject, as described above, to get the subject sharp. It's best to switch off the flash, in order to avoid distracting reflections from the fence or bars.

Petting Zoo—One of the best places to get satisfying animal shots is a petting zoo, where you can get as close to the animals as you want. The animals are always friendly and easily coaxed with a handful of food.

You can capture many special moments as an inquisitive child reacts or interacts with the animals. It's important to be alert and ready, and to take a lot of shots, as you'll want to capture the subtle variations that occur within seconds.

Animals behind cage bars or fences usually present a problem for active autofocus systems. However, when this photo was taken, the goat was almost flush against the fence. Bright outdoor lighting, enabling the camera to select a small lens aperture, provided adequate depth of field, even with the camera focused on the fence rather than on the animal. Both animal and fence are reproduced sharply.

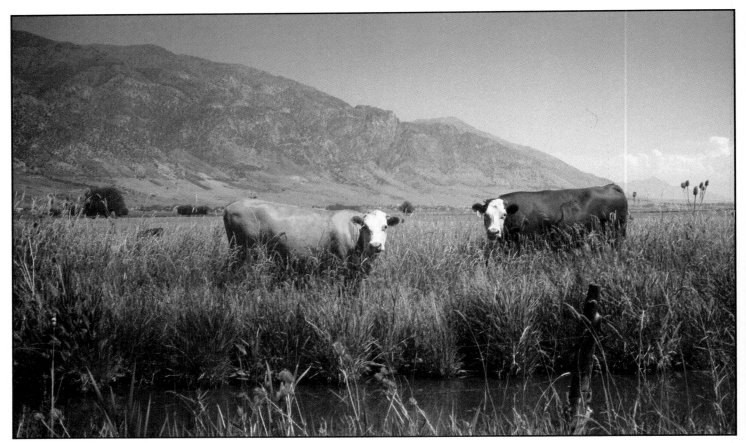

A wide-angle focal length is ideal for photographing animals in an appealing setting.

ANIMALS IN NATURE

Photographing animals in nature requires an abundance of patience as well as a little luck. While autofocus point-and-shoot cameras are versatile, they do have their limitations. For one thing, even a 105mm-focal-length lens will not allow you to photograph wild animals from a sufficiently close distance to give you a satisfactory image size. Also, the fastest shutter speed of most of these cameras will not freeze the action of an animal racing across an open plain.

To get good pictures, be aware of your camera's limitations. Photograph only those animals that you can get close to and that will stay still long enough to be photographed. Normally, deer, cows and horses all fall within that category.

The best lighting in which to photograph most animals is the golden side lighting of early morning or late afternoon. That's when the light produces the most flattering effects.

If the animals are not familiar with you, you might have to earn their trust before they will let you get near enough for photography. You might try using a little food as incentive, or visiting them on a regular basis, getting a little closer each time. If your camera has a continuous shooting mode, use it to take shots in rapid succession, as your subject might not stay in view for very long.

Drive-Through Safaris—One way of photographing wild animals without going on a safari is to visit a drive-through "safari," where you can remain in the safety of your car as you view the animals in a simulated natural habitat. The animals are not afraid of the cars and will venture quite close to your vehicle, going about their business while you take your shots.

In many instances it will be necessary to keep your windows rolled up at all times. Unless your camera is one of the few autofocus point-and-shoot models with a passive autofocus system (see Chapter 3), your camera will either focus on the window, if it is within the camera'a focusing range, or revert to infinity.

If the animal is right by your car, three or four feet away, lock focus on the farthest point within the car, recompose the image, and take the shot. If the subject is fairly distant, either set the camera to its scenic mode (see Chapter 2), thus shifting focus to infinity, or position the camera flush against the window, or at an oblique angle, to produce the same effect.

To prevent window flare from flash, the scenic-

Morning and late-afternoon sunlight provide flattering, golden illumination. When the light comes from the side, it also enhances the texture of the subject.

mode setting will automatically disengage the flash. If you're using a different shooting method, be sure to turn off your camera's automatic flash.

TRAVEL AND VACATION

An autofocus point-and-shoot camera is almost ideal for travel and vacation photography. It offers convenience and versatility, portability and ease of operation. When you travel, you will invariably be bombarded by many new sights which you will want to record quickly with your camera.

Take a supply of both fast and slow films, since you will not always know what kind of conditions to expect. Most importantly, be aware of the details which most clearly convey the essence of your journey, such as local costumes and architecture, and signs printed in foreign languages.

When you photograph your traveling companions in various travel or vacation spots, make a point of including typical details that relate to the location. After all, your travel photographs should not look as if they were shot in your own backyard.

If you're going to be taking shots from moving vehicles, keep in mind that closer objects will appear to move past you much faster than more distant objects and scenes. For example, a distant mountain range will appear almost stationary, while a herd of cattle near the side of the road will pass you very rapidly.

Don't forget to set your camera to a focused distance of infinity when you're shooting through closed windows, and keep the flash turned off.

If you're traveling to a faraway place that you may never visit again, you can't take too many pictures. But be selective, and don't just shoot anything and everything. Try to record such things of interest as the local transportation system, architecture, people and costumes, and landscapes. You will want to preserve the many memories, even if not all of the photos turn out to be masterpieces.

When you're on a travel schedule, you can't be too choosy about lighting and weather conditions. Generally, you're quite literally "here today and gone tomorrow." As a rule, it's better to take a shot—even if the conditions aren't optimum—than to miss it and regret it later. Besides, there will be times when the results are sure to surprise you for the better.

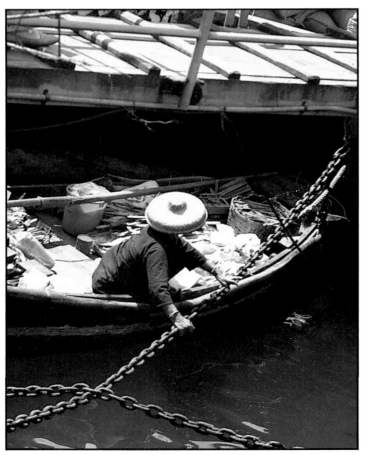

When you travel, don't spare the film. It represents one of your lesser expenditures. The photos you shoot will enable you to enjoy your trip over and over again. A high viewpoint helped to achieve a graphic image that also says something about the location (left). Taking graphic impact one step further (above), the use of a telephoto focal length and a tilted camera angle made these decorative signs appear almost abstract.

BUILDINGS AND MONUMENTS

Buildings and other rectilinear man-made structures have parallel sides, both horizontally and vertically. In photographing these structures, you can either aim to retain the lines as parallel, by keeping the film plane in the camera parallel to the subject, or you can deliberately exaggerate the perspective, by having the lines converge toward the distance. You can achieve the latter by tilting the camera in relationship to the subject plane.

When shooting monuments, whose proportions can range anywhere from less than human-size to grandiose, it's a good idea to pictorially define the subject's scale. One of the best ways to accomplish this is to have a person in the scene. A person, standing close to the structure, will instantly communicate its size to the viewer of the photo.

If there aren't any people available, trees or lamp

The best way to convey the size of a large building or monument is to include a person in the frame as a scale reference. A wide-angle focal length was ideal for this shot.

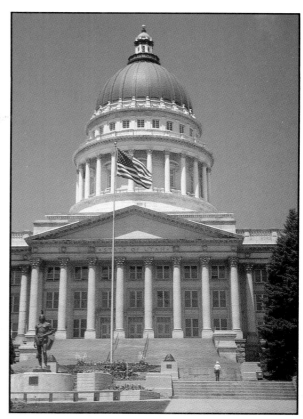

Tree branches can help to partially "frame," and thereby "contain", a subject that is surrounded by a large area of empty space, such as open sky.

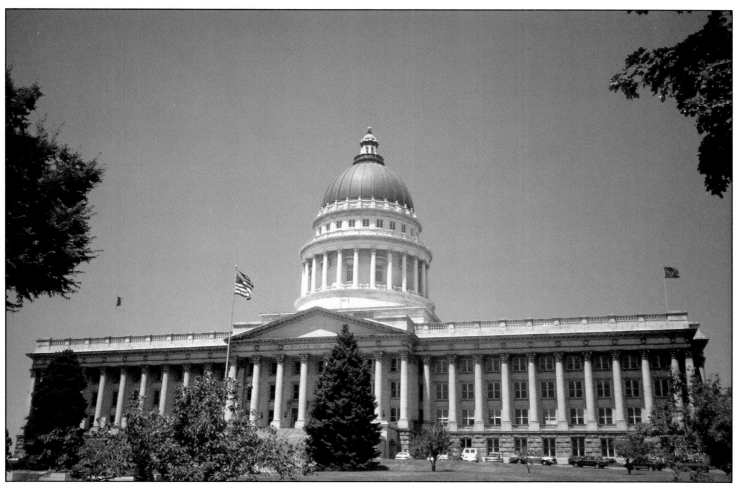

posts can serve the same purpose. The best shots are those that convey as much information about the subject as possible while still being simple and pleasing in design. Try to include both foreground and background detail, to show the subject's environment. If you later find it desirable to eliminate some of that detail, you can always crop the image.

Buildings are often visually symmetrical and static. To emphasize this characteristic, make the composition symmetrical, too. Alternatively, you might consider placing the subject off center, or including another element of interest, such as a person in the composition. Including a person will not only add interest, but also scale, to the scene.

If the subject's background is boring or distracting, you can avoid it by cropping the image in the camera, or by concealing much of the background behind foreground elements such as trees. The trees can serve as a natural frame for the image.

With relatively distant subjects such as buildings, limited depth of field will generally not be a problem.

However, in poor lighting conditions you may want to play it safe by using a relatively fast film and pre-focusing at a point between a third of the way and halfway into the desired depth-of-field zone.

INTERIORS

Documenting beautiful indoor locations requires a conscientious approach. The framing of the scene should be well thought out and the lighting must be flattering.

When shooting interiors, the use of a tripod is almost essential. It allows you to use existing room light without the risk of blurred images due to camera shake at slow shutter speeds. But a tripod also enables you to lock in a composition and study all the details contained in the scene. This way, you can make fine adjustments in the composition without having to re-establish the basic framing every time you take a shot.

Remember, if you tilt the camera up or down, vertical elements, such as doors, windows or corners,

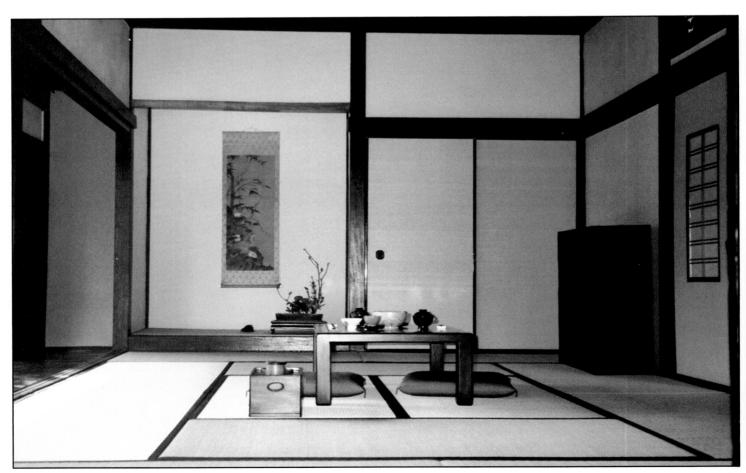

Some interior scenes can be enhanced by a high-angle view, others by a low-angle view. Still others, such as this room, look best from a head-on view. For this photo, the camera was aimed horizontally, so that all vertical lines recorded parallel to the image frame.

will appear to converge. This isn't necessarily a bad thing, but you should be aware of this as you compose your images.

If the interior is lit by either tungsten or fluorescent light, and you're using daylight-balanced film, your photos will have a distinct color imbalance. One way of eliminating this problem is to use your camera's built-in flash. However, if you want to maintain a natural-light quality, use the available light and an appropriate corrective filter (see Chapter 6 and Chapter 10). Or, have the processing lab correct for the color shift in the printing process.

If the room is lit primarily by incoming daylight, use daylight-balanced film and no filtration. Turning on a tungsten lamp somewhere in the scene will add interest, as well as a warm, pleasant glow.

It's worth pointing out that color print films are balanced for use in daylight or with electronic flash. To get the most faithful, accurate results in tungsten illumination, use of a blue 80-series filter is recommended. If you don't use a filter, the lab can still compensate at the printing stage. However, the result is not likely to be as good as it would be if you used the appropriate filter on the camera lens.

FESTIVITIES

Colorful decorations, enjoyable activities and peak emotions can always be found at festive occasions and are ideal subjects for photography. Often, however, the abundance of photo opportunities can be overwhelming, making it difficult to capture everything on film. This is why the best approach to shooting any celebration is to plan ahead and to have a lot of film on hand, as well as a good battery in the camera. Since planned events are an integral part of most special occasions, you can anticipate at least those key moments and be ready to record them when they occur.

Following are recommendations for photographing just a few typical celebrations. For other events, such as anniversaries, reunions and parties, follow the same basic guidelines, applying them to the particular situation that confronts you.

BIRTHDAYS

The major moments at a birthday party are the blowing out of the candles on the cake, the cutting of the cake, the opening of presents, and the playing of games. You'll want to produce more than mere documentary shots; you'll want to capture the essence of fun and high spirits.

Before the festivities begin, examine the environment for potential camera angles. Try to compose

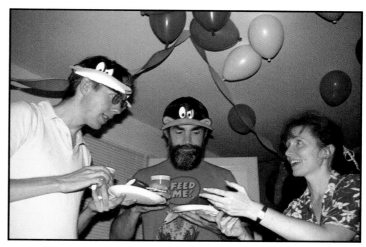

For a shot to instantly convey the essence of a party, establish a camera angle that includes festive decorations, either in the foreground or background. Here, a low camera angle was necessary to achieve such a result.

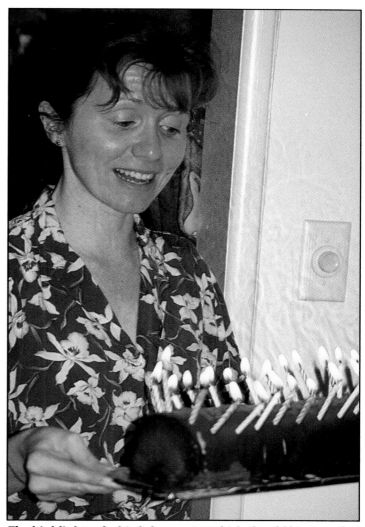

The highlights of a birthday party, which should be recorded on film, are usually the blowing out of the candles on the cake and the opening of presents. It's also a good idea to take at least one shot of the complete and fully lit cake, while it still exists!

your images to include party decorations in the background or foreground. Your shots should convey the essence of a party at a moment's glance.

Since the most dynamic facial expressions occur when presents are being opened, be ready to photograph the birthday boy or girl's first reaction upon opening a gift, and take several subsequent shots to record expressions of anticipation, surprise, glee and delight. Because the expressions will not always be predictable, shoot a lot of film to be sure that you get the pictures you want.

If you have a camera with a data back (see Chapter 2), you might want to shoot a few frames with the date imprinted on the image, too.

WEDDINGS

You don't need to be a professional wedding photographer to take a variety of satisfying wedding photographs. All you need is an adequate supply of film, a fresh battery in your camera, and prior knowledge of when and where key events will occur. This way, you can establish a clear view of your subjects

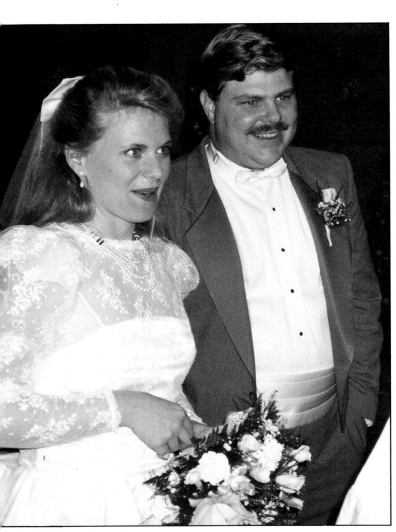

Capture the joyous moment as the couple enter into matrimony. When using the date capability of a data-back camera, be aware of where the date will appear in the frame. Here, it is barely visible against the bride's white gown, along the left border. To record the date more clearly, it would have been better to compose the image with a dark area in that part of the picture. Also, as this photo illustrates, red-eye cannot always be avoided when you're shooting flash pictures in conditions over which you have no control.

One of the peak moments at a wedding is the bride and groom's first dance together. Cameras that have a data back come in particularly handy, as they can document the date for posterity. Notice how the date stands out clearly against a dark background. If the bride's light dress had been in that location in the picture, the date would have been barely visible. When recording the date, always bear in mind that it's best to have a dark area where the date will record.

When shooting wedding portraits, try to find suitable backgrounds that will not compete with the subjects. The flower arrangement at left serves this purpose ideally. Photo by Tavo Olmos.

before a crowd gathers and be ready to shoot when peak moments occur.

Your shots should document the various high-points of the wedding, which include the arrival at the church, the ceremony, the strong show of emotions present in both the bride and groom, as well as family members and friends. Before the event, ask the person officiating at the wedding at what positions you may locate yourself, and where and when you may use flash.

At the reception, shoot the bride and groom's first dance together as husband and wife, the cutting of the wedding cake, and the throwing of the bouquet. Be prepared to move around a lot. If you can't get in front of a gathering of people to get a desirable view of the newlyweds, try to get a high view, over the heads of the crowd, by carefully standing on a chair.

A single-focal-length autofocus camera is sufficient for shooting many of the scenes that occur at a wedding. However, a dual-lens or zoom-lens camera will enable you to crop in on subjects so that you can take candid portraits as well as document some of the finer details that otherwise might not record satisfactorily.

If your camera has a data back, take a few shots with the date mechanism turned on. That way, your photos will ensure that you never forget the couple's anniversary!

CHRISTMAS

Like birthdays, Christmas is a fun time of year, when family and friends get together and celebrate. Several of your images should include the Christmas tree, with its colorful lights and nicely wrapped presents, as this will instantly communicate the Christmas spirit. The tree is also an excellent background for group shots and family portraits.

Since Christmas is best reflected in the reactions of children, be ready to capture the expressions of excitement and anticipation as children take part in the Christmas celebration.

Also, to document the occasion from start to finish, you'll want to have "before" and "after" shots of the

same setting, to show the passage of time. A nice series of photographs, that will rekindle memories for years to come, might include the tree when it is first brought home, as it's being decorated by family members, in its full glory and, after the celebration, when torn wrappings and exposed gifts are still lying about.

To make the Christmas tree's lights appear bright and luminous, use your camera's slow-sync flash capability, if it has it (see Chapter 2 and Chapter 7). The flash will expose your subjects normally, while the camera's slow shutter speed will enable you to record the quality of the existing light. When shooting in this mode, or if you turn your camera's flash off altogether to take available-light photographs, be sure to use a sturdy means of supporting your camera, otherwise camera-shake at slow shutter speeds will blur your results.

Try shooting the subject with and without flash, just in case the camera's built-in flash overpowers the tree lights.

The Christmas tree is the primary focal point of the holiday festivities. The photo at left was taken with flash. To make the tree lights more evident than they are here, while still using flash, a slow-synchro flash mode would be required. For the photo at right, the flash was deactivated. Notice how the tungsten light "warms" the scene. The use of fast Ektar 1000 film enabled the camera to be handheld despite the dim lighting.

Capture the full range of emotions as presents are un-wrapped. The 50mm focal length of a zoom-lens camera was used to make the two photos of the couple opening their present, while the longer 70mm focal length made possible a tighter portrait of genuine excitement.

SPORTS AND ACTION

Sporting events and other action offer a fund of photo opportunities, from peak-action moments to the reactions of spectators, and the anticipations and rituals of participants. The best way to become skilled at photographing sports and action is to practice. Moving subjects can elude the camera's eye, and therefore the film, if you don't press the shutter button at just the right moment. You should be prepared to use a lot of film to ensure getting the best possible shots.

SUBJECT MOTION

Before you set out to photograph an athletic activity, you should give some thought to how you want your results to look. If you want to "freeze" the action, to produce a sharp image of the subject, you will need a fast shutter speed and should, therefore, use a fast film. If you want to blur the action, to emphasize the subject's motion, use a slow film that will cause the camera to use a slower shutter speed.

Should you want to use an even slower shutter speed than you think the camera will automatically provide in a given situation, place a neutral-density filter over both the camera's lens and the light sensor. This will cause the camera to select a slower shutter speed and wider aperture than it normally would, while still providing accurate exposure. (See also Chapter 5.)

Panning the Camera—Since you don't know the exact shutter speed your camera will employ, reproducing a moving subject sharply on film can be somewhat unpredictable. If you hold your camera still and wait for the subject to move across the frame to take the shot, the subject might appear blurred in the final result. You can avoid or minimize this effect by employing the *panning* technique, in which you track the subject with your camera, keeping the moving subject as static as possible in the frame, and making the exposure at the desired moment.

For best results, always *follow through* with the pan. If you stop panning the instant you take the shot, the results might be blurred due to the abruptness of halting the camera in the middle of the exposure. Although this technique might sound easy, it does require practice. Using a continuous shooting mode comes in handy, too.

Of course, panning will not stop the movement of individual subject parts, such as legs, arms, rotating wheels, etc., but it will certainly help you get a generally sharper image.

Peak of Action—Since everything that goes up must eventually come down, a brief moment occurs

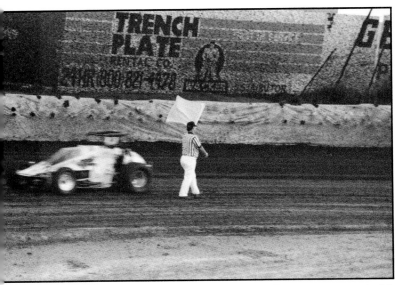

Focus was established on the flagman. The camera was held steady, so that the flagman would record sharply while the moving car recorded as a blur.

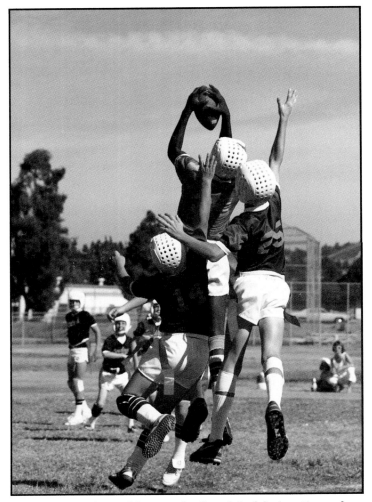

Shooting moving subjects at the "peak" of their action, when the up-down motion is momentarily suspended, makes possible sharp results even at relatively slow shutter speeds. Fortunately, such moments are usually also the most exciting in an action.

Panning does not help with a subject that is moving toward the camera. Unless it is moving very fast, such a subject will usually appear acceptably sharp anyway, at a moderately fast shutter speed.

in many types of action when upward motion must cease in order for downward motion to commence. This is the *peak of action* and is the only brief moment at which a subject such as a pole vaulter or basketball player hangs suspended and relatively motionless in midair.

Although peak-action photography requires precise timing and quick reflexes, it does enable you to record subjects sharply when using relatively slow shutter speeds. A bonus is the fact that peak-of-action shots frequently show the most dramatic moment of the entire event.

FRAMING AND FOCUS

When photographing any type of action or event, you don't always have time to compose your shots, so

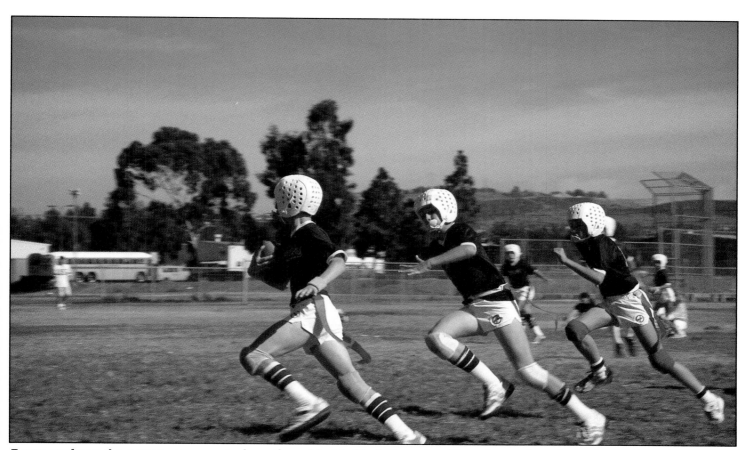

Try to prefocus the camera on a spot where the subject is likely to arrive. Then shoot when the action arrives there.

you should try to establish a good camera position before the action commences. Find a location that will provide you with a clear and interesting view of the subject, a simple, uncluttered background, and good lighting. Also, since subjects usually move too quickly for your camera to establish proper focus, it's a good idea to prefocus on a point at which your subject is due to arrive—like a finish line or end zone—and shoot the instant the subject arrives at that point.

With sports that have random movement, such as football or soccer, where it's not possible to predetermine a spot at which good action will occur, track the subject with the camera, but don't touch the shutter button until you want to shoot. Otherwise, the camera will focus when you first touch the button and the subject might not be in focus by the time you take the shot.

Obviously, it's helpful to be familiar with the event or activity you intend to photograph, as this will enable you to be at the right place at the right time, to record the most important moments on film.

LANDSCAPES

A favorite subject among photographers, landscapes are as challenging to photograph as they are captivating to behold. The grandeur and splendor inherent in the natural environment stimulate the imagination and evoke emotions and memories upon viewing the recorded images. All too often, unfortunately, landscape photos turn out to be a disappointment. One common reason is the failure to isolate the main point of interest that best communicates the unique essence of the place or environment.

First, consider what it is that most attracts you to the scene, and then find the best angle to exploit those characteristics. Focus on a single area of interest, and adjust your composition to complement its features and surrounding details. For example, if a dramatic sky is the most important part of the scene, tilt your camera upward, to include more of the sky. If you're more interested in fields, lakes and trees, point your camera downward more. If the composition lacks a natural focal point, place a person in the scene. This

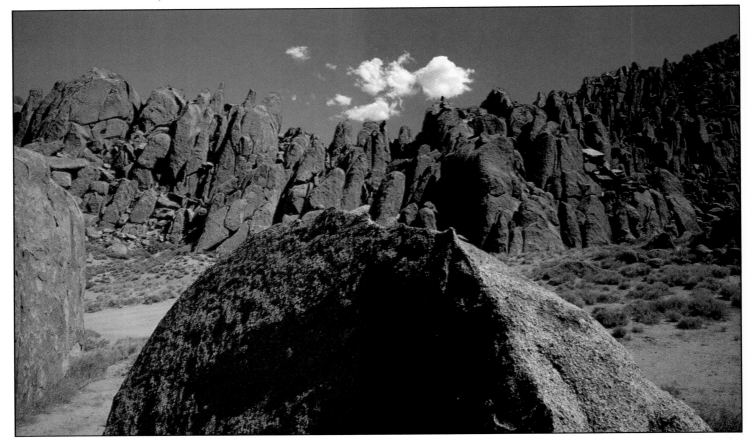

With a wide-angle focal length and bright lighting—providing a small lens aperture—depth of field is virtually unlimited, unless the subject is very close to the camera. In this scene, everything from the nearby rock to the distant scene is totally sharp and clear.

Don't put your camera away just because the day is overcast and dim. Such conditions make for some of the best "atmosphere" shots.

will not only add interest, but also convey a sense of scale.

Always be aware of the lighting and weather conditions. Subtle variations can have profound effects on a resulting image. Diffuse morning light, for example, can convey a soft, romantic atmosphere, whereas afternoon sunlight on a clear day can create a bold, dramatic photo.

For best image quality, use the slowest film possible for the prevailing lighting conditions. Of course, if you're working in dim light, you'll need a relatively fast film, at least if you need to stop some movement in your photos and want plenty of depth of field.

The grainier qualities inherent in some of the faster films can give your results a textured appearance and a mood that's appropriate for some scenes.

SNOW AND BEACH SCENES

Although beach scenes and snowscapes are popular subjects, they will reproduce poorly on film unless certain exposure adjustments are made. *Large,* bright areas in a scene will cause the camera to employ less overall exposure, making snow and sand reproduce as a murky mid-tone gray in a photograph.

This can be avoided by increasing the camera's exposure in one of several ways, as explained in Chapter 5. Remember the basic rule: to record a very *light* subject accurately, *increase* exposure; to record a *dark* subject accurately, *decrease* exposure.

Another way to obtain good exposure of snow or bright beach scenes is to include a mix of other tonalities in the scene, so that the camera's meter reads a *total* scene that is, in effect, *average,* rather than very bright.

PLANTS AND FLOWERS

If your camera has a macro focusing capability (see Chapter 2), you can isolate a single flower or small group of plants in the image frame to produce simple and attractive photographs. To be sure of getting unblurred images, avoid windy conditions. When there are periodic gusts, wait for them to subside before you shoot.

Your camera's wide-angle focal length is ideal for capturing expansive views of a scene, in which you can emphasize the colors, textures, shapes and patterns displayed by a large area of plants or flowers.

It's best to do your shooting either in soft, diffuse light, which produces subtle tonalities and delicate shadows, or in golden, late-afternoon sunlight, which creates stronger tonal contrasts and makes colors appear richer and more vibrant. It's best to avoid the hard, overhead sunlight of midafternoon, as this will tend to reduce textural details and burn out the colors in highlighted areas.

Remember that you can usually move around a subject and alter your camera angle to obtain a more satisfying illumination.

As a rule, side light and backlight are ideal for shooting plants and flowers. Side light will emphasize the form and texture of the subject; backlight will enhance shapes, as well as the colors of translucent flowers and foliage. If you have a backlight compensation feature on your camera (see Chapter 2), experiment with it, to find the best effect. With translucent petals and leaves, the colors will appear deeper and richer *without* compensating for the backlit situation.

Be sure to use a tripod or other firm camera support if you are working in conditions that might otherwise cause blurred results due to camera shake at slow shutter speeds.

A telephoto or macro lens setting is ideal for dynamic, detailed close-ups.

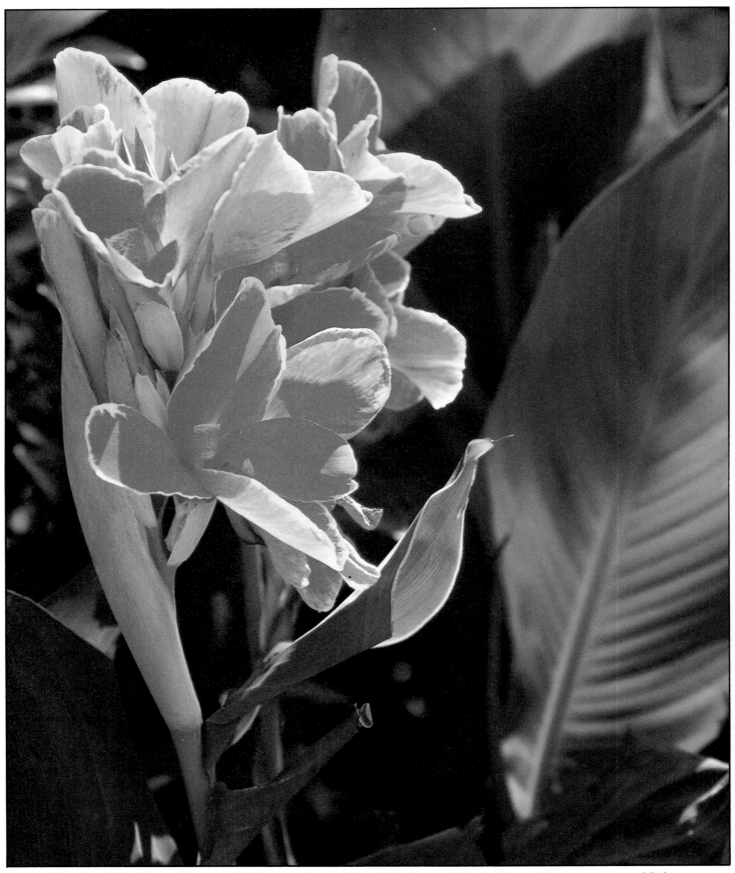

The golden, low light of late afternoon brightens colors and provides interesting shadows. Always try to establish a camera angle and position that best utilizes the direction and quality of light.

STILL LIFES

Still-life photography involves the recording of inanimate, stationary objects. Still lifes can be found already existing, or they can be specifically created in a studio or other suitable setting. This form of photography is an excellent means of strengthening your compositional skills, especially since you can take your time setting up the shot without having to worry about your subject moving.

A tripod is almost essential. With a firmly located camera, you can maintain a specific composition, enabling you to study the fine details and make minor adjustments in framing and lighting without having to continually reframe the subject.

FINDING STILL-LIFE SUBJECTS

The alert observer can find attractive still-life subjects anywhere, from attics and garages to barnyards and gardens. By isolating an arrangement of objects, you can create small, intimate scenes that tell a story and convey a mood or atmosphere.

Lighting—Natural lighting is usually desirable for still-life photography because it communicates atmosphere, or ambience, rather than simply revealing the various objects in the arrangement or composition. For example, golden light skimming across a wall indicates the presence of a nearby window, located somewhere out of the image frame, and conveys the essence of late-afternoon sunlight.

If the natural lighting is particularly harsh, you can soften the overall effect and lighten deep shadows by either employing fill flash or using a white reflector card to bounce some of the incoming light back onto the subject.

Generally, using the camera's built-in flash as the main light source will give the composition a flat, unexciting appearance. In certain situations, however, such as when you want a group of objects to be highlighted against a darker background, flash might be highly suitable.

There are two types of still lifes—the kind you find already existing and the kind you create yourself. To maintain the quality of natural lighting in this "found" still life, the flash was turned off. The camera was supported firmly on a fence rail to prevent a blurred image.

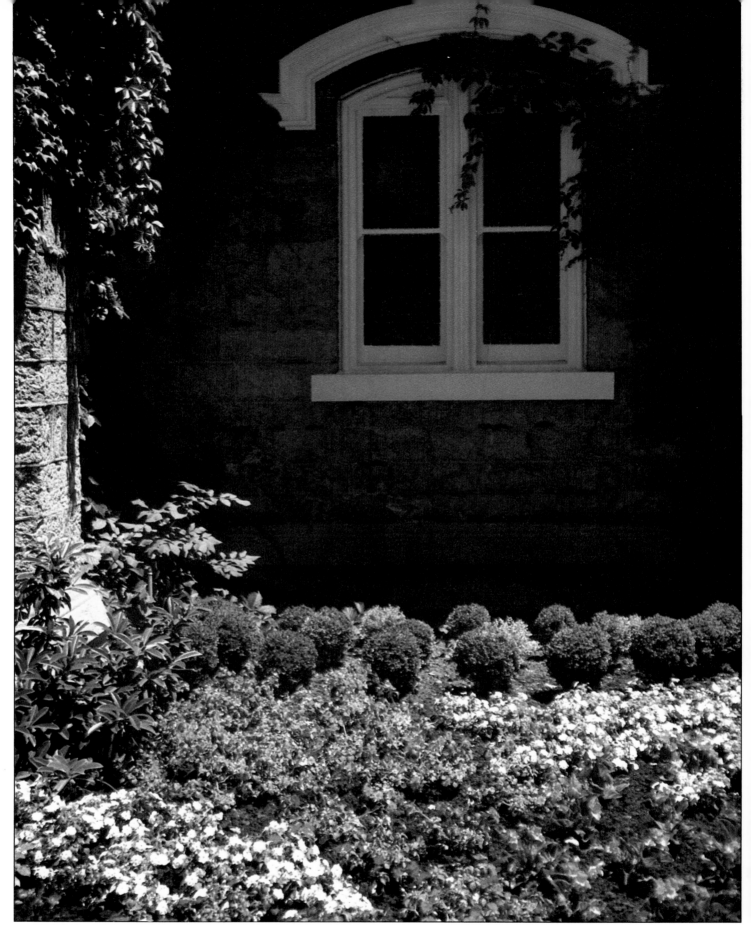

Composition—Although making radical changes in a naturally found still life can often destroy its natural flavor, you shouldn't be afraid to make minor alterations to improve your composition, when it seems aesthetically appropriate. For example, you might want to shift the angle of a prominent object to achieve a more dynamic effect, or remove distracting elements to maintain an uncluttered environment.

CREATING A STILL LIFE

When you create a still life from scratch, you have ultimate control over the composition, from the selection and arrangement of the objects, to the background material and quality of the light.

Before establishing proper lighting and camera angle, begin by placing your objects, one at a time. Position the most important objects first and then add the subordinate elements. You might have to rearrange some of the items, or remove one or two, in order to create the best composition.

To gain confidence in creating still lifes, start by keeping the number of elements to a minimum and work with things that hold your interest, such as memorabilia, collectables, or hobby equipment.

For best results, keep your compositions simple. A few yards of fabric or "seamless" background paper—available at most art and photo supply stores—will make excellent backgrounds for a wide variety of subjects.

Creative Lighting—"Creating" a still life, as opposed to "finding" one, implies that you will be working in a studio or similar location, where you have total control of the environment, including the light-ing. Generally, the lighting setup should be simple. A single source of illumination should be sufficient, although you should have a silvered reflector or white piece of cardboard on hand to reflect soft fill light into the shadow regions.

Remember, the lighting you choose must not only reveal the subject, but at the same time create a specific mood or atmosphere. For example, since tungsten light reproduces on daylight-balanced film as a warm, orange tone, it can be effective in enhancing the sentimental and antique nuances of a still life.

Flash, when used properly, can also be an effective main-light source, giving your images a professional-looking "studio" quality. The best way to use flash is to place a separate, more powerful slave-triggered flash about 45 degrees to one side of the camera. This will give the still life the side lighting necessary to accentuate form and texture. If necessary, use a white or silvered reflector card to bounce light into deep shadows.

You can eliminate the effect of the on-camera flash altogether by covering it with a small, opaque card in such a way that the light from the flash does not reach the subject but does reach the slave trigger of the second flash.

If you want to take advantage of natural lighting, you should be aware of when and where the light enters the room. Remember that the sun's position changes constantly. Be sure to arrange your still life and establish your camera angle *before* optimum lighting occurs, so that you'll be ready to shoot the instant the lighting becomes ideal. This is important, since even a subtle change in the illumination can alter the visual impact of the composition.

This photo clearly illustrates two kinds of contrast. The background to foreground relationship is contrasty because one area is lit brightly while the other is in deep shadow. The wall to window-frame relationship is contrasty because one is much more reflective than the other.

10 *USEFUL ACCESSORIES*

You don't need complicated equipment or expensive gadgetry to take fine photographs with autofocus point-and-shoot cameras. However, some of the optional accessories available for these cameras can prove useful as your photographic needs expand. Check with your local camera store to find out what accessories are available for your particular camera. When purchasing any accessory, it's always a good idea to bring your camera along to the store. This way, you can make sure the accessory is compatible with your camera.

CAMERA SUPPORTS

Throughout this book, mention is frequently made of the importance of tripods and other camera supports. Not only do they enable you to take sharp photographs when the camera employs relatively slow shutter speeds, but they also allow you to lock in a carefully selected composition.

TRIPOD

Appropriately named for its three-legged configuration, a tripod need not be heavy, bulky or costly in order to fulfill its task as a steady camera support. Many tripod manufacturers, including Cullmann and Gitzo, offer a wide assortment of tripods, ranging from short to tall, lightweight to heavy-duty.

You should always consider your own particular needs before purchasing a tripod. For example, if you frequently shoot indoors or on smooth, level terrain, a lightweight, medium-height tripod might be what you need. On the other hand, if you do a lot of shooting outdoors, in rugged terrain and harsh weather conditions, you'll benefit from a more sturdy tripod that can withstand sudden gusts of wind and that features spiked feet.

Before purchasing a tripod, try it out at the store. Be sure the camera mount is capable of locking your

For most shooting, a lightweight tripod, such as the Cullmann Magic (upper photo) is suitable. Both the Model 1 and Model 2 of this tripod series are compact, easily portable, and ideal for travel. Collapsed, these tripods can fit into a camera bag (lower photo) or a backpack. Extended (previous page), they provide sufficient steadiness and support for your compact automatic camera.

In harsh weather conditions or rugged terrain, a sturdier tripod, such as the Cullmann Titan CT-400, depicted here, is recommended. It can be placed in sand, dirt or snow without the risk of damage. For added steadiness on certain surfaces, it can be fitted with spiked feet attachments.

A monopod is a one-legged camera support that is both convenient and portable. Of course, a monopod cannot stand up on its own but must be supported by the photographer. A shoulder or chest support, shown on the unit on the right, can add considerably to the stability of a monopod in use.

camera securely in place. You should feel comfortable with the tripod's functions, such as the extension and retraction of its legs, the raising and lowering of its center column, and the adjustment of the camera angle—up, down, and to the side. Also, check that the tripod doesn't collapse easily under pressure.

MONOPOD

Consisting of a single, usually retractable leg, a monopod is also a convenient camera support. When not in use, it can be easily packed and carried. Fully extended, it can even serve as a sturdy walking stick. The camera is mounted on a monopod in the same way as on a tripod: a screw on the mounting plate must be tightened into the camera's tripod socket.

Because a monopod has only one leg, you should brace it against yourself in order to keep it as steady as possible. Like a tripod, a monopod can have a swiveling and tilting head, enabling you to easily adjust your camera to the desired angle.

BEANBAG

If you are looking for a simple camera support that is easily carried in a backpack or camera bag, you might invest in a canvas beanbag. Beanbags are lightweight and durable. They can be balanced easily on virtually everything from a tree branch to a fence post. With the beanbag securely in place, nestle the camera into the bag—but not so deeply as to obstruct the lens. Look through the viewfinder to accurately frame the subject, and take the shot. If you need to fine-tune the composition, move the camera and beanbag simultaneously so you don't have to reestablish the camera's position on the bag.

TELE-CONVERTERS AND OTHER CLOSE-UP DEVICES

Camera manufacturers offer several methods for easily getting a larger image than are possible with a camera's built-in lens alone.

TELE-CONVERTER

If you want to increase the *maximum* focal length of your lens, a telephoto lens attachment or *tele-converter* will enable you to do just that. Depending on the converter, you can increase the longest focal length of your lens by about 25 to 30 percent, so that you can crop in on subjects without having to move the camera closer to the subject.

Tele-converters, which are placed in front of the lens, and not between lens and camera body, will not reduce the amount of light that reaches the film. Consequently, exposure compensation is not required.

While many camera manufacturers offer tele-converters exclusively for their own camera models, independent manufacturers also produce lens attachments adaptable to a wide variety of autofocus point-and-shoot cameras.

Most tele-converters can easily be snapped into place by means of a hinge that hooks over the top or bottom plate of the camera. A viewfinder with bright-frame lines is built into the converter so that, when the attachment is in place, your camera's viewfinder is automatically adapted for the new focal length. This way, you see the effect of the converter and can compose images accurately.

Tele-converters do have their limitations. For example, they only increase the camera's *longest* focal length, and not the entire focal length range. This means that dual-lens and zoom-lens cameras effectively become single-focal-length cameras when a tele-converter is attached. If you want to return to the normal focal-length range of the camera, you must remove the converter *completely* from the camera.

TELE-EXTENDER

Minolta and Ricoh have solved the single-focal-length problem by offering a *tele-extender* for their *Minolta Freedom Zoom 90* and *Ricoh Shotmaster Zoom* cameras. The extender makes it possible to increase *all* inherent focal lengths of the camera. Furthermore, the Minolta extender can be flipped out of the way, and need not be removed completely from the camera, to ensure proper camera functioning without it.

CLOSE-UP ACCESSORY LENS

Some camera manufacturers, including Minolta

This Auxiliary Lens Kit for the Minolta Freedom III camera consists of a snap-on telephoto converter lens and a close-up lens, for additional creative capabilities.

The Zoom Extender attached to this Minolta Freedom Zoom 90 camera increases all the focal lengths of the lens, not just the longest focal length.

and Ricoh, offer close-up attachments that enable the camera to actually focus at a closer distance than it can with the camera lens alone. These lenses attach to the front of the camera lens in the same way as a tele-converter. When a close-up lens is attached to the camera lens, the camera automatically adjusts the focus setting for the close-up lens. When a close-up attachment is in use, the "too-close" focus warning will not appear and the shutter will not freeze.

When not in use, lens attachments can be stored conveniently in their own protective cases, which are small enough to fit into pockets and camera bags. Some converter cases can be hooked onto camera straps or belts, for easy access.

A tele-converter increases the effective focal length of a camera's longest focal length. Pictured at right is the snap-on 2.5X Canon AF Telephoto Converter. The other two photos show the converter in place on the Canon Sure Shot Multi Tele Date camera.

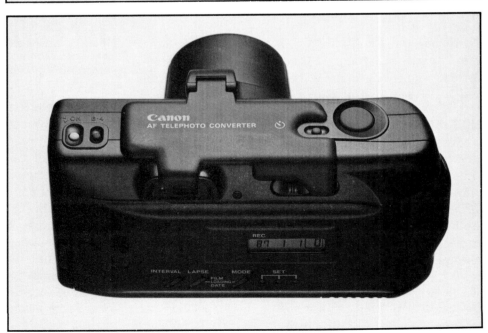

FILTERS

Camera filters transmit and absorb light in different ways, depending on the filter type. Filters are thus able to correct for unwanted color shifts, produce interesting special effects, or alter your camera's automatic exposure setting. Filters are relatively costly and should be handled with the utmost of care.

Depending on the camera you own, you might be able to obtain round, threaded filters, which screw directly onto the front of the lens. Your camera's instruction manual will tell you what thread size the camera will accommodate, if this is, indeed, possible.

Some camera manufacturers produce filter sets expressly for their own camera models. Minolta, for example offers a set of three special-effect filters: soft-focus, star-effect and fog. These attach easily to the front of the lens and do not affect the camera's focus and exposure systems.

If your camera was not designed to accommodate threaded or "snap-on" attachments, both Cokin and Tiffen offer a vast assortment of non-threaded, square filters, available in plastic, glass or gelatin. While both round and square filters can simply be held in front of the lens while you're taking photographs, this can sometimes prove troublesome. To avoid this inconvenience, Cokin has developed a filter holder expressly for compact cameras and standard Cokin filters.

The Cokin filter holder can be attached to your camera either with Velcro strips, which must be adhered to the bottom of your camera and the top of the filter holder's base, or it can be screwed into the camera's tripod socket.

If you have a zoom-lens camera, be sure to purchase the filter holder specifically designed for zoom-lens cameras. Before purchasing the system, also be sure that the filter properly covers the lens and the camera's light sensor, and *not* the autofocus window. The filter must cover the light sensor for the camera to select a proper exposure setting. However, if it obstructs the AF window, its close proximity will cause the camera to lock focus at infinity.

FILTER TYPES

Most camera stores carry a tantalizing assortment of filters with which you can create visually unique images, and even generate a few surprises. Keep in mind, however, that the viewfinder of the average compact camera does not show you *exactly* what the camera lens sees. Therefore, you should only use those filters which do not require precise adjustments

The Cokin Creative Filter Systems for autofocus point-and-shoot cameras accommodate all standard Cokin filters. Pictured are the standard system (right), for single- and dual-lens cameras, and the zoom-system (left), expressly for zoom-lens cameras.

in relation to the lens. The following are filters that will work successfully with autofocus point-and-shoot cameras.

Color filters for color films are available for two basic purposes: to correct or balance the colors in an image, and to create special color effects. There's a third purpose, applying to black-and-white films only, and that's the control of image contrast.

Color Effect Filters—When you place a filter of any color over your camera's lens, the image on film will take on a "color bias" of the filter color. For example, if you photograph a scene with a red filter over the lens, the scene will take on an overall red appearance on film.

Contrary to what you might think, a colored filter does not *add* its own color to the scene but *subtracts* all other colors. If you put a deep-red filter over the lens, only red wavelengths will be transmitted to the film, while blue and green wavelengths will be blocked out.

Color-effect filters are available in a wide assortment, and can be used for creating special effects in color and black-and-white photography.

Color Conversion and Light Balancing Filters—To avoid unwanted color shifts that can be caused by different types of light sources, *corrective* color filters can be used. For example, for shooting daylight-balanced color film in tungsten lighting, using a blue 80-series conversion filter will prevent your photos from looking too orange. If you happen to be using one of the films balanced for tungsten light and find yourself shooting in daylight, an amber 85-series filter will prevent your photos from having a blue cast.

Light balancing filters in the blue 82-series and amber 81-series are similar to conversion filters but weaker. They are designed for fine-tuning color balance.

To correct for the green imbalance caused by most fluorescent lighting, Tiffen and some other manufacturers make a special FL-D filter, for use with daylight-balanced film.

UV and Skylight Filters—To reduce the bluish cast caused by the scattering of ultraviolet rays at high altitudes and in distant scenes, a UV (ultraviolet) filter, which absorbs ultraviolet radiation, can be a handy accessory. Skylight filters basically do the same thing, but absorb some blue light as well as UV. They help to eliminate the bluish cast that occurs in color photos shot in open shade or under overcast conditions. Neither UV nor skylight filters will affect your camera's exposure.

Color filters alter the overall color of a scene. Some filter types can be used creatively for special effects, while others are specifically designed to correct unwanted color shifts caused by different types of light sources. Pictured in the center is a polarizing filter, handy for eliminating unwanted reflections from non-metallic surfaces and producing richer, more saturated colors.

 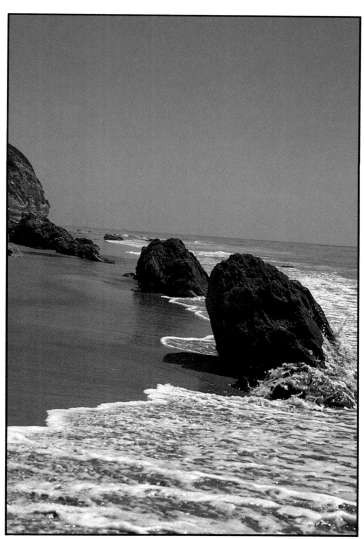

The shot on the left was made in hazy sunlight. It is realistic but a little dull pictorially. To make the photo on the right, a blue filter was placed over the camera lens. The added blue enhanced the sky and water and made this beach scene look more summery.

Neutral-Density (ND) Filters—A neutral gray in color, neutral-density filters reduce the amount of light permitted to reach the film, without affecting color balance. Neutral-density filters are available in a range of strengths (see Chapter 5), enabling you to increase or reduce your camera's selected exposure setting, or rate a roll of film at a different ISO speed, to suit a specific subject.

When a neutral-density filter is placed over the lens and not the light sensor, exposure will be reduced; when the filter is placed over the light sensor and not the lens, the camera will provide more exposure.

Polarizing Filter—When light is reflected from most surfaces—an exception being unpainted metal—at a specific angle, the light becomes "polarized." Polarized light can be removed partially or totally by the use of a polarizing filter.

For example, when a street scene is reflected from a shop window at an angle of about 30 to 35 degrees to the window pane, the reflected light is polarized. By using a polarizing filter on the camera lens, you can control that polarized light. By rotating the polarizing filter, you can eliminate more or less of that reflected polarized light.

When the polarized light is totally eliminated, you can see what's inside the store, beyond the window, rather than just seeing the reflection.

That's perhaps the main usefulness of the polarizing filter or polarizer. You can remove reflections from glass, cars, furniture, water, and many other surfaces.

The removal of such reflections serves a secondary, but important purpose. It provides increased color saturation. For example, the colors of a painted build-

 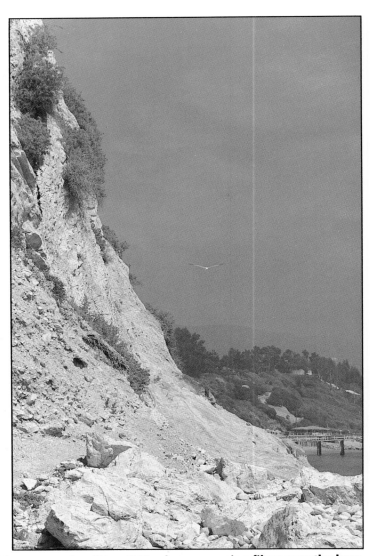

When shooting tungsten-balanced film in daylight, you should use an amber 85 or 85B color conversion filter over the lens (left). Without such filtration, a photo will have a distinct and undesirable bluish color cast (right).

ing will look richer and brighter when you remove unwanted surface reflections from the walls.

The darkest part of the blue sky largely consists of polarized light. This enables you to darken a blue sky, even when you're using color film, by using an appropriately oriented polarizer on the camera lens. The use of a polarizing filter will not affect the color balance of the image.

Basically, with a polarizer "what you see is what you get." You need simply look through the polarizer at the scene and rotate it until you get the effect you want. Then, place the filter over the camera lens in *exactly the same orientation.*

For best exposure, the polarizer should cover both the camera lens and the camera's light sensor. If this is

not possible, placing a 1-step neutral-density filter over the light sensor will help to provide an adequate exposure.

Star Filters—Available in three basic types, a star filter will create four-, six-, or eight-pointed stars out of point-light sources and small specular reflections. Star filters consist of a cross-hatched screen pattern which diffracts the light, causing particularly bright points of light to reproduce as star shapes. The best effect is achieved against a relatively dark background.

Diffraction Grating—A diffraction grating creates spectral color streaks as a result of very closely spaced parallel lines, etched into the surface of the filter. When a camera with a diffraction grating over the lens

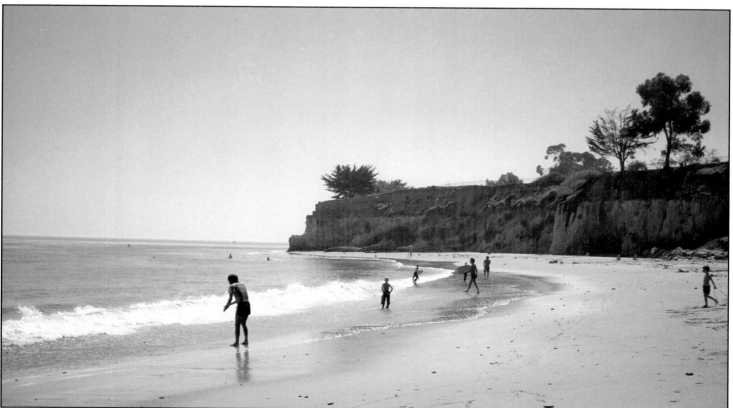

Polarizers can sometimes be useful for producing richer, more saturated colors in a photo. Note, in the top photo, how the polarizer emphasized the ocean's white foam and the bright blue sky. Since the filter did not cover the camera's light sensor, the overall exposure gave a darker image than did the exposure without the filter (bottom photo). However, the darker tonality, as well as the higher contrast, made for a more striking image. Incidentally, a polarizing filter darkens a blue sky without affecting the overall color balance of the photo, making that filter invaluable in much color photography.

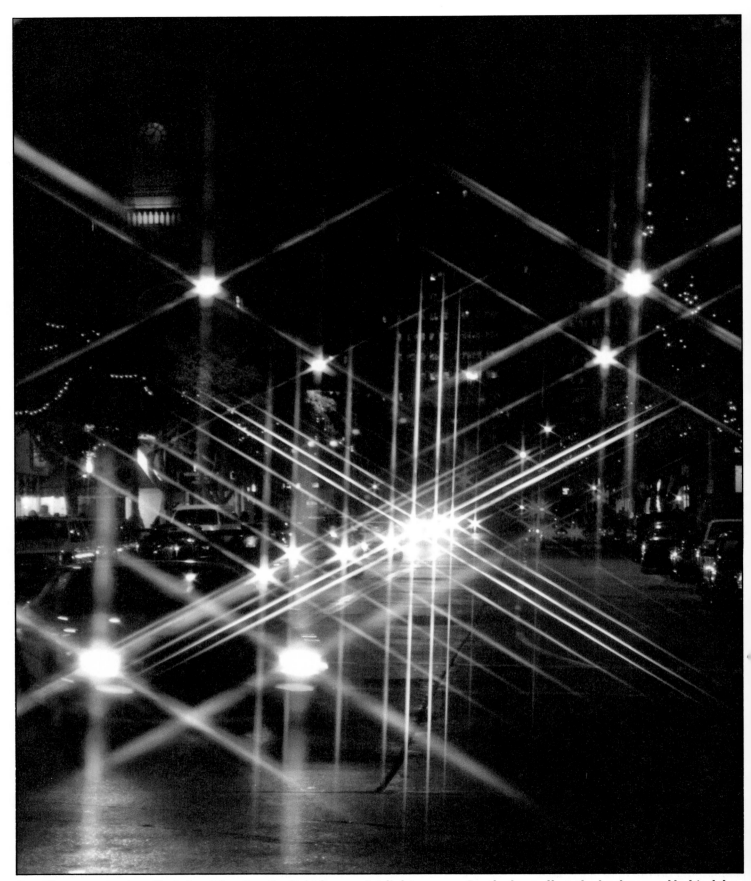

Star filters create star effects by diffracting the light from point-light sources. For the best effect, the background behind the lights should be dark.

is aimed at a continuous-spectrum point source of light, the filter bends the light, breaking it down into its component colors. The result is a rainbow-colored splash of light that emanates from the original point source. If the light source does not have a full color spectrum, the color splash will be limited accordingly.

Laser Filters—Known for producing even more dazzling effects than conventional diffraction gratings, laser filters are actually holographic diffraction gratings that produce patterns of color streaks that intersect each other to produce complex color spectra when aimed at point-light-sources. Like star filters and diffraction gratings, laser filters are best used at night, as the spectral streaks of color will stand out most against a dark backdrop.

Diffusion Filters—To create a romantic, ethereal atmosphere in your photographs, a diffusion filter will soften details and slightly "flare" bright areas, without making a subject appear out of focus. The effect can be especially flattering for portraits of women. It is useful for softening facial lines and blemishes. It can also be used effectively in some scenic photography.

Several types of diffusion filters are available: those that have particles ground into them, those with wavy crisscross patterns, and those with lightly etched concentric circles. Regardless of these design differences, all diffusion filters produce basically the same effect. The optically clear and flat areas of the filter enable light to pass directly through to the lens, producing a normal, sharp image on film. The altered areas of the

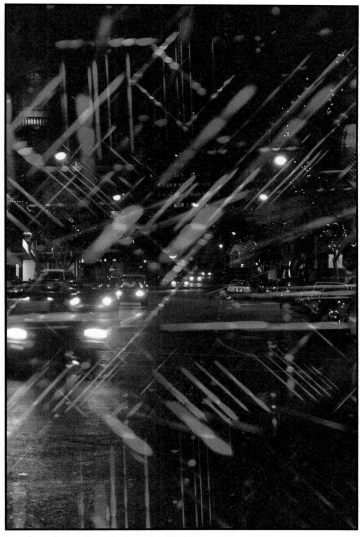

Laser-generated diffraction gratings can create dazzling color streaks when aimed at point-light sources. The patterns vary, depending on the filter type. Cokin's Galaxy diffractor was used to create the colorful effect on the left. Cokin's Cosmos diffractor was used to make the image on the right. Such laser filters are best used at night, against a dark sky. The use of a tripod is highly recommended.

filter bend the light that strikes them, thereby producing an overlapping diffused image. This is how a diffused, yet sharp image is created.

Diffusion filters are available in varying strengths, and can be used for color and black-and-white photography.

Fog Filters—Similar to diffusion filters, fog filters have particles ground into them that scatter the light entering the lens, in a similar way water particles in the air—in the form of fog or mist—disperse rays of light. Hence, fog filters make scenes appear foggy.

Fog filters are useful for softening the appearance of a scene, muting tones for a pastel effect, and creating a mysterious or exotic atmosphere. Like diffusion filters, fog filters come in several strengths, for producing fog effects of different prominence. The filters are colorless and are suitable for both color and black-and-white photography.

SPECIAL FILTER EFFECTS

Experimenting with filters can be enjoyable and rewarding. Here are some suggestions for creating images that have instant impact.

Filter Over the Flash—When you place a colored filter over your camera's flash unit instead of over the lens, the foreground subject will be illuminated by the color of the filter, while the background—beyond the range of the flash and therefore lit by available light—maintains its normal appearance. You must, of course, be sure that there is enough ambient light in the background to record the scene satisfactorily.

This technique can be used to enhance a subject's natural coloring or to alter the subject's color. For example, if the subject is a pale green shrub, a bright green filter over the flash will enable the shrub to reproduce as a deeper, more vibrant-looking green. On the other hand, if the subject is a person, a weak yellow to orange filter over the flash can enhance the subject's complexion, while the background color is unaffected.

When experimenting with this technique, shoot the subject from different distances, so as to deliberately affect the intensity of the flash illumination in respect to the subject. When you reach the far end of the flash range, the effect will become very subtle; conversely, the closer you are to the subject, the more effective the subject illumination will be.

It's a good idea to take comprehensive notes as you shoot so that, when you get back your results, you'll know exactly how you achieved the shots you like best. Also, be sure to tell the folks at the lab that your shots were taken with color filters, otherwise the lab may try to correct the color at the printing stage.

Three-Filter Technique—If your camera has a multiple-exposure capability that permits three or more shots to be taken on a single frame of film, you can employ the three-filter technique to create interesting effects using color film.

All you need are a No. 25 red, a No. 38A blue and a No. 61 green filter. The advantage of using these specific filters is that they are all of about equal density, enabling the camera to use the same exposure with each filter.

If you were to make three exposures of a static scene on the same frame, using these three filters one at a time, the end result would be a reasonably normal looking image. This is because red, blue and green are the primary colors of white light. However, if something in the scene, such as clouds or water—or even a person—were to move between the exposures, the final image would appear in three different places on the film, cast in the three filter colors. Where the filter colors overlap, you would get additional colors. For example, a combination of red and blue would yield a magenta color.

To use this technique most effectively, mount your camera on a tripod so you can lock in your composition. Everything in the scene should remain in register except for the moving parts.

For best exposure, hold a 1-step neutral-density filter over the camera's light sensor for each exposure. This should compensate appropriately for the light loss due to the filters, on the one hand, and the added exposure due to image overlap, on the other. Alternatively, if your color filters are large enough, you could hold them so as to cover both the camera lens and the light sensor. This, too, should yield an adequate, although slightly overexposed result.

CAMERA BAGS

A camera bag is a worthwhile investment. It will protect and cushion your camera in adverse conditions, and enable you to keep accessories and other useful items on hand at all times. A wide assortment of camera bags and cases is available, ranging from small belt pouches to large shoulder bags. Most camera bags made today are lightweight and durable, and many are weatherproof as well. Many also come with movable padded dividers which you can arrange or remove to best suit your equipment.

Because there is such a diversity of camera bags on the market, you should have some idea of how much equipment you will want the bag to accommodate. This will help you determine the size and shape of the bag you're going to need. If you like to carry a lot of little accessories, make sure the bag has a couple of

A color filter placed over the camera's flash unit will illuminate the subject in the color of the filter, while the background maintains its normal appearance—as long as there is ample ambient illumination in the background.

pockets or compartments that will keep smaller items separately contained.

The best way to choose the right camera bag is to "try it on." Put it over your shoulder, or around your waist, and walk around. It should stay securely in place and its weight should feel comfortable and well balanced. You should also be able to open and close the bag quickly and easily.

PROTECTION FROM X-RAYS

If you plan to take a supply of film with you when you travel by air, a lead-lined bag is invaluable for protecting your film from harmful X-rays at airport security checkpoints. Especially if you carry fast films, or plan to go through several checkpoints, the X-rays could otherwise fog your film and spoil your images. Sima produces a variety of sizes of lead-lined bags, including special tubes for 35mm film cans. You can also get lead-lined bags that will hold an entire camera—a useful device for protecting loaded film.

A wide assortment of camera bags is available, ranging from shoulder bags to belt pouches. A small bag is ideal, if you just want to carry your camera and a minimal supply of film. A larger bag is required if you like to have a lot of accessories on hand at all times.

A lead-lined X-ray shield will protect your film from damage by harmful X-rays at airport security checks. Excessive X-ray exposure will fog your film—especially if you use film faster than ISO 100. These bags are inexpensive and come in various sizes, to suit individual needs.

CAMERA CARE EQUIPMENT

Caring for your camera is an important aspect of good photography. If you keep your camera free from dirt and particles that might interfere with its optical or mechanical operation, the camera will give you long and faithful service. Virtually every camera store sells camera cleaning kits that are inexpensive and contain everything you need to properly maintain your camera. Usually, this includes lens-cleaning fluid, non-abrasive lens tissues and a blower brush. These items can be purchased separately as well.

To clean your camera properly, use the blower brush to remove any dust from the surface of the camera. For removing particles from the lens, you should use a fine lens brush, resembling an artist's brush. Beware of touching the tip of the lens brush, as oil from your skin will collect on the bristles and will, invariably, end up on the lens.

When you have removed all dust and dirt particles from the lens, moisten a wadded piece of lens tissue with lens cleaning fluid and gently wipe the surface of the lens. This will remove any fingerprint smudges or water marks that might reduce the sharpness of your photos. As necessary, this procedure should be repeated for the viewfinder, the autofocus windows and the light sensor.

Periodically, when your camera isn't loaded, you should also inspect the inside of the camera for dust or other particles that might have collected on the inner surface of the lens as well as the film plane, pressure plate and take-up spool. Remove such particles with an air blower or very fine brush.

Camera cleaning kits are inexpensive and well worth the investment. Proper maintenance is very important to the longevity and proper functioning of your camera.

Remove dust particles on both sides of the lens with a fine lens brush (top). Blow any stubborn particles away with an air blower (center). Use a soft, lint-free cloth or a lens tissue to gently wipe away any smudges or spots on your camera's autofocus windows, exposure-sensor window, or lens (bottom).

11
TROUBLESHOOTING

When used correctly, fully automatic compact 35mm cameras can produce some beautiful "surprises" on film. However, when a camera is not used correctly, or when it malfunctions, it can produce surprises that are less than desirable. Such frustration can usually be avoided by a proper understanding of the camera's features and functions, a little knowledge of basic photographic principles, and careful camera handling. The purpose of this book is to teach you the essentials in each of those categories. However, errors are still likely to occur from time to time. This "troubleshooting" chapter is designed to help you to identify, avoid, or correct picture-taking problems.

Following are some of the more common picture faults, together with suggested cures or prevention.

PROBLEM: PHOTOS BLURRED OR UNSHARP

If your photos are not consistently sharp, this is most likely due to user error and not a malfunction of the camera's autofocus system.

Cause: Improper Focus—If the main subject is not centered in the image frame when the camera establishes focus, the background, or whatever else is in the center of the viewfinder frame, will reproduce sharply, while the subject appears fuzzy.

Prevention—Always establish and lock focus on the centered subject, then recompose the image the way you want it.

Cause: Smudged or Obstructed AF Window—You may be covering one or both of the autofocus windows with a finger as you take the picture. Or, the AF window may be smudged so badly that it fails to function properly.

Prevention—Hold the camera correctly, so as not to obstruct important parts. If necessary, clean the autofocus windows with a soft, lint-free cloth.

Cause: Slow Shutter Speed—When the camera employs a slow shutter speed, moving subjects will generally record with a blur. Stationary subjects and scenes will also appear unsharp if the handheld camera is not held absolutely steady.

Prevention—When the camera is likely to use a slow shutter speed, in dim lighting conditions and when you're using a slow film, for example, play it safe and mount your camera on a sturdy tripod or place it on some other steady support.

Cause: Jerky Shutter Operation—Even at moderately fast shutter speeds, a handheld camera can produce blurred images if you abruptly jerk or jab the shutter button.

Prevention—Adopt a firm stance and always squeeze the shutter button gently, holding the camera quite still until the exposure is over.

Cause: Dirty or Smudged Lens—Smudges or fingerprints on a lens can "soften" an image to the point where it is distinctly unsharp.

Prevention—Avoid touching the camera lens. If the lens does get dirty or smudged, do not use the camera until you've cleaned the lens, following directions provided in this book.

PROBLEM: PHOTOS TOO LIGHT

If your prints or slides are too light, lacking detail and color, the film has received too much exposure. This can happen in several ways.

Cause: Incorrect Film-Speed Setting—When you load a roll of film that is not DX-coded into your camera, the camera will generally set a film speed of ISO 100 automatically, regardless of the film's actual speed. If the film's actual speed is higher than ISO 100, your photos will be overexposed.

Prevention—If you intend to use film that is not DX-coded, choose one of speed ISO 100, or as close to it as possible. When using film other than ISO 100, it's best to use color print film, which has a greater exposure latitude than color slide film.

If the problem occurs with a DX-coded film cassette, your camera may be setting the wrong film speed. Have your camera checked by a repair specialist.

Cause: Obstructed or Smudged Light Sensor—If the camera's light sensor is partially obstructed by a finger or a smudge, the metering system will interpret the subject as being darker than it actually is. Because of this, the camera will provide more exposure than is necessary.

Prevention—Avoid any form of obstruction of the light sensor, and keep the sensor window clean.

Cause: Incorrect Use of Exposure Compensation—Some cameras maintain an exposure-compensation setting, even after you may not want to use it any longer. If your camera is unintentionally set for increased exposure, your images will be too light.

Prevention—Check whether your camera automatically cancels an exposure-compensation setting after use. If it does not, remember to always reset the camera to its automatic program mode before resuming normal shooting.

PROBLEM: PHOTOS TOO DARK

If your prints or slides are too dark, the film did not receive enough light or exposure. There can be several causes for this problem.

Cause: Incorrect Film-Speed Setting—If you load a film that is not DX-coded and is slower than ISO 100 into a camera that will automatically set ISO 100 for such a film, the camera will supply less exposure than is actually necessary for the slower film. As a result, the photos will be too dark.

Prevention—If you intend to use film that is not DX-coded, choose one of speed ISO 100, or as close to it as possible. When using film other than ISO 100, it's best to use color print film, which has a greater exposure latitude than color slide film.

If the problem occurs with a DX-coded film cassette, your camera may be setting the wrong film speed. Have your camera checked by a repair specialist.

Cause: Incorrect Use of Exposure Compensation—Some cameras maintain an exposure-compensation setting, even after you may not want to use it any longer. If your camera is unintentionally set for decreased exposure, your images will be too dark.

Prevention—Check whether your camera automatically cancels an exposure-compensation setting after use. If it does not, remember to always reset the camera to its automatic program mode before resuming normal shooting.

Cause: Improper Use of Flash-Off Mode—If you de-activate the flash, even though the illumination on the scene is sufficiently dim to call for flash, your photos are likely to be too dark.

Prevention—Make sure your camera's built-in flash is in its automatic firing mode when you're shooting in dim light. If you deliberately want to shoot in relatively dim lighting without flash, use a fast film. Also, mount the camera on a tripod or other firm support, to avoid blurred results due to camera shake at slow shutter speeds.

PROBLEM: LIGHT STREAKS, BANDS OR LINES IN PHOTOS

There can be several causes for light streaks or bands in photos. With care, they can be avoided.

Cause: Camera Back Opened Accidentally—If a bright streak appears in part of a picture, you may have opened the camera back before the film had a chance to rewind into the cassette.

Prevention—Always check the frame counter or the LCD display panel to be sure the film has been rewound before you open the camera back.

Cause: Film Cassette Handled in Direct Sunlight—If you expose a film cassette to direct sunlight, or some other bright light source, for an extended period, light may leak into the cassette, fogging the film.

Prevention—Always load and unload film in subdued light, either in a shaded area or indoors. Remember that fast film is most light sensitive, so that such film should be handled with particular care in this respect.

Cause: Dirt in Film Cassette—If uniform dark lines appear in all your slides and prints, a dirt particle in the film cassette may be scratching the film as it passes through the camera.

Prevention—Always keep films in their protective plastic cans when they are not in the camera. Keep film cassettes away from sand and dirt, and out of locations that may accumulate dust and unwanted particles, such as pockets and handbags.

Cause: Dirt Particles on Camera Pressure Plate—The film can also become scratched on its back surface if there are dirt particles on the camera's pressure plate, which holds the film in place at the focal plane.

Prevention—Don't open the camera—to load or unload film—in windy conditions, especially at locations such as a beach, where dust and sand could be blown into the camera. If unwanted particles do get into the camera, carefully use a brush or air blower to remove them.

Cause: Error in Processing—If irregular white streaks, spots and marks appear in your prints, the fault could lie with the processing lab. The cause could be dust particles on a negative during printing. If a slide was scratched during the mounting process, it could also contain unwanted marks.

Cure—If the original negatives are in good condition, you can have clean reprints made. If a negative or slide has been scratched, the damage is permanent, although there are treatments that can be used on film to minimize the effect of scratches. Ask a photo dealer for details.

Prevention—If you are dissatisfied with the work of your processing lab, find a new one. When you have found a lab that does reliable, good work, stay with it.

PROBLEM: DARK AREA OVER PART OF PHOTO

If a corner or side of a picture is dark, lacking all image detail, something was obstructing the lens when you took the picture.

Cause: Finger or Camera Strap in Front of Lens—When a finger or part of a camera strap obstructs part of the camera's lens, part of the image will be missing in the photo.

Prevention—Hold the camera correctly, taking care not to obstruct the lens or any other functional camera part with fingers, straps or any other object.

Cause: Obstruction Inside Camera—If a dark area appears in a picture and you know that nothing was obstructing the lens, there may have been something inside the camera that prevented light from reaching the entire image area.

Prevention—Before you reload the camera to take more pictures, check the inside of the camera for unwanted particles such as small pieces of carboard, paper or film.

PROBLEM: PHOTOS LOOK WASHED-OUT OR "FOGGED"

When photos have an overall hazy, weak appearance, the film has probably been "fogged." Fogging can be caused in several ways.

Cause: Light Leak in Camera—If photos are consistently fogged, roll after roll, your camera may have developed a light leak, allowing unwanted light to reach the film, even when the camera back is closed.

Cure—Have your camera repaired, if it is practicable, or get a new camera.

Prevention—Handle your camera with care. Do not drop it or force it in any way. Keep your camera away from excessive heat.

Cause: Outdated or Badly Stored Film—Fogged images can be caused by film deterioration due to improper storage or use after its expiration date.

Prevention—Use film before the expiration date printed on the film box. Store film in a cool, dry place. If you're not going to use the film for several months, store it in a refrigerator. Before opening the sealed film package, allow the film to warm up again to room temperature.

Cause: Airport X-Ray Checks—Allowing film to pass through airport X-ray checkpoints several times can cause fogging, especially of the faster films.

Prevention—Request that your film be hand inspected or protect your film in special lead-lined bags, available for that purpose.

PROBLEM: COLOR IMBALANCE

When photos have an unwanted color imbalance, it is usually caused by the fact that the illumination is not appropriate for the film type being used.

Photos Are Too Reddish: Cause—Daylight-balanced film was used in tungsten lighting without proper filtration.

Cure—To some extent, the processing lab can correct the imbalance in the printing process.

Prevention—Use the proper film for the lighting conditions, or use appropriate corrective filtration (an 80-series filter), as suggested in Chapter 10.

Photos Are Too Bluish: Cause—Tungsten-light-balanced film was used in daylight without proper filtration.

Cure—To some extent, the processing lab can correct the imbalance in the printing process.

Prevention—Use the proper film for the lighting conditions, or use appropriate corrective filtration (an 85-series filter), as suggested in Chapter 10.

Photos Are Too Greenish, Muddy: Cause— When pictures have a muddy, greenish appearance, film may be outdated or may have been stored inappropriately.

Prevention—Do not use film after expiration date printed in the film box. Store film in a cool, dry place. If you're not going to use film for several months, store it in a refirgerator. Allow film to return to room temperature, before you open the sealed film package.

Cause—You may have taken them in fluorescent lighting.

Prevention—Use a special filter, designed to correct for this condition. See a photo dealer for details.

Photos Have a Partial Color Imbalance: Cause—When the overall appearance of a photo is good, but a part of the image has a distinct color imbalance, it is probably due to a reflection of colored light onto that part.

Prevention—Avoid having colored surfaces, such as painted walls, bright foliage, etc., close to any part of the subject. If you want to use a reflective surface to brighten shadows, use a white or light-gray surface rather than a colored one.

PROBLEM: BLANK NEGATIVES OR BLACK PRINTS AND SLIDES

If you get your film back from the lab, only to find that your negatives are totally blank, or your prints (if any) and slides are totally black, the film was never exposed.

Cause: Film Not Advancing Through Camera—When loading film, if you don't pull the film leader all the way over to the automatic take-up mark in the camera, the film will not advance through the camera.

Prevention—Always be sure to load film correctly. If your camera has a film-loaded indicator, use it to make sure the film is loaded correctly before attempting to take pictures. You can also check the frame counter; with most cameras, the frame count won't advance unless the film does.

Cause: Unexposed Film Given to Processing Lab—If you mistake an unexposed roll of film for an exposed one, and give it to your processing lab, you'll get back blank negative film or black slides.

Prevention—If your camera does not wind the film leader all the way back into the cassette automatically, do it by hand as soon as you remove an exposed roll of film from the camera. This way, you will always be able to distinguish an exposed roll from an unexposed roll.

PROBLEM: CAMERA WILL NOT FUNCTION

If your camera does not "respond" when you press the shutter button, don't be alarmed. The cause is usually rectified quite easily.

Cause: Lens Shield Closed—When the camera's lens shield is closed, the camera cannot be operated. This is a safety device that prevents you from accidentally wasting film.

Cure—Open the lens shield, thereby switching on the camera, before you attempt to take pictures.

Cause: Dead Battery—If you cannot open the lens shield, or if you can open the lens shield but the camera still does not respond, the battery is probably dead.

Cure—Replace the battery with a new one. It's a wise safeguard to always have a spare battery on hand, especially if you are traveling with your camera.

PROBLEM: RED-EYE

This is an unflattering flash-photography phenomenon in which the pupils of a subject's eyes appear red.

Cause: Frontal On-Camera Flash—When the flash is close to the camera lens, the flash reflection from the red retina in the back of the eye reaches the camera lens and the film. This causes red spots in the images of eyes.

Prevention—Use off-camera flash, when you can. To minimize red-eye with on-camera flash, have the subject in as bright ambient light as possible, or looking in the direction of a fairly bright light source, so the irises of the eyes close down as much as possible. Alternatively, avoid having the subjects look in the direction of the camera. A few cameras have integrated devices that help minimize red-eye.

PROBLEM: LENS FLARE

When the light from a bright source, such as the sun, strikes the camera lens, the effect of lens flare will be evident in your pictures.

Cause: Light From a Bright Source Strikes Lens—When light from a bright source is permitted to strike a camera lens, internal reflections in the lens cause overall flare and flare spots.

Prevention—When shooting toward the sun or any other bright light source, be sure to shield the camera lens so the source is not able to strike the lens directly. To avoid flare when using flash, do not aim the camera at right angles toward a reflective surface, such as a mirror or window.

PROBLEM: OVERLAPPING IMAGES

If two or more images appear on top of each other on one film frame, you have made two or more exposures on one frame of film. This could be due to one of several causes.

Cause: Multiple Exposure Mode Accidentally Used— You'll get overlapping images if your camera is set for the multiple-exposure mode.

Prevention—Unless you deliberately want to make multiple exposures, be sure the camera is set for the normal shooting mode.

Cause: Exposed Film Reloaded Into Camera—Some cameras will not automatically rewind the film leader all the way into the cassette, so that you may mistake an exposed roll of film for an unexposed roll and accidentally load it into the camera a second time. This will lead to double exposures.

Prevention—When removing exposed film from the camera, always be sure that the leader is wound all the way back into the cassette, if not automatically by the camera, then by hand by you. This way, you can easily distinguish an exposed roll from an unexposed roll.

Cause: Malfunction of Film Advance System—If neither of the above possibilities is applicable, the camera's film advance system may not be functioning properly.

Cure—Take your camera to a camera repair specialist.

INDEX